IN THE
ARTS & CRAFTS
STYLE

IN THE
ARTS & CRAFTS
STYLE

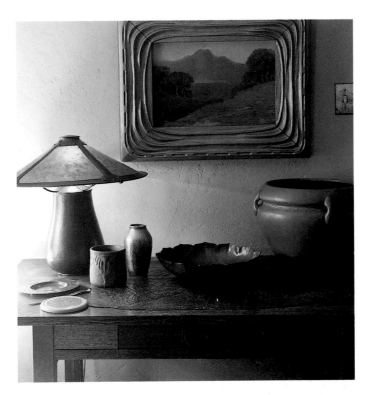

BARBARA MAYER

photographs by ROB GRAY
foreword by ELAINE HIRSCHL ELLIS

CHRONICLE BOOKS • SAN FRANCISCO

A Running Heads Book

IN THE ARTS & CRAFTS STYLE
was conceived and produced by
Running Heads Incorporated
55 West 21 Street
New York, New York 10010

ISBN 0-8118-0505-7

Library of Congress Cataloging-in-Publication Data

Mayer, Barbara, 1938–
 In the arts & crafts style / Barbara Mayer : photographs by Rob
Gray ; foreword by Elaine Hirschl Ellis.
 p. cm.
 ISBN 0-8118-0202-7 : $35.00
 1. Arts and crafts movement—United States. 2. Decorative arts—
United States. I. Gray, Rob. 1952– . II. Title. III. Title:
In the arts and crafts style.
 NK1141.M39 1992
 745′.0973′09034—dc20
 92-4650
 CIP

Creative Director: Linda Winters
Editor: Rose K. Phillips
Designer: Liz Trovato
Managing Editor: Jill Hamilton

Consulting Editor: Gregory A. Dobie,
Los Angeles County Museum of Art

1 3 5 7 9 10 8 6 4 2

Chronicle Books
275 Fifth Street
San Francisco, California 94103

Typeset by Trufont Typographers Inc.
Color Separations by Hong Kong Scanner Craft Company, Ltd.
Printed and bound in Singapore by Tien Wah Press (Pte.) Ltd.

Dedication

For Caroline and Don Simonelli, who understand the art and craft of friendship

ACKNOWLEDGMENTS

In one respect, at least, this book shares something with both the Arts and Crafts movement and its revival. It has been an enterprise to which many people contributed their knowledge and their best efforts. I would like to thank them.

For suggesting the project to me, Renee Kahn; for reading portions of the manuscript and offering comments, Gordon Mayer and Suzanne Potter; for her outstanding editorial guidance and help, Rose K. Phillip at Running Heads. I'd also like to thank Jill Hamilton of Running Heads. Caroline Herter and Carla Charlton of Chronicle Books were also enormously helpful.

For their assistance in obtaining needed books, I thank the South Salem Library in South Salem, New York, Dorothy Carr, director, and the library of the Cooper-Hewitt Museum in New York, Steven Van Dyke, director.

Among those who answered my questions and provided information, I would like to specifically mention these individuals: Joseph Butler, Beth Cathers, Nick Dembrosky, Stephen Gray, David Hanks, Bill Hosley, Vance Jordan, Nancy McClelland, Merilee Meyer, Cheryl Robertson, and Christopher W. Wright.

Thanks also go to Mitch Tuchman and Greg Dobie of the Los Angeles County Museum of Art. Mr. Tuchman was an invaluable help early in the project, while Mr. Dobie acted as consulting editor. Research coordinator Joanna Wissinger— who discovered and scheduled West Coast locations and sought out additional contacts and sites elsewhere in North America—was also indispensable. David McFadden at the Cooper-Hewitt Museum made enormously helpful developmental suggestions.

Claus Rademacher Architects, R. Greenberg Construction Corporation, and Jeremy P. Lang of Butler Rogers Baskett Architects contributed their fine work to the book. A number of collectors opened their homes to us for photography: on the East Coast, grateful acknowledgment goes to Jed Johnson and Alan Wanzenberg, Stephen Birmingham, Edgar Smith, Shelly and Vincent Fremont, Arthur Cobin and Vivian Boniuk, John and Susan Barton, Sarah and Richard Kearns, Karen and Jimmy Cohen, Betty Jean Kass, and Richard and Peggy Danziger.

On the West Coast, Isak Lindenauer, Bryce Bannatyne, Dianne Ayres, and Clarissa Welsh of *Antiques and Fine Art* kindly suggested photography locations and provided interesting background on the Arts and Crafts style in California. West Coast collectors Randell Makinson, Robert Winter, Ron Bernstein, Barbara and Tony Smith, Caro Macpherson, Roger and Jean Moss, Dr. Robert and Cricket Oldham, Nancy Dowd, Monty Montgomery, Roger Williams, Curt Wilson, John Gussman, Jim Risley, and Dolores Rhodes enhanced the book through their collections. Many thanks also to Ted Bosley of Gamble House and the Berkeley Mill & Furniture Company.

CONTENTS

❧ *Foreword page 9*

❧ *Introduction page 13*

❧ *Chapter One* INFLUENCES AND INNOVATIONS *page 25* ~ English Roots ~ A New Aesthetic

❧ *Chapter Two* HALLMARKS OF THE STYLE *page 45* ~ Attention to Detail ~ The Character of the Home: Then and Now

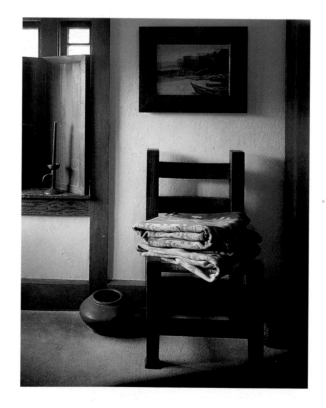

❧ *Chapter Three* FURNITURE *page 83* ~ Arts and Crafts Classics ~ Collector's Choice

❧ *Chapter Four* OBJECTS AND ACCENTS *page 111* ~ The Crafted Home ~ Details of Design

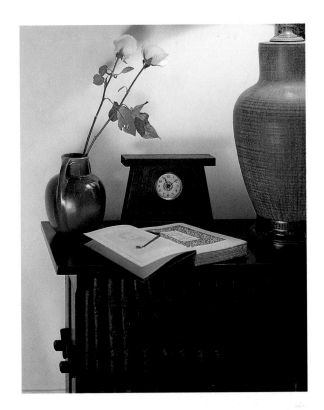

❧ *Chapter Five* CASE STUDIES *page 149* ~ Tradition Meets Innovation ~ An Architect's Dream ~ Stickley Sophisticates ~ Farmhouse Craftsman ~ California Craftsman ~ American Gothic ~ Twentieth-Century Retrospective ~ Hollywood Hacienda ~ Collective Consciousness

❧ *Bibliography* *page 209*

❧ *Sources* *page 211*

❧ *Index* *page 221*

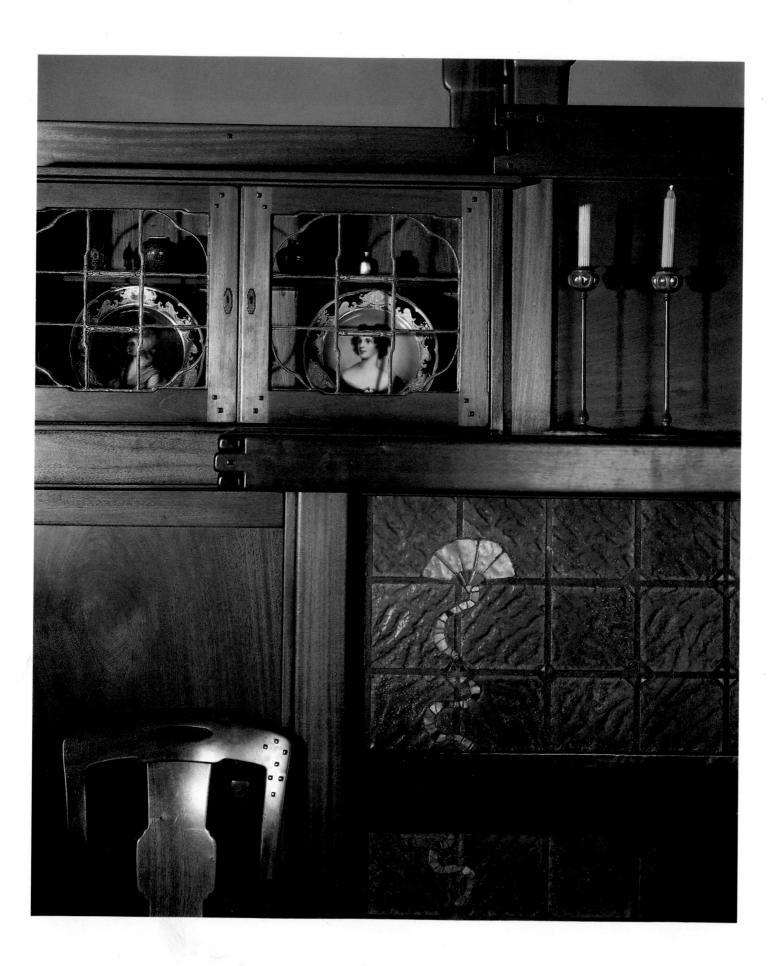

Foreword

The intricate joinery of a built-in buffet in the dining room of the Gamble house, located in Pasadena, California, is a mark of the Greene & Greene style.

What sets Arts and Crafts apart from any other design form is that it was more than a style: It was a movement concerned as much with questions of social reform as with issues of design aesthetic. The design elements emphasizing as they did honest lines, natural materials, and superior craftsmanship in the homes, furniture, and accessories echoed reform aspects that spoke to matters of personal and collective integrity and responsibility. The overriding belief that "the root of all reform lies in the individual and that the life of the individual is shaped mainly by home surroundings"—as Gustav Stickley wrote in *The Craftsman Home* (1909)—centered the emphasis of both aesthetics and reform in the home and on family life. This afforded people an opportunity to exert mastery over their life and environment at a time when so much seemed beyond their control.

At the height of the movement's popularity, Stickley, a designer as well as the publisher and editor of *The Craftsman* magazine, explained how he saw these two facets as parallel: "*The Craftsman* has been the outward and visible expression of the more philosophic side of the Craftsman idea, just as the houses and their furnishings have put into form its more concrete phases," to quote again from *The Craftsman Home*. The beauty of the objects of the Arts and Crafts movement, coupled with the strength of its convictions, provided a much needed sense of permanence, reliability, and integrity.

The reform of home design and furnishings was to be only the beginning; it would inescapably lead to involvement in all aspects of social reform—something John Ruskin and especially William Morris championed. Most followers of Arts and Crafts believed it was necessary to return dignity to the worker, something lost as a consequence of the introduction of the factory system and its resulting assembly line method of production. Their remedies differed, their convictions did not. In America many also understood how essential an informed and participatory citizenry was to a democratic society and took as a goal of the Arts and Crafts movement to lead the way in achieving that. It was only natural, so they said, that you should now turn your attention to those great issues of social reform, questions of civic improvement, education, science, conservation, and

industrial progress—and indeed they were increasingly given equal space in *The Craftsman* along with articles on designers, craftworkers, furnishings, and homes.

The objects of the Arts and Crafts movement are as beautiful as their designers proclaimed, which is surely sufficient to explain their continuing appeal. But we must not forget that they presented people with not just beautiful objects, they offered the acquisition of an enhanced morality and sense of civic responsibility. This volume testifies to the endurance of those beliefs and acknowledges the debt we owe to its creators, its philosophers, and the absolutely exquisite products of their hands and minds.

—Elaine Ellis

March 16, 1992

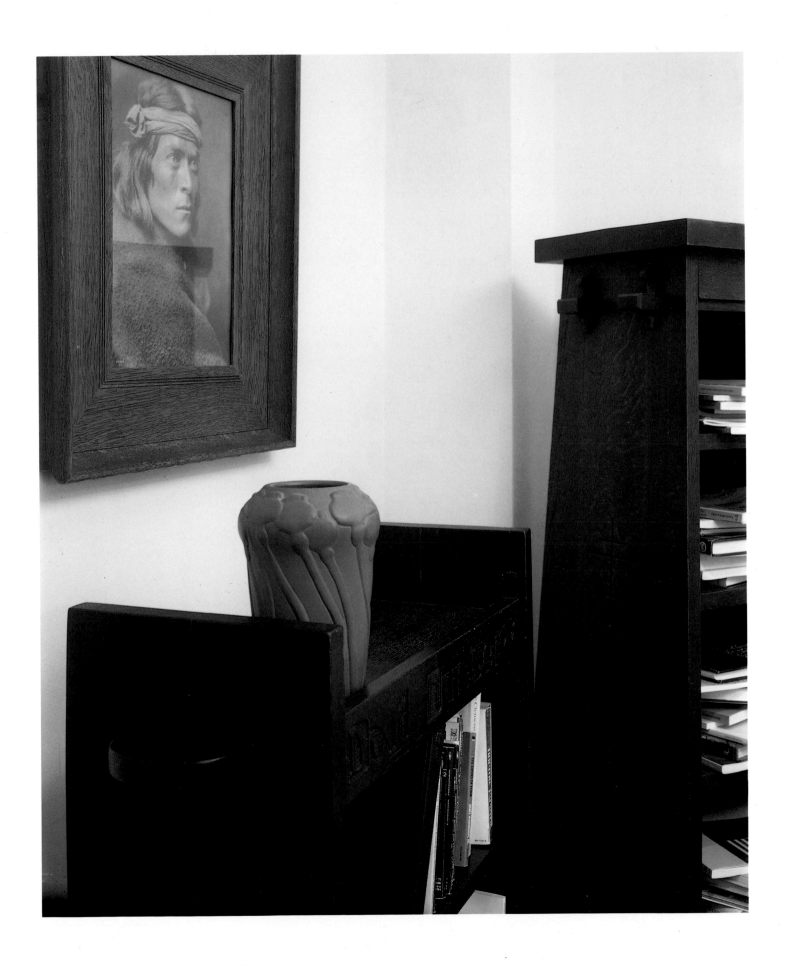

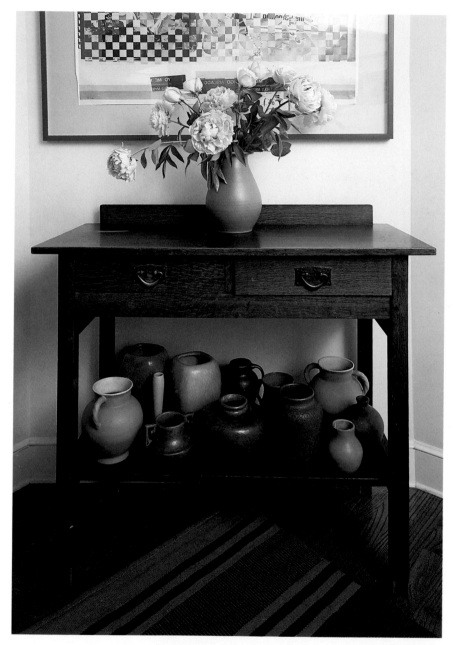

A Gustav Stickley server holds a collection of Fulper pottery, in characteristic green.

INTRODUCTION

The special kinship we feel with the Arts and Crafts period is not surprising. The concepts of that movement have shaped our definition of the home, how it is furnished, and even the kind of life that should be conducted within its walls.

Nineteenth-century efforts to reform the arts gained strength in the United States after 1876. The height of the Arts and Crafts style was a span of about twenty years, beginning in the 1890s and lasting until about 1915. The last decade of the nineteenth century marked the end of a tumultuous time for the United States, a newly independent infant at that century's beginning. In less than a century, Americans went through two wrenching wars fought on home ground

and experienced remarkable changes in their relationship to the political and the physical worlds. The type of work most people did, where they lived, how their children were educated, and their day-to-day amusements also shifted in this dynamic period.

What was learned through these experiences of disruption? Eternal truths: the strength of simplicity, the value of honesty, an appreciation of the home's importance, a respect for tradition, and a strong sense of place.

In the Arts and Crafts style, each of these fundamental elements occupies a central position.

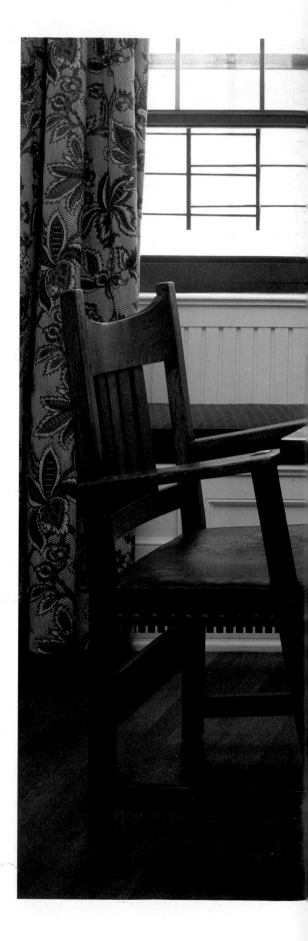

The owners of this duplex apartment installed a cushioned window seat to create an Arts and Crafts ambience. The chair and library table are by L. & J.G. Stickley.

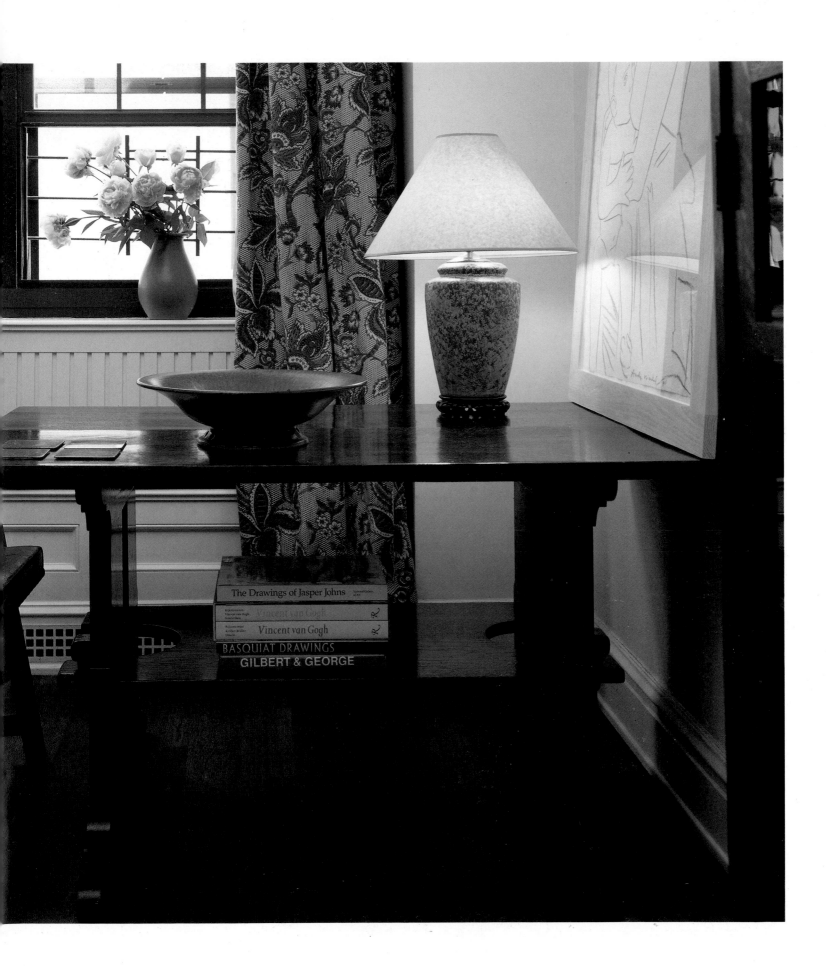

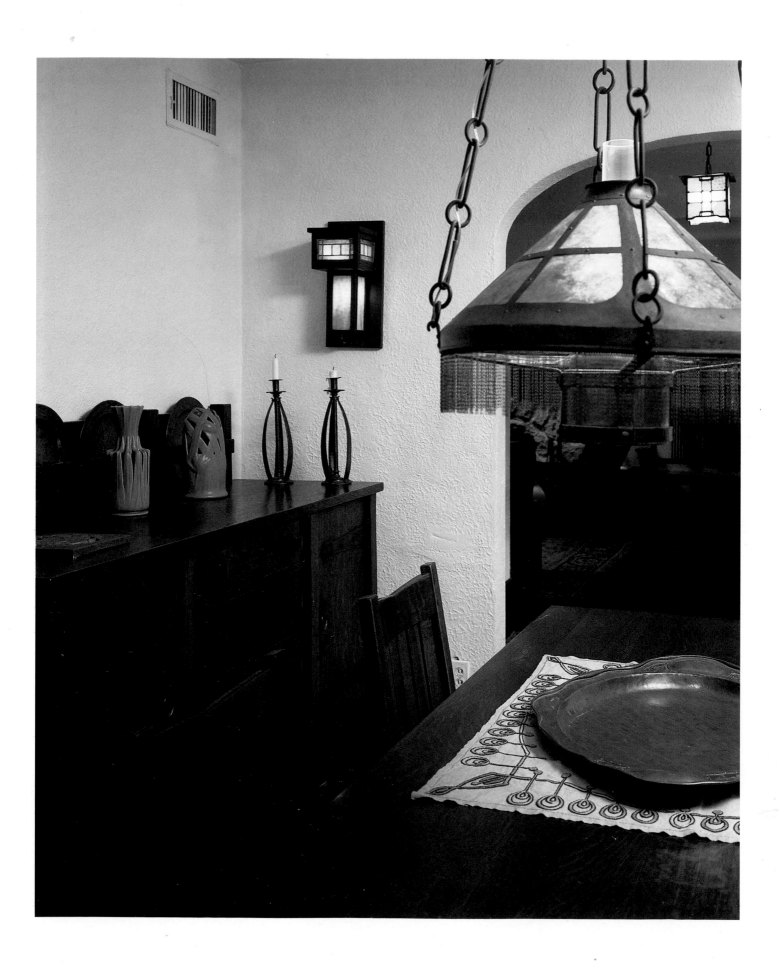

Simplicity and Honesty

In this typical Arts and Crafts dining room, the buffet server is ornamented with period candlesticks, Teco pottery, ceramic tile, and Roycroft plates. A Stickley copper kerosene lamp with mica shade has been electrified.

The Arts and Crafts style reformed a method of decorating that had become excessive during the course of the nineteenth century. The growing use of machines to produce cheap versions of elaborate designs flooded the market with inexpensive, poor-quality goods. A typical Victorian home was stuffed with furniture and knickknacks, and all the surfaces, including the windows and walls, were covered with all manner of gaudy decorations.

In contrast to the clutter of Victorian homes, Arts and Crafts interiors were symphonies of simplicity. Light flooded into a room through windows hung simply with a single set of plain curtains, in place of the layers of fabric that kept the Victorian room in darkness even in broad daylight.

Plain, solid wood furniture was arranged in a functional manner. The pieces, usually of oak, were ornamented mainly by the grain of the wood, the joinery, and the hardware. Typical fabrics and coverings were of leather, wool, and linen, in solid colors and block-printed cottons with stylized floral patterns or strong geometric repeats.

Materials were employed in a way that emphasized their inherent natural qualities. People appreciated the soft beauty of aged red brick, the strength of natural stone, the depth of a highly glazed multicolored porcelain vase, the matte finish of a rough earthenware bowl, the mark of the hammer on a simple silver pitcher.

A Harmonious Home

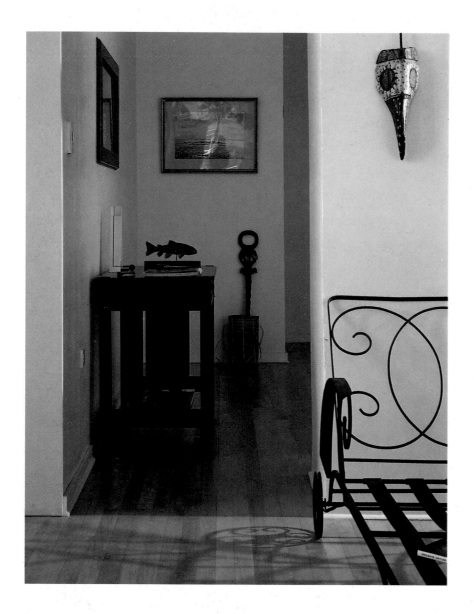

Left, the entry is a place of ceremony in the Arts and Crafts interior; the utility of the console and mirror plays against the exotic accessories in this foyer.

Right, paintings by Andy Warhol and a contemporary collage-and-calligraphy artwork by David Carrino update period table and chairs, purchased from an up-state New York lodge. The southwestern textile was as popular then as now.

The Arts and Crafts style broached the idea that a thoughtfully arranged home filled with beautiful objects would contribute to physical and spiritual health, and therefore was at least as great a contribution to the good life and a good society as magnificent art museums filled with rare, opulent objects.

Beyond simply stating the obvious truth that people of all classes would benefit from such homes, promoters of the style acted on their principles by widely marketing inexpensive housing and simple, affordable furnishings to make this possible.

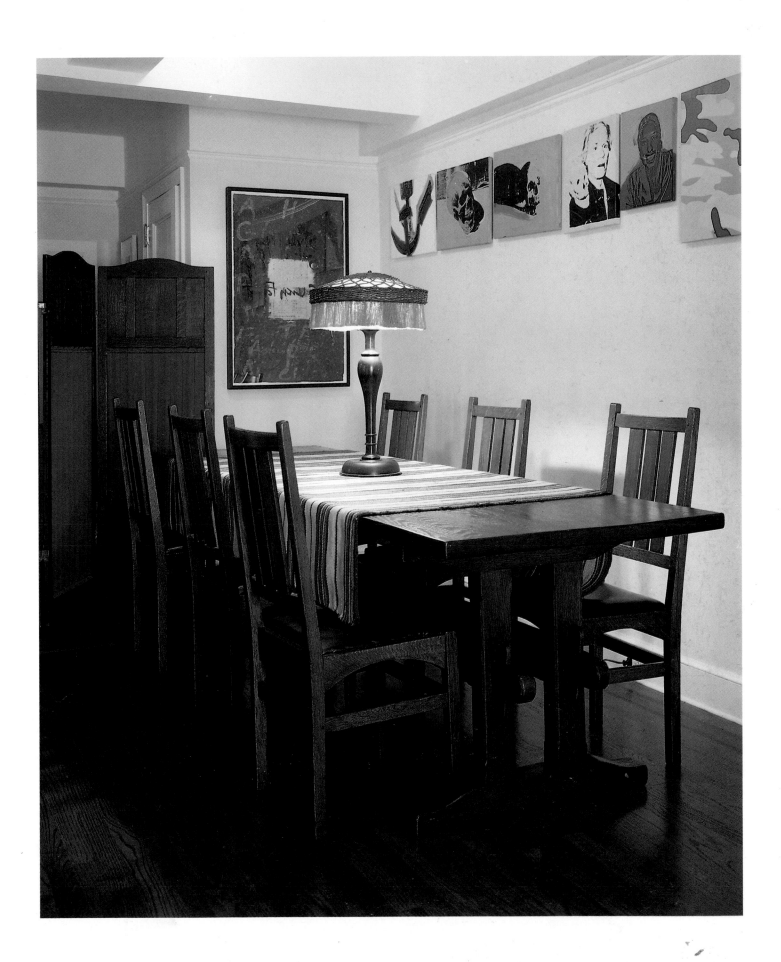

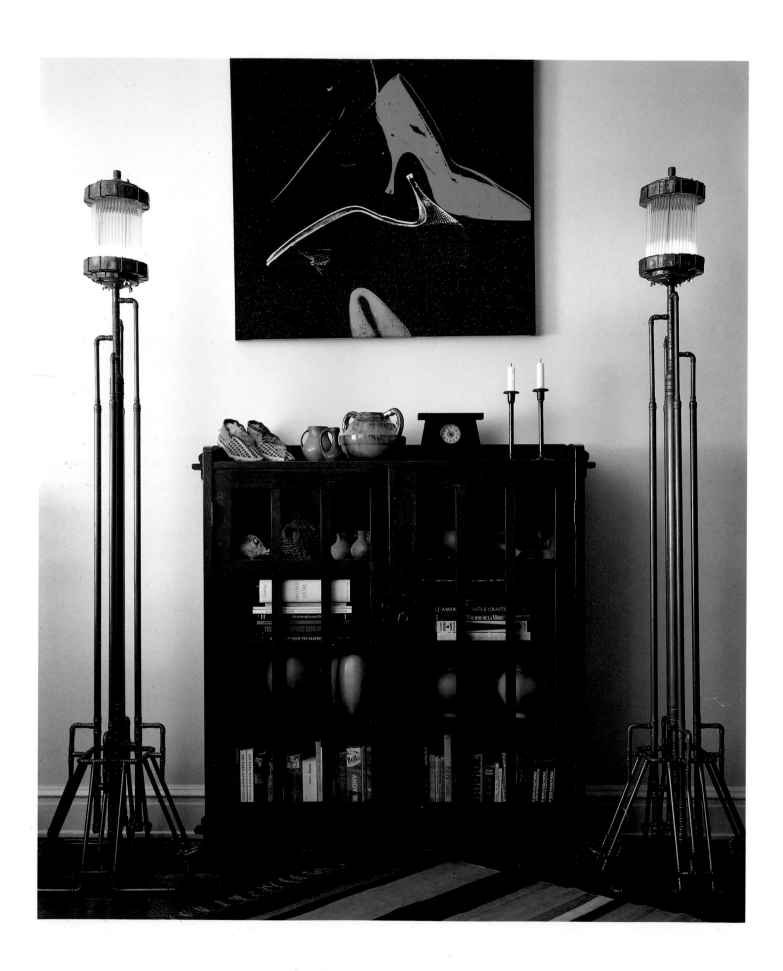

Tradition and a Sense of Place

Lamps by London artist-designer Patrick Costello flank an L. & J.G. Stickley bookcase. Its glass-fronted doors reveal an art book collection. On the wall hangs Andy Warhol's Diamond Dust Shoe.

It is now a widely accepted notion that people need to feel connected to the place in which they live. This idea was an essential element of the Arts and Crafts style, which instilled a respect for local traditions and a sense of place through the use of indigenous materials and crafts. Buildings were also related to their specific setting by careful siting and through appropriate landscaping.

An appreciation of the special attributes of particular localities predisposed those who created the Arts and Crafts style to notice and conserve highly valuable cultural artifacts, such as Native American baskets and ceramic works that otherwise might have been lost. Their belief that furnishings should accommodate people's needs instead of the other way around is, if anything, even more deeply appreciated today.

Still, the reason we treasure the Arts and Crafts style is not really because of a desire to be morally correct. It is because of the beauty found in its rooms and furnishings. They demonstrate more clearly than words the power of simplicity and the rich design possibilities of patterns abstracted from nature.

This beauty and its relevance to the present were rediscovered only in the late 1960s, after the style languished for almost five decades, a victim of a machine-driven modernism that ignored the contributions of handcrafted decor.

In fact, during the 1940s and 1950s, the Arts and Crafts style endured a devaluation so extreme that major museums in such important Arts and Crafts cities as Cincinnati, Philadelphia, and St. Louis sold or gave away noteworthy objects, particularly ceramics. Kenneth Trapp, organizer of the Oakland Museum's 1993 California Arts and Crafts exhibition, said that these objects were considered oddities of little historical value or aesthetic merit.

By the 1960s, however, the influence of modernism diminished. The pendulum of style paused for a moment, then began to swing in the opposite direction, impelled perhaps by warnings that important buildings and objects were being destroyed. The first steps of recovery began.

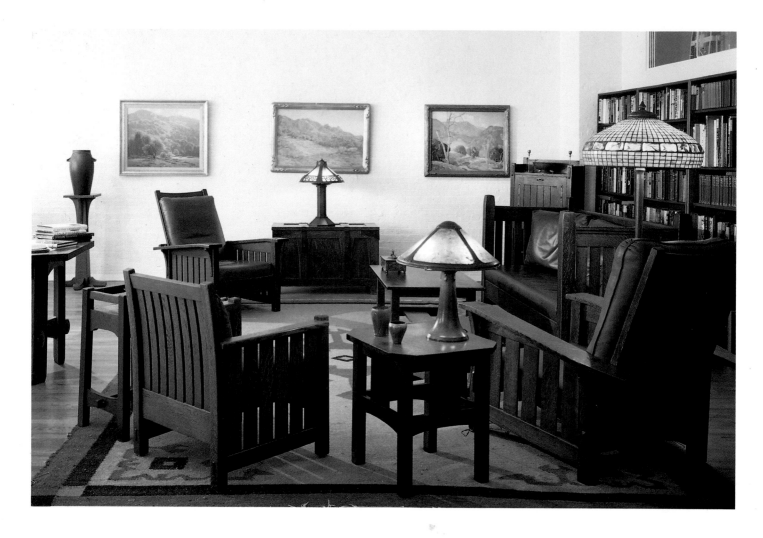

In the mid-1960s, for example, the Oakland Museum acquired a collection of paintings, furniture, decorative objects, and picture frames amassed from the 1890s to the 1940s by Arthur and Lucia Mathews. Likewise, the Cincinnati Art Museum put some of its collection of Rookwood pottery on display in a new gallery.

An exhibition of nineteenth-century American decorative arts at the Metropolitan Museum of Art in 1970 had a salutary effect on rehabilitating that century's artistic reputation. Then, in 1972, an exhibition titled "The Arts and Crafts Movement in America: 1876–1916" took place at Princeton University and traveled to Chicago and Washington, D.C. The show and an accompanying catalogue were sparks that ignited an interest that has only grown stronger.

Other shows followed in the 1970s. The "California Design 1910" show and catalogue at Pasadena Art Center was, for example, the first assessment of the movement within an entire state. The 1980s produced many

Landmark Arts and Crafts furniture accessories include settle and cube chairs by L. & J.G. Stickley and a bridal chest by Gustav Stickley. Lamps by L.C. Tiffany (right), Dirk Van Erp (foreground), and Gustav Stickley (background) illuminate the room. They are displayed on a period drugget rug.

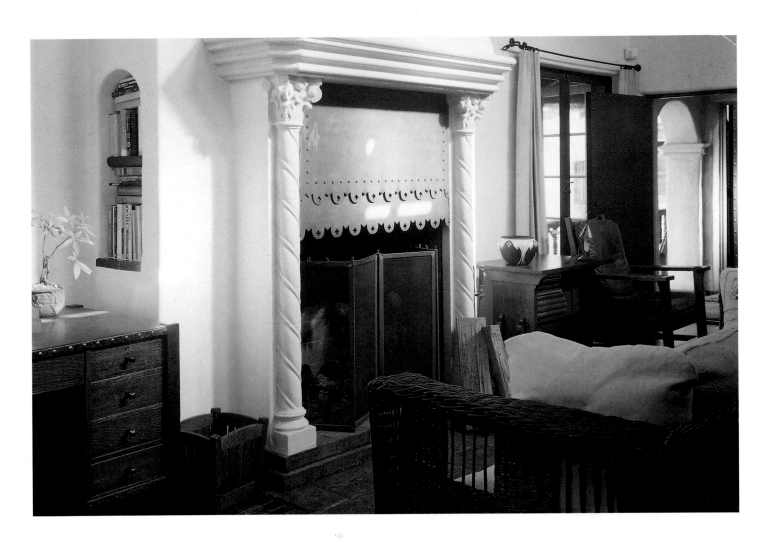

Gustav Stickley advised people to use wicker sofas to soften the feeling of the oak-dominated living room, in which an impressive fireplace was generally a prominent feature.

more exhibits, a flood of information in books and articles, and fierce competition for choice objects, as well as record auction prices and a great deal of publicity. In December of 1988, for example, at Christie's auction house in New York City, a successful bid of $363,000 for a ten-foot-long Gustav Stickley sideboard announced to the world that there was such a thing as the Arts and Crafts movement in America and that it had produced unique and desirable objects.

Today, the Craftsman style has resumed its place as part of a permanent language of decoration. Period furniture and objects are still available through a number of dealers and auction houses. Reproductions of furniture, lighting, textiles, and wallpaper are now widely offered by a variety of companies.

This book looks at Arts and Crafts, not merely as a fascinating period piece, but as a living style and philosophy that can make any home more satisfying, more comfortable, and more beautiful.

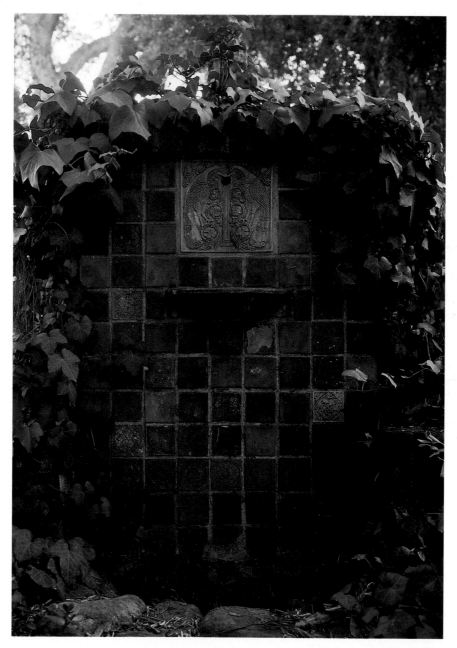

Tiles were an important design element for both Arts and Crafts interiors and gardens.

Chapter One

INFLUENCES AND INNOVATIONS

The Arts and Crafts movement was an international style, by no means limited to America. The Scotsman Charles Rennie Mackintosh, for example, had an impact on the American scene and also served as a stylistic link between Great Britain and the Continent. European movements—in Austria, France, and Germany, in particular—directly influenced the Americans Harvey Ellis, Dard Hunter, Louis Sullivan, Charles Rohlfs, Greene and Greene, the ceramists of Rookwood, and others. Despite the European factor, the English contributions exerted the greatest influence on America. To understand the American movement, one must first look across the Atlantic to Britain.

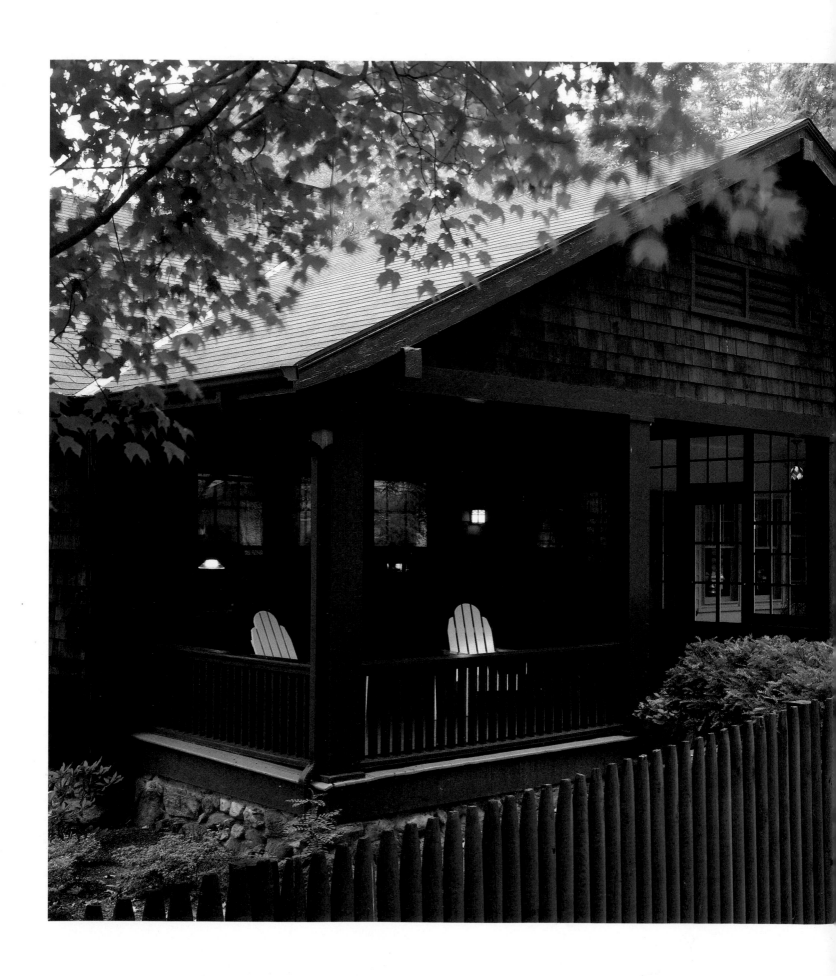

English Roots

In the 1830s, long before there was an Arts and Crafts movement, protests against the conditions that it would address had surfaced in Great Britain. People expressed a longing for the "good old days of merrie England," when honest artisans catered to the simple needs of the populace and factories did not exist to turn out poorly made products.

Even today, it is easy to understand why there might have been objections to many aspects of the Industrial Revolution. True, it brought more goods into the stores, and at lower prices. But particularly in the decorative arts, these items were usually inferior in quality to the handmade ones.

Augustus Pugin "We should have had no [William] Morris . . . but for Pugin," the English architect J. D. Sedding proclaimed in 1888. Augustus W. N. Pugin, an architect who lived from 1812 to 1852, was one of the first to deplore the industrialism that was separating art and labor and designer and craftsman. At the same time, he exalted the glories of Gothic architecture and medieval furniture. In *Contrasts*, published in 1836, Pugin found the Victorian world inferior to the medieval in design standards and quality of life. Though he did not claim to be anti-technology, he wanted to confine machines to "their legitimate uses" in relieving the tedium of repetitive tasks.

Pugin believed the medieval guild system of artisans promoted a more democratic society than the later Renaissance system, which set the designer apart from the laborers who executed the work. His point of view set a precedent followed by later English thinkers associated with the Arts and Crafts movement.

This upstate New York home is attributed to Gustav Stickley. Adirondack chairs on the porch harmonize beautifully with the simple grace of the Arts and Crafts style.

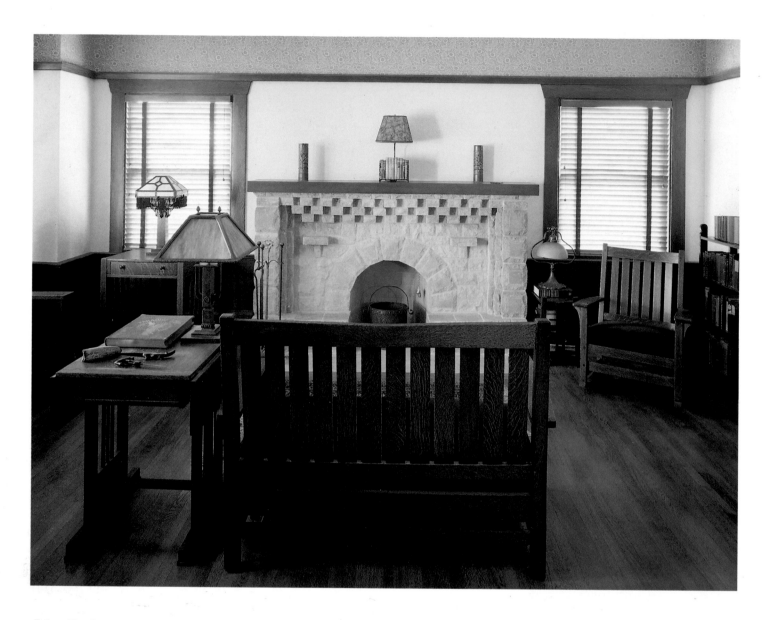

John Ruskin These arguments were convincing to the most important philosopher of the Arts and Crafts movement, John Ruskin (1819–1900), who incorporated them into his widely circulated writings. As a renowned art critic and a professor of art history at Oxford University, Ruskin's influence was considerable. He conducted a relentless campaign in books, essays, and lectures to return English (and American) design to the vernacular mode, to remove foreign influences and to eliminate machine-made decorations. Two of his most influential works were *The Seven Lamps of Architecture* (1849) and *The Stones of Venice* (1851).

Ruskin introduced the idea that work was meant to be joyous, which became a basic precept of the Arts and Crafts movement. He also believed there should be no division between physical and intellectual labors.

The wallpaper frieze in the living room of this 1912 Bay area house, above, is a Bradbury and Bradbury adaptation of a William Morris design. A settle and chair by L. & J.G. Stickley and Mission-style lamps furnish the room.

Right, wrought-iron candlesticks in the Spanish colonial revival style and a Gothic-inspired dropfront desk add a degree of opulence to the normally low-key Arts and Crafts style.

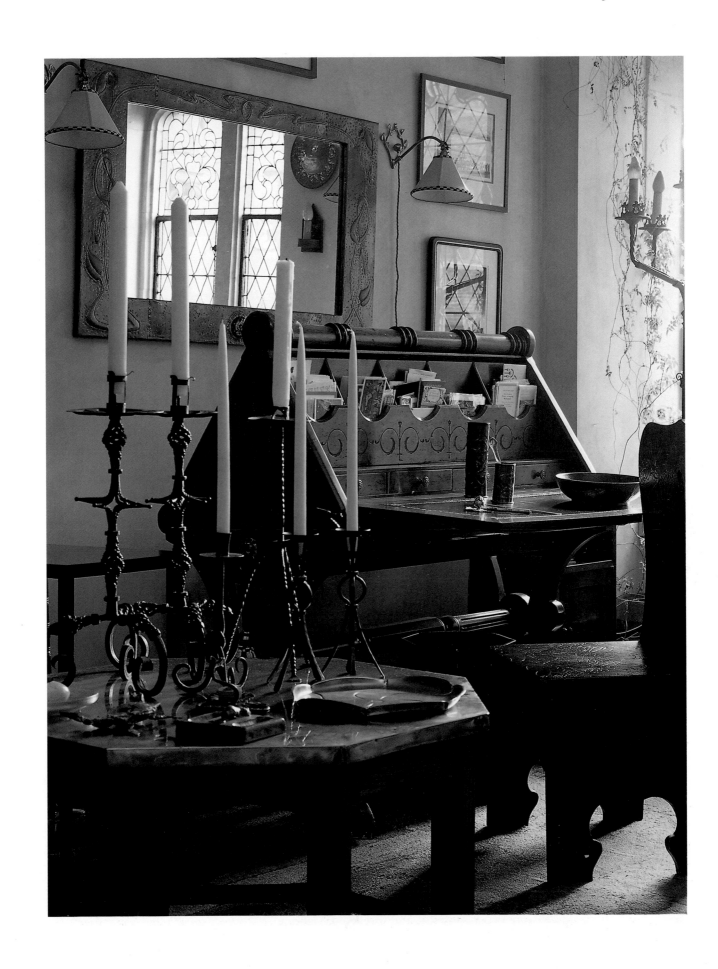

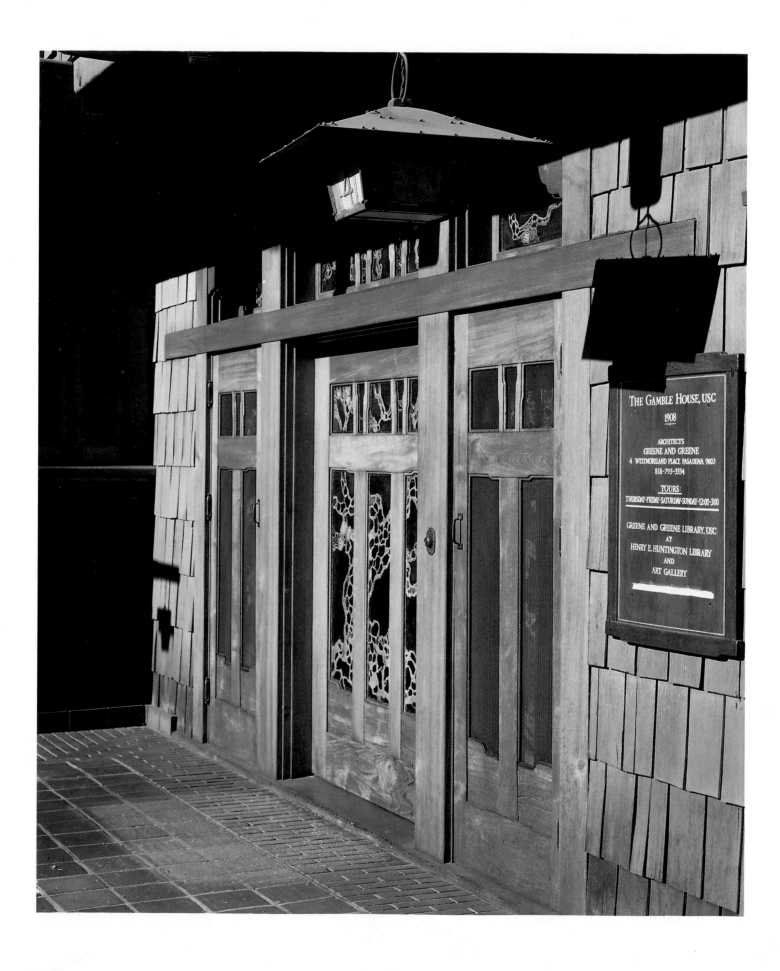

The Gamble house, one of Greene & Greene's masterpieces, is now a museum. The elaborate stained glass and wood entry is characteristic of their work.

William Morris Ruskin's contribution to the movement was also as an influence on its most important and inspirational figure, William Morris (1834–1896). As an undergraduate at Oxford in 1853, William Morris is said to have been so influenced by reading *The Stones of Venice* that he dropped plans to become a minister in order to make his life's work the reform of society through the arts.

Morris's ability to inspire others to participate in his vision facilitated the development of the Arts and Crafts movement. In 1859, Morris hired Philip Webb, his friend and fellow architectural apprentice, to design and build Red House at Bexley Heath in Kent, so called for the red brick that was used in its construction. The house had murals painted by Rossetti, furniture by Ford Madox Brown, and decorations painted by Edward Burne-Jones and Morris himself.

This project was a dry run for the firm of Morris, Marshall, Faulkner and Co., the company Morris set up with these friends and others in 1861 to produce furniture, stained glass, tiles, embroidery, glassware, and objects in metal and to handle interior decorating commissions. Reorganized as Morris and Co. in 1875, when some of the original partners dropped out, it had many imitators in England and the United States.

Morris's design ideas stressed time-honored craft techniques and natural materials. Using traditional methods, he often obtained dyes from vegetables. He perfected the use of woodblocks for printing wallpaper and textiles, many with decorative patterns of abstract flowers and plants. These patterns were sold from Paris to Chicago.

A charismatic figure, Morris inspired innumerable designers in England and the United States to follow his lead in working with crafts and organizing craft groups.

Charles Lock Eastlake In 1868, Charles Lock Eastlake (1836–1906) published *Hints on Household Taste* in England. The book became a best seller. It was equally successful in the United States, where it was published in 1872 and subsequently reissued several more times through 1890. Eastlake proposed that a single, cohesive style dominate the home, rather than a hodgepodge of influences. This decorative philosophy bore many similarities to the Arts and Crafts style. One of his schemes, for example, called for straight-line furniture inspired by the Middle Ages, plain tile

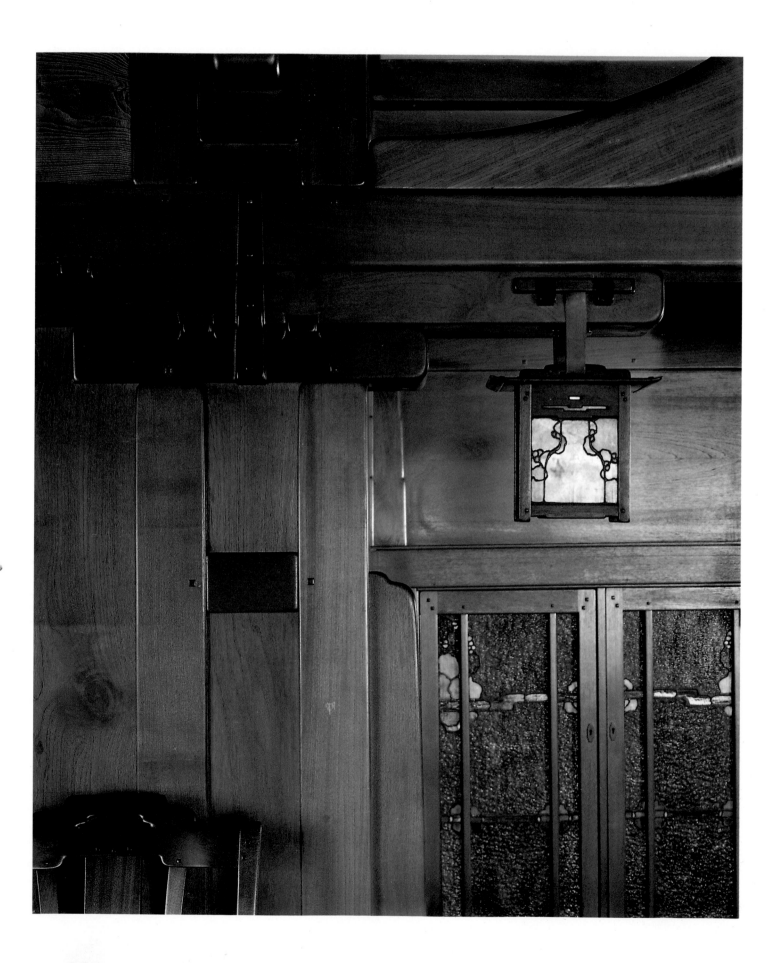

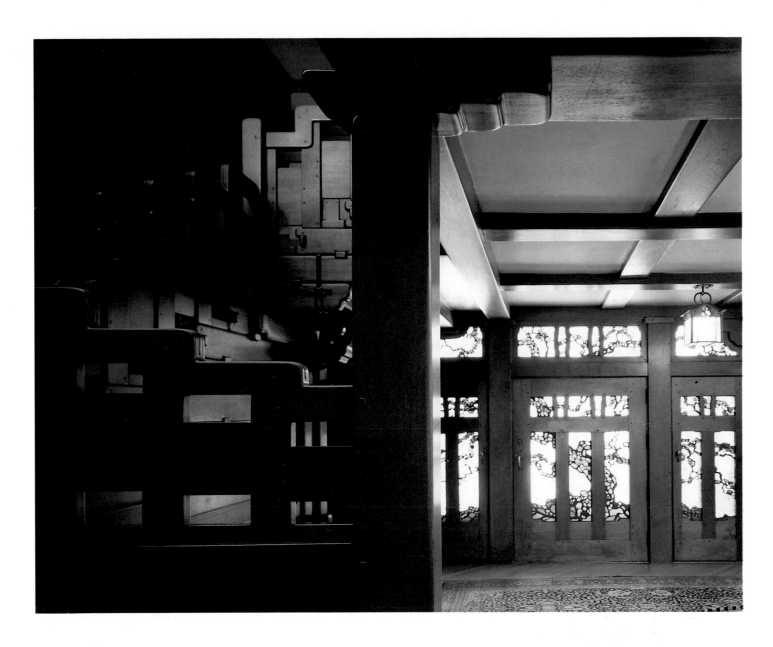

The endless variety of surfaces of wood, glass, and metal enriches the "ultimate bungalow" masterpieces, above, of the Greene brothers.

In the Gamble house, left, the elaborate interlocking wood members are both structure and decoration.

floors laid in a geometric pattern, an Oriental rug, simple wool window curtains, and divided walls with wooden dados below and decorative friezes above.

Similarly, a typical Arts and Crafts scheme might involve furniture with simple lines and honest construction; a plaster wall divided into two or three sections; a rich yet understated color scheme of greens, browns, or blues; and open-weave curtains covering the windows, allowing plenty of light to come through. Such authors as Eastlake exposed the American reading public to the ideas and innovations stemming from the aesthetic of British Arts and Crafts.

A New Aesthetic

William Morris, the key figure of the Arts and Crafts movement, died in England in 1896. But in the United States it was a year more for beginnings than endings. *House Beautiful*, the first magazine ever to feature Frank Lloyd Wright's work, was founded in Chicago. The first Roycroft books were published in upstate New York. The Dedham Pottery and the Deerfield Society, both prominent Arts and Crafts organizations, began in Massachusetts.

Just one year later, in 1897, the first major American exhibition devoted to Arts and Crafts took place at Copley Hall in Boston. In June of that year, the Boston Society of Arts and Crafts was set up, following the example of the English Arts and Crafts Exhibition Society. Formation of Chicago's Arts and Crafts Society soon followed in October with its charter membership consisting of architects, artists, craftsmen, social workers, educators, and political reformers. After these first societies were formed, organizations and activities proliferated throughout the country.

As the first decade of the twentieth century advanced, Americans were subscribing to dozens of periodicals, joining hundreds of crafts societies, taking crafts classes in night schools and settlement houses, and purchasing crafts at myriad exhibitions. They were also able to buy Arts and Crafts furnishings at local stores.

In Chicago, for example, Morris fabrics, wallpapers, and furniture were available at Marshall Field & Co., and his ideas were promoted by the William Morris Society, organized in 1903. Courses in the arts and crafts were offered by the Illinois Art League.

The Chicago Art Institute held annual decorative arts exhibitions starting in 1902 and continuing through 1921, and even had a curator of Arts and Crafts. The Chicago Architectural Club (founded in 1888) held exhibitions at the Art Institute, which the Society of Decorative Arts also patronized, maintaining a salesroom there where members' work was sold.

In the State of New York, which established its own Guild of Arts and Crafts in 1900, Gustav Stickley was manufacturing furniture near Syracuse, while his brothers Leopold and J.G. Stickley were in nearby Fayetteville in their own factory. In Buffalo, Charles Rohlfs was making furniture, while Paul Wilhelm worked in copper, silver, and enamel. Elbert Hub-

Pottery by George Ohr is arranged on a Harvey Ellis-designed Gustav Stickley chest of drawers.

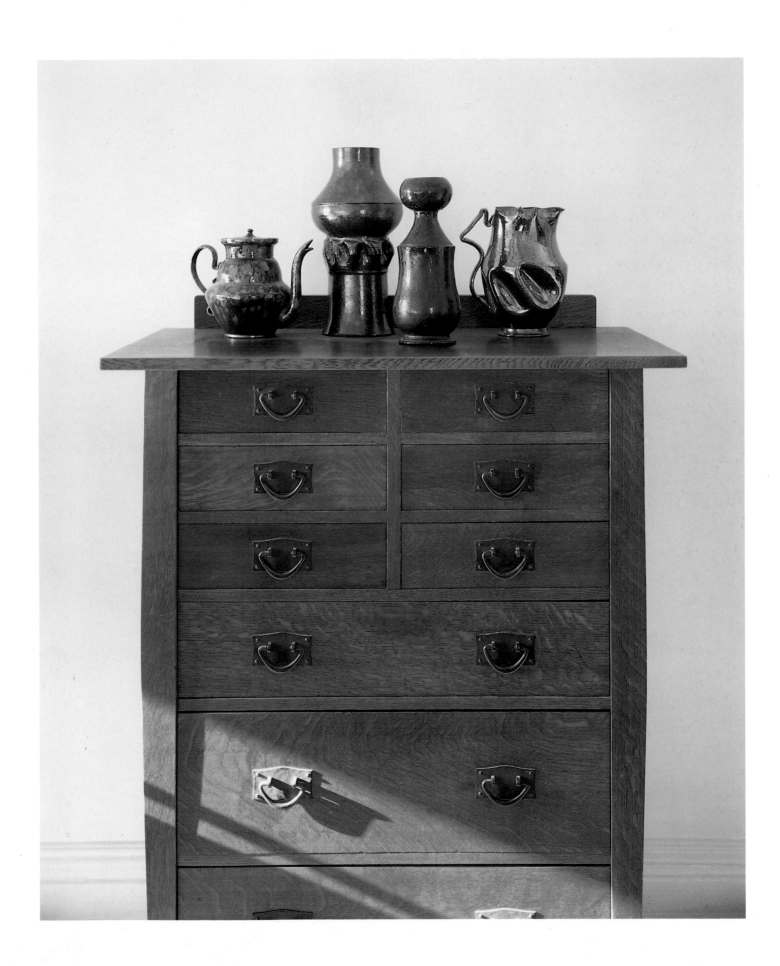

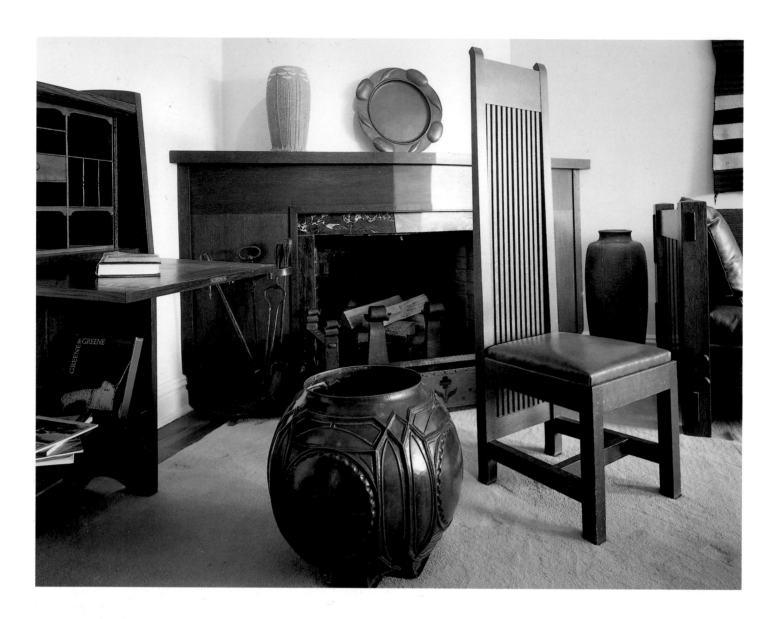

bard's Roycrofters craft workshop was established in East Aurora.

Looking at the Arts and Crafts movement from the vantage point of the present evokes a powerful sense of déjà vu. Much seems familiar about this time of ferment, with its lively cast of colorful characters who had a flair for publicity and made good copy.

Architectural Currents The Arts and Crafts movement's approach to home design and the changes wrought in home building represent one of its great contributions. The designers went much further than merely cleaning up the cluttered Victorian buildings to which they objected. Employing locally occurring wood and other materials—pine, oak, and limestone in the Midwest, for example—they related buildings to site and

Above, Frank Lloyd Wright designed this high-backed dining chair for the Willits house and the urn for the Waller house—both Illinois residences. A daisy vase by Grueby is on the mantel.

In the bedroom of a modern country house designed by New York-based architect Jeremy P. Lang, right, idiosyncratic carved stretchers distinguish a desk by Charles Rohlfs. Both lamps are by Dirk Van Erp.

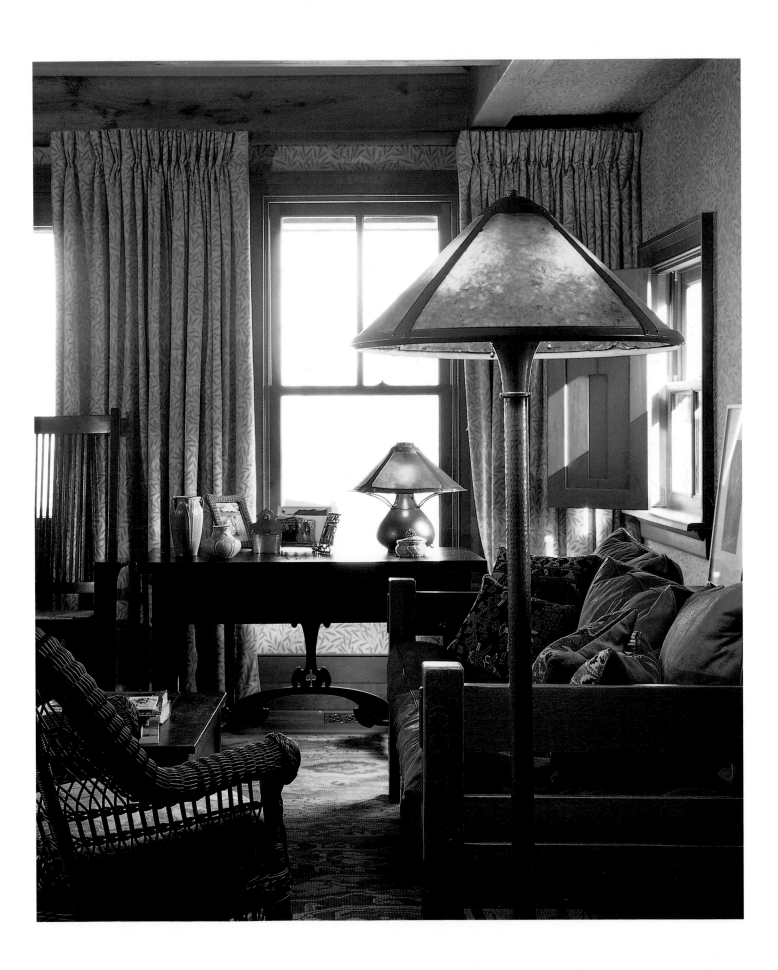

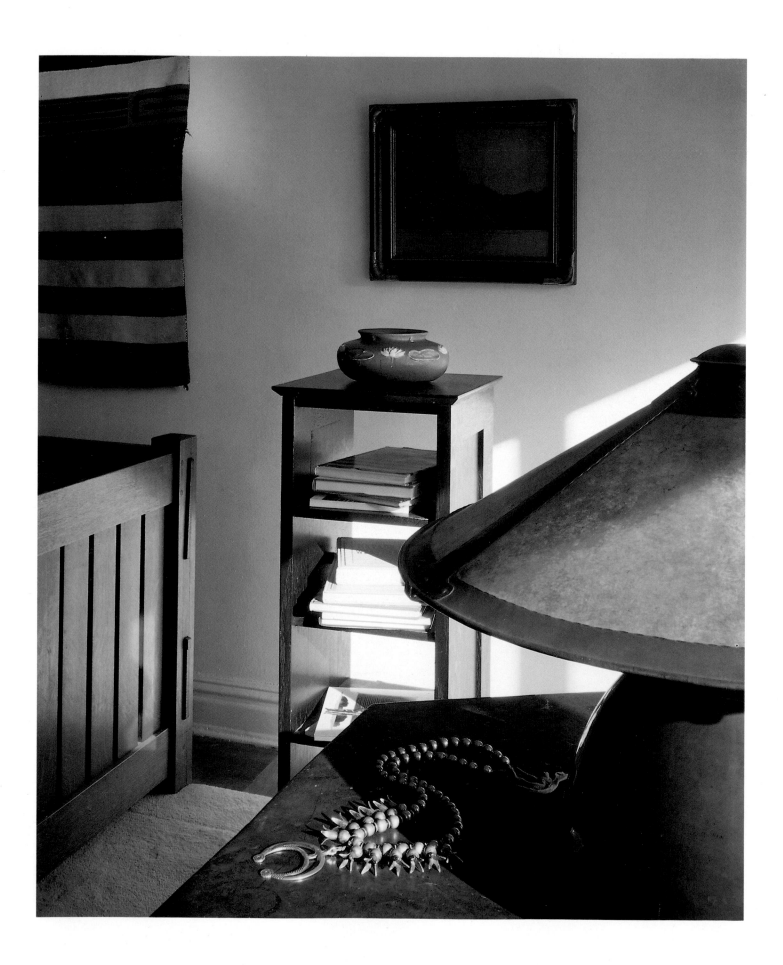

A Grueby waterlily vase is displayed on a Stickley table. The squash blossom Navaho necklace and "chief-style" weaving in black, red, and white add a powerful element to the setting.

landscape in a sensitive and aesthetically pleasing fashion. On the flat plains of the Midwest and southern California, their buildings emphasized the horizontal line. The Bay area of California was a lively center of Arts and Crafts activities. Architects such as Bernard Maybeck, Ernest Coxhead, and Julia Morgan designed homes that nestled into the hills and canyons surrounding San Francisco, Berkeley, and Oakland. Farther south, Charles and Henry Greene designed luxurious custom houses in the Pasadena area.

The principle of emphasizing local or vernacular building traditions was an important one. However, the Arts and Crafts builders didn't let it stand in the way of using an appealing detail, such as a curving Japanese-style roof, Irimoya roof tiles, torii gates, or porch posts resting on rounded boulders in the Japanese manner. They were just as likely to use a thatched roof or gothic windows to evoke the atmosphere of rural England.

There was no overriding stylistic approach since each structure was expected to respond to its site and the user's needs. What all these builders in different parts of the country had in common was their pleasure in craftsmanship, shown in details such as a roof line, the type of windows, and the choice of materials, along with their involvement in every aspect of the home—from conception through execution of building and furnishings and on to quality of lifestyle.

Led by Frank Lloyd Wright, whose early Prairie School buildings featured interior floor plans in which rooms flowed into one another, architects designed homes to encourage informal family gatherings, counteracting what many saw as a growing rootlessness and loss of family traditions. Wright, in his early period as a designer of Arts and Crafts-style buildings, said he sought his inspiration in nature, not in books. For Wright, incorporating nature meant siting and designing a building so that it interacts with—and is a reflection of—the surrounding landscape.

In general, Arts and Crafts architects favored architectural devices that brought nature and its occupants into close contact. Piazzas, porches, terraces, patios, lattice work, planters, window boxes, and pergolas were all valued features in the home. There were houses and furnishings suitable for every economic level.

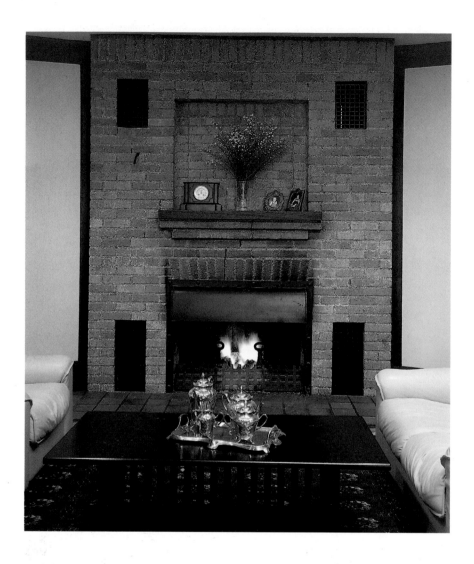

Left, a brick hearth in an upstate New York house is believed to be the work of Gustav Stickley. Contemporary furniture is in the Arts and Crafts mode.

Furnishings for the People　At the turn of the century, the number and variety of decorative products of the Arts and Crafts style grew enormously as manufacturers added new lines. Many eagerly turned one-of-a-kind designs into mass-produced pieces. The simple, unornamented pieces, which varied slightly from maker to maker, were known by a variety of names, including Mission, Arts and Crafts, Quaint, and Craftsman. The last-mentioned term was Gustav Stickley's preferred description, but "Mission" was the word that caught on with the public. Joseph McHugh, a New York manufacturer and retailer who owned the Popular Shop in Manhattan, is believed to be the first to mass-market a simple Mission-style side chair with a rush seat and oak or elm frame, which he copied from a California original. To the public, Mission was not merely a particular type of simple furniture, but it also carried the idea of missionary zeal to simplify furniture design.

In Gamble house director and curator Randell Makinson's Pasadena home, right, Frank Lloyd Wright designs for a monumental lighting fixture and for a centrally located table are re-created by Heinz and Company. On the table, a Tiffany candlestick with original glass shade is an impressive find.

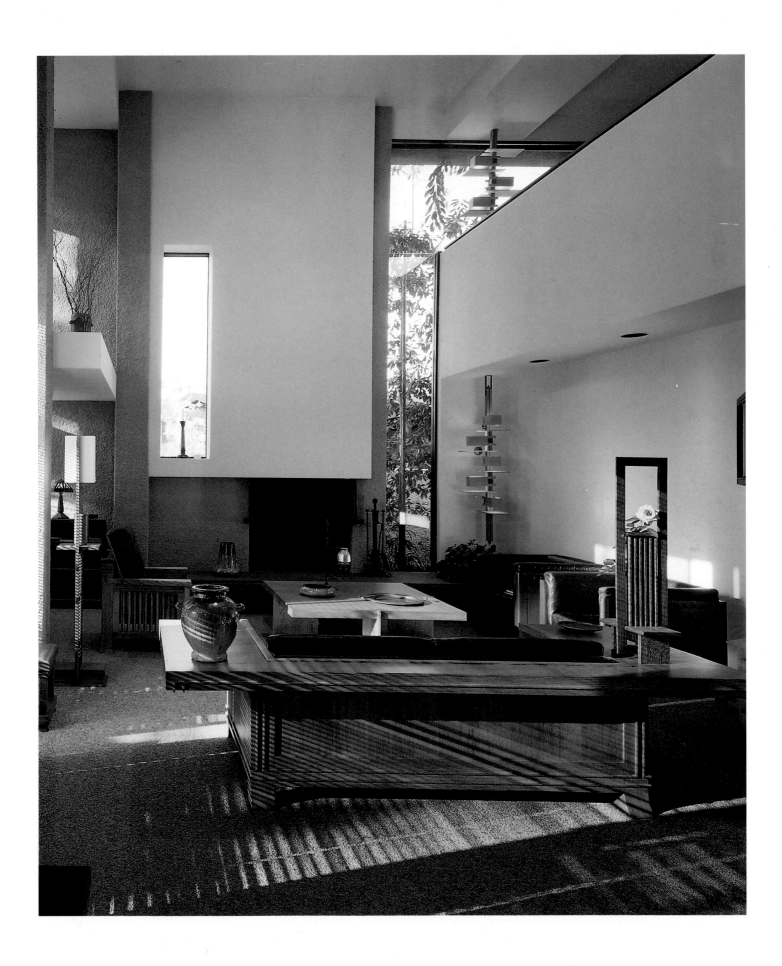

Mass-merchandising became possible in America only through the power of the machine. In the United States, negative attitudes toward the use of machinery were never so prevalent as in England. Wright, for example, rebutted the anti-machine point-of-view in a famous speech, titled "The Art and Craft of the Machine," presented to the Chicago Arts and Crafts Society at Hull House in 1901. In contrast to William Morris, who blamed machines for a loss of creativity, Wright argued that they were an ideal means of *achieving* creativity, when correctly used.

By the year 1917, the Arts and Crafts movement was noticeably in decline—partly as a result of social changes brought on by impending war and partly because the media continued their old habits of looking for something new. Modernism would hold sway until the 1960s, when once again the ideas of the Arts and Crafts movement would fuel a revival of a craft aesthetic—a revival that has led to an exciting quest for knowledge of the furniture, the interiors, and the ideals of the movement.

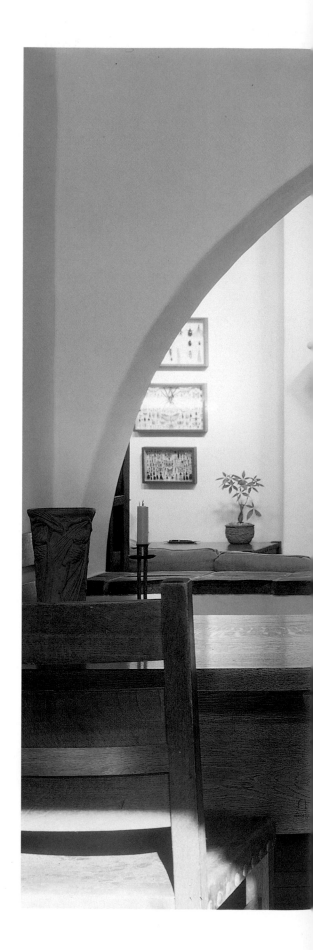

Arts and Crafts oak furniture, Native American textiles, and gothic-inspired architecture complement one another simply because all are pure designs.

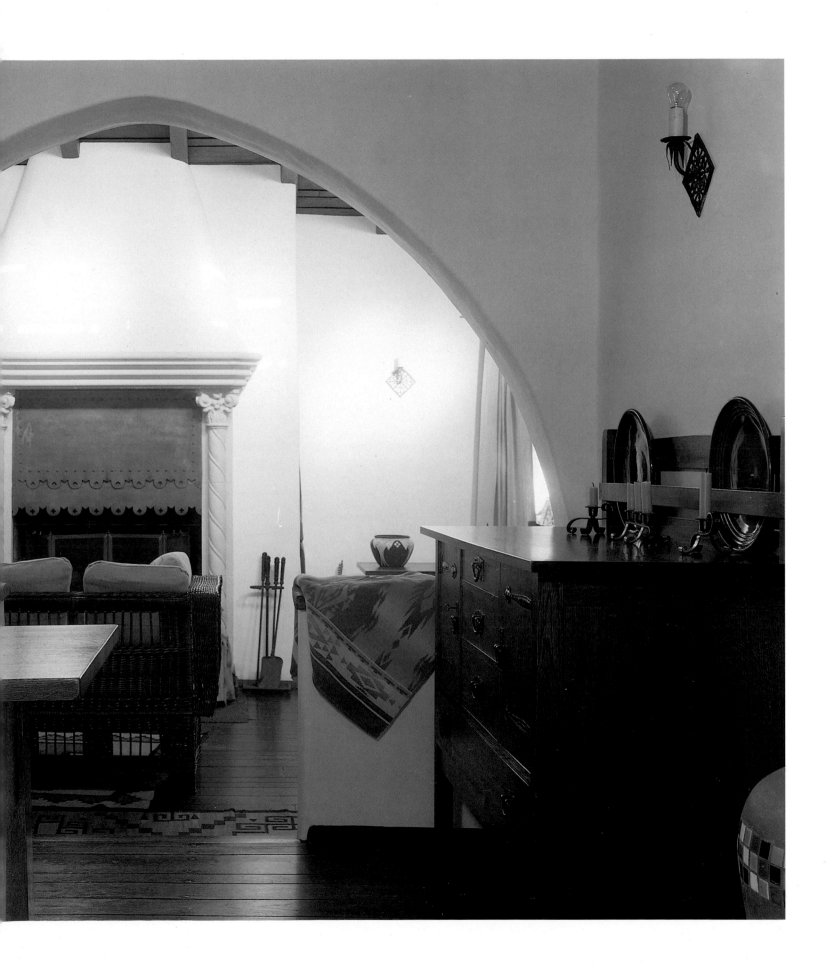

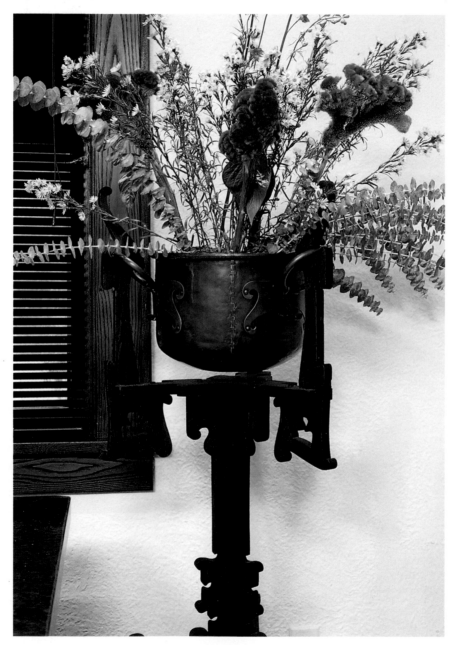

A Rohlfs plant stand is as artful as any sculptural form.

Chapter Two

HALLMARKS OF THE STYLE

Imagine for a moment that the year is 1899 and you have been invited for dinner at the home of Mr. and Mrs. Frank Lloyd Wright in the Oak Park suburb of Chicago. Your host is a young, up-and-coming architect who is reputed to be somewhat unconventional.

As you enter the dining room, you recognize at once that you are in a room utterly different from any other. You notice first that virtually an entire wall is composed of continuous, uncurtained art glass windows in a delicate geometric design reminiscent of the lotus flower. The other walls are covered with horizontal oak paneling. Recessed drawers are unobtrusively built into the wall. The floor is surfaced in small red,

highly polished tiles instead of carpeting, which most people have in their homes. The same tile is used to face the fireplace on the wall opposite the windows. There is also a massive but unornamented golden oak dining table. Surrounding it are imposing chairs, whose crisp vertical-slat backs are unusually high.

The most extraordinary feature of the room, however, is the luminous ceiling, softly glowing behind a wooden grille composed of a complex pattern of circles and squares. Electric bulbs are shielded from sight by a thin translucent sheet, which you later learn is paper.

Move ahead now to 1909 in the resort town of Pasadena, California. You have spent the night as the guest of Mr. and Mrs. David B. Gamble, whose new home, designed by the architectural firm of Greene and Greene, has just been completed. Awakening a little after sunrise, you venture forth in search of a cup of coffee. In the entry hall, you stand transfixed as the sun pours through the Tiffany-style glass panels in the front door, warming the wood-paneled interior and reflecting a green and golden light onto the floor. For a brief time, the space is transformed into Aladdin's cave or a sacred grove. Once again you experience the shock of the new.

Wright's home in Oak Park, to which he added the dining room in 1895—the architect's first creation of an environment in which architecture, furniture, lighting, and ornament were unified—and the Gamble house in Pasadena—the Arts and Crafts masterpiece of Charles Sumner and Henry Mather Greene, begun in 1908—are both museums now, accessible to anyone. By personally experiencing these spaces, it is possible to comprehend how they must have enthralled those who saw them in their own time.

The description of the Wright house offered here comes from an article written by Alfred H. Granger in *House Beautiful* magazine in 1899 and quoted by David Hanks in *The Decorative Designs of Frank Lloyd Wright* (1979). The musings on the Gamble House come from Reyner Banham's introduction to Randell L. Makinson's book *Greene & Greene: Architecture as a Fine Art* (1977). Both descriptions convey how startling those homes must have been to people who were used to the typically cluttered rooms of the period.

Arts and Crafts ceramics enhance a glass-fronted bookcase by Gustav Stickley. Wood paneling and white plaster walls are a harmonious composition.

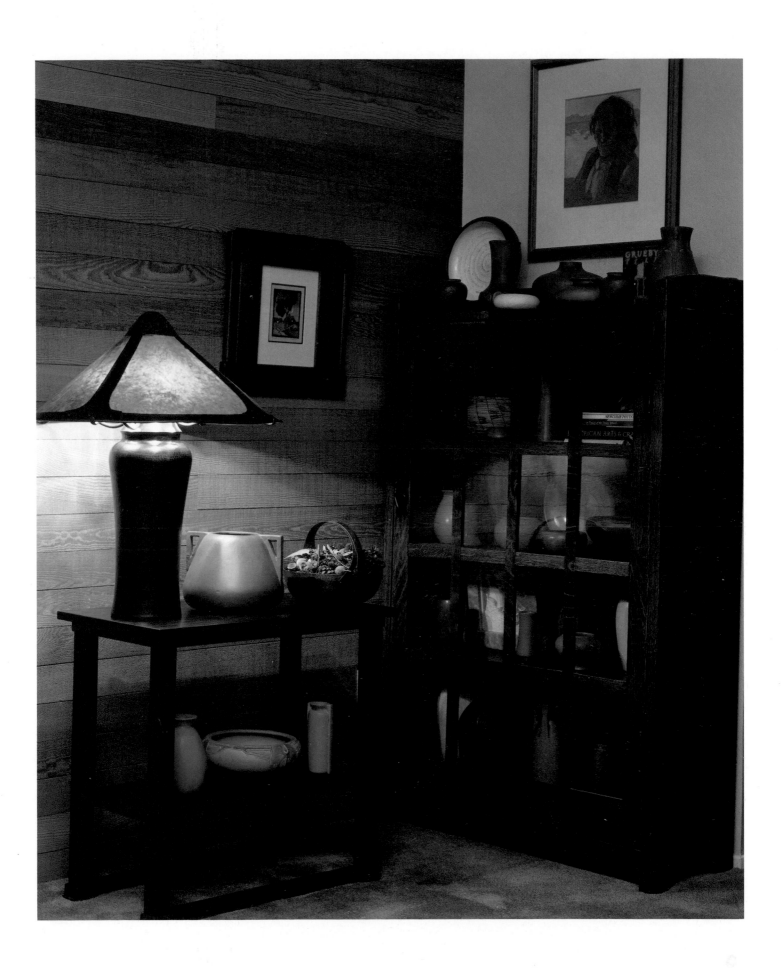

Attention to Detail

℘ If genius includes the ability to take infinite pains with every detail and to integrate each part into a masterful whole, then Arts and Crafts designers such as the Greenes and Wright were incomparably brilliant. They focused their attention on every aspect of architecture and decor in the homes they designed for clients who shared their point of view.

For Frank Lloyd Wright it was not enough to conceptualize the architecture and interior fittings of his houses. He also took pleasure in designing the accessories. For the Avery Coonleys, he provided a design for table linens, insisting on rectangular napkins rather than square ones because he believed the rectangle was more suitable for the human lap.

The Greenes, who practiced architecture together in Pasadena, perhaps

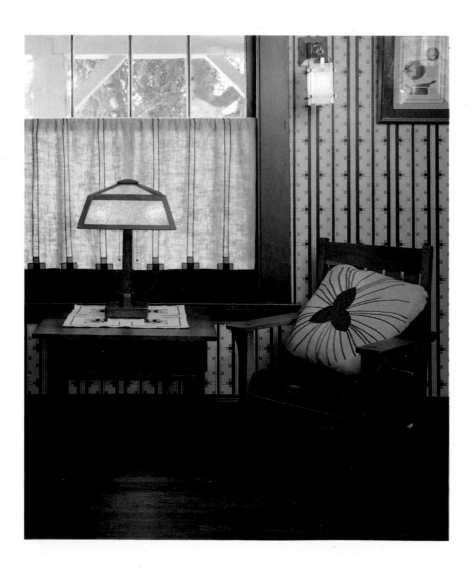

Stylized wallpapers and rough-textured window coverings with impressive embroidery details are hallmarks of rooms composed in the spirit of Arts and Crafts.

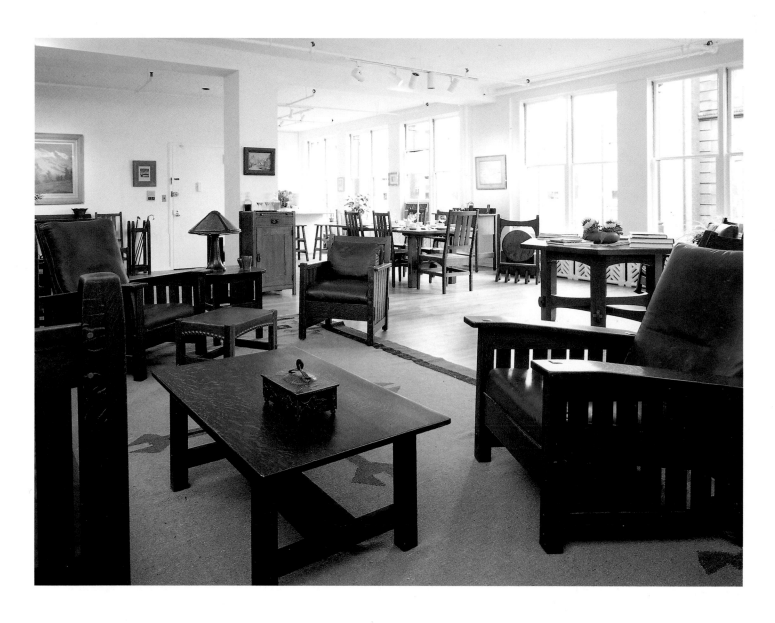

Undraped windows flood Arts and Crafts rooms with light, which combats any tendency toward somberness in the decor. Large-proportioned spaces are especially well suited to the style, since the furniture need not be crowded and each piece can command its own area.

best exemplify the intensity of devotion to craftsmanship that characterized the Arts and Crafts style. The brothers, who arrived in Pasadena in 1893 to join their retired parents, always maintained that it was their education at the Manual Training High School of St. Louis, rather than their architectural studies at the Massachusetts Institute of Technology, that most influenced their architectural practice.

In California, the Greene brothers came under the spell of the Franciscan mission architecture, a relic of an earlier period. Both men, but especially Charles, also pursued the study of Japanese architecture and art, which had impressed them at the Japanese exhibit at the 1893 World's Columbian Exposition in Chicago.

It took the Greenes a decade to create their unique architectural vision. Their primary material was wood, although they also employed shingles, masonry, tile, brick, and the rough boulders and stones littering the floor of the Arroyo Seco on which Pasadena is partially situated. The Greene brothers were connoisseurs of wood, selecting mahogany, teak, walnut, ebony and, of course, California redwood for different projects.

The various elements that influenced them came together in 1904 in the design of several homes. In the two-story shingle bungalow designed for Jennie A. Reeve in Long Beach, for example, they combined the multiple gabled overhanging roofs and projecting support beams that became their trademark. The Greenes' use of cobblestones and brick masonry made this home appear to literally grow out of the rocky ground. Other features that they would reuse were the elegant oversized front door and a horizontal arrangement of leaded-glass casement windows, which served a dual purpose in admitting daylight and providing attractive views while adding to the visual presence of the exterior.

The use of ethnic textiles warms period rooms. In this combination living room and parlor, bookcases, fireplace accessories, ceramic vases, and copper provide all-important texture and detail.

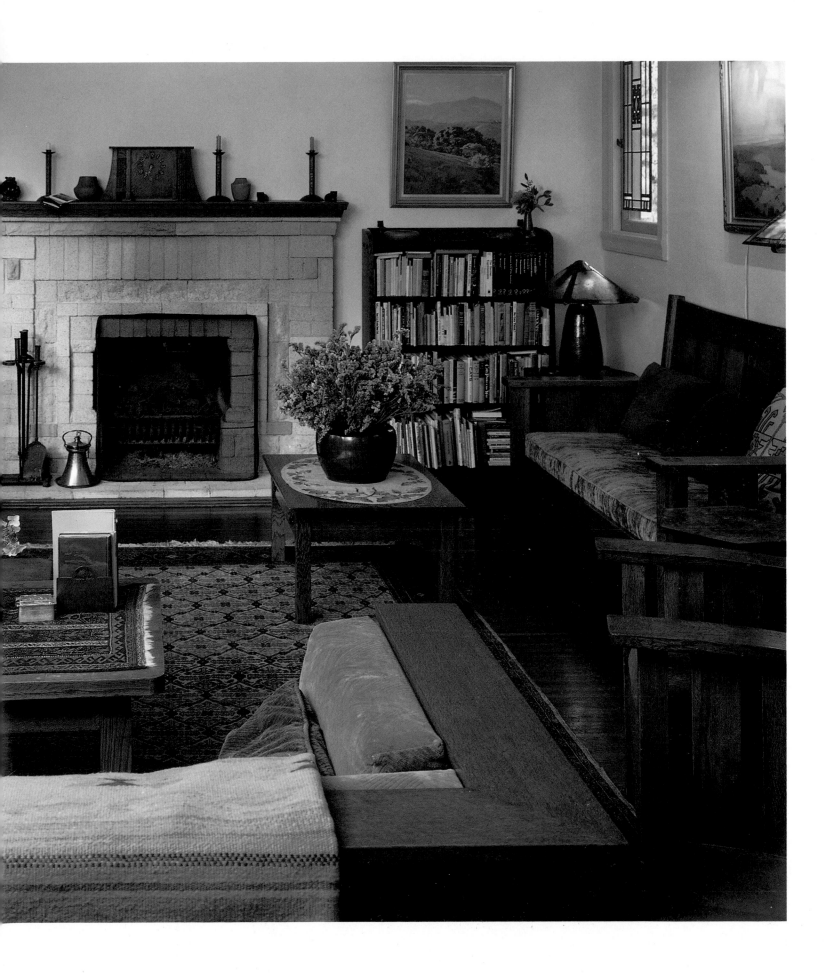

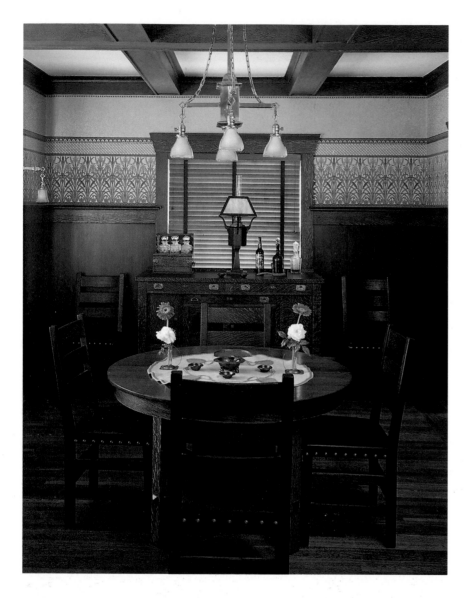

Typical division of wainscoted wall with a Bradbury and Bradbury "Iris Frieze" design evokes the era in this Bay area dining room. The use of the doily on the L. & J.G. Stickley table is a classic motif.

Charles Greene designed the furniture and accessories that were so important in the overall effect of the house. A massive fireplace was a focal point in the living room. Window seats caught the sun and provided a pleasant spot from which to observe the beautiful ocean views. A corner nook in the living room served as a small protected space within the larger room. Built-in cabinetwork and wood paneling were waxed to the point that they glowed. No detail was too small to warrant thoughtful consideration. Even the leaded-glass windows of the china cabinet were designed to match the windows of the house.

Wright and the Greene brothers were not alone in their quest for a total environment. Among others who created houses in which every decorative element was considered and planned in relation to the whole were Wright's

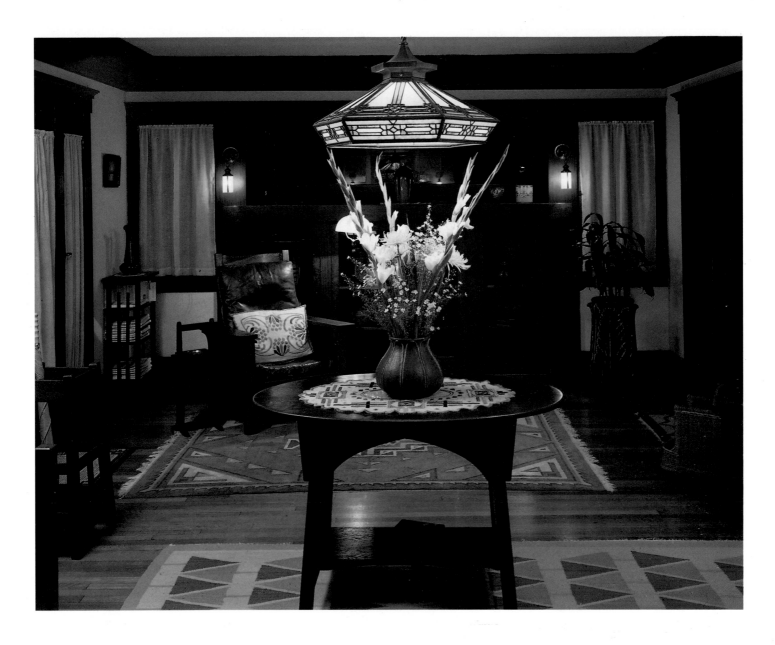

Ron Bernstein is a literary and film agent who believes in the unity and integration of all the Arts and Crafts decorative arts. While most Arts and Crafts appreciators invariably collect oak furniture or pottery, Bernstein additionally collects rugs, textiles, light fixtures, lamps, hand-hammered coppered pieces, draperies, books, wicker furniture, and dishes. Each of the rooms in his two-story 1915 Los Angeles bungalow reflects this unified design statement. In the middle of the living room— also pictured on page 66—sits a Limbert cutout oval table with a multicolored oval table scarf, which echoes the design. A Grueby pot sits atop the scarf. Hanging over the table is a Duffner & Kimberly chandelier. Built-in cabinets are in the background, as well as a classic L. & J.G. Stickley chair, at left, and experimental Rookwood garden urn, at right. The Grueby pot, garden urn, and the green tones of the rug enhance the color of the room.

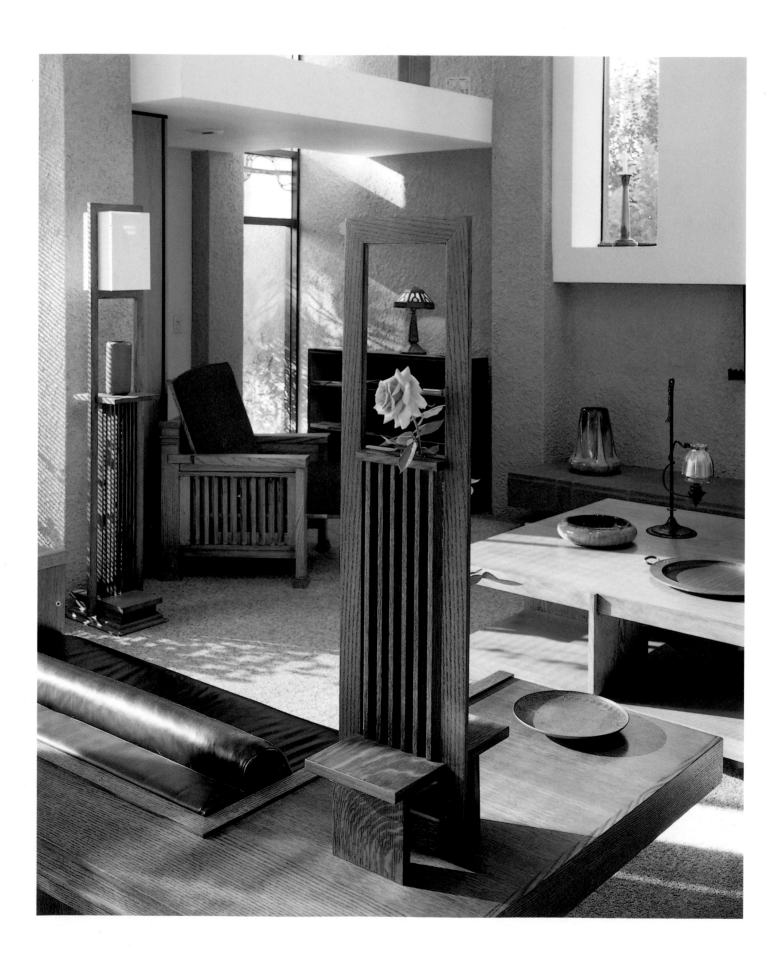

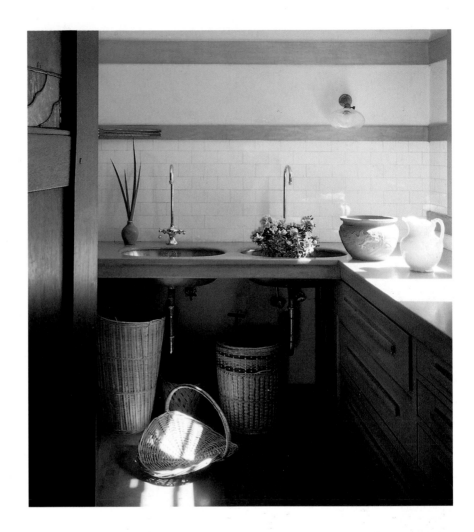

Left, Frank Lloyd Wright conceived the design for this print stand (elevated at center on settle wing), a device for displaying Oriental graphics, but the piece was created in 1990 by Heinz and Company. The freestanding light fixture was also re-created by Heinz and Company using a Wright prototype.

A tile wall and careful cabinetry in the butler's pantry at Gamble house, right, reveal painstaking workmanship.

fellow Prairie School architects William Gray Purcell, George Feick, Jr., and George Grant Elmslie—members of the firm of Purcell, Feick, and Elmslie—as well as George Washington Maher. Maher's methodology, in particular, is of interest. The Chicago-based architect would choose a signature botanical and a geometric figure for each of his clients. He combined abstract forms derived from these two motifs into a decorative architectural scheme.

It was the work of such architects as Wright, the Greenes, Maher, and others that spurred the development of a complete and unified design so fundamental to the philosophy of the Arts and Crafts style.

The Character of the Home: Then and Now

⌘ There were certain features common to all Arts and Crafts homes, from do-it-yourself cottages to "ultimate bungalows," as Randell Makinson calls the magnificent houses of the Greene brothers built between 1907 and 1909 in his book, *Greene & Greene: Architecture as a Fine Art*. These included a bias towards plain and unadorned surfaces and natural materials, a floor plan that emphasized fewer but larger rooms, and decorative motifs that were abstracted from nature.

The home merited such consideration because it was thought of as the most important influence in forming character and in strengthening the

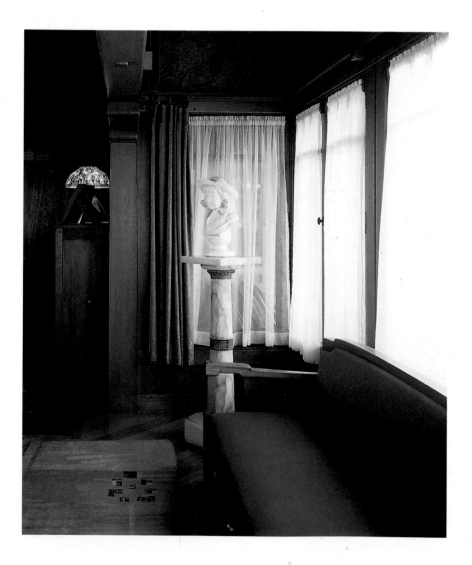

Left, a windowed alcove in the Gamble living room provides a place for a chat.

Contemporary pottery is not out of place with turn-of-the-century furniture and lighting. Right, a collection of extraordinary Eastern masks substitutes for the traditional overmantel painting.

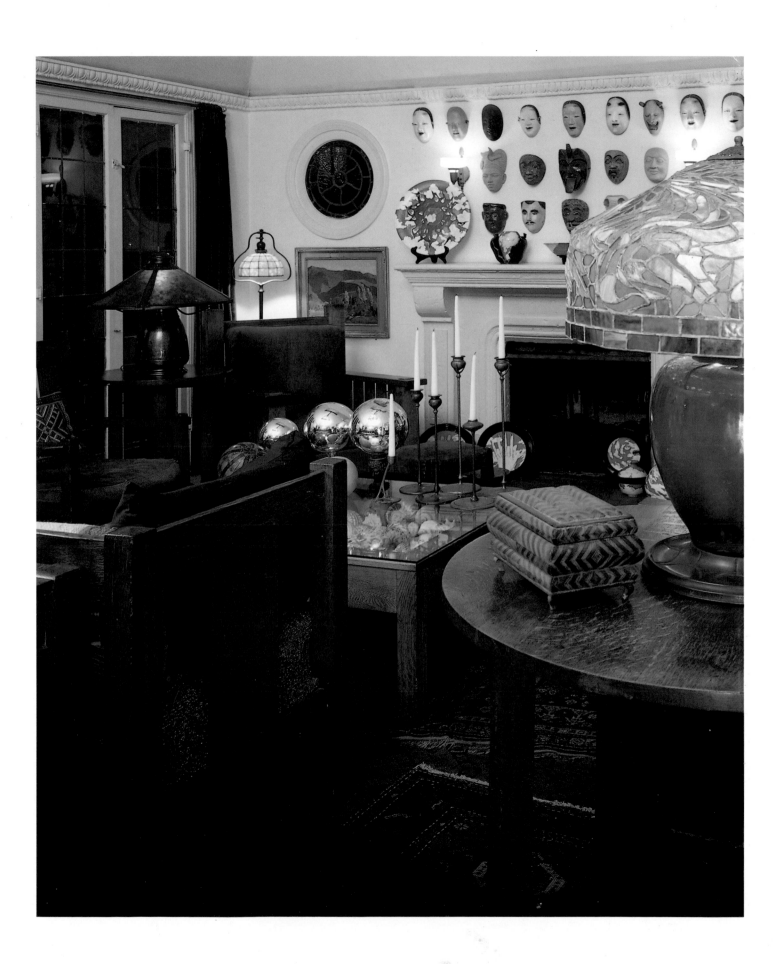

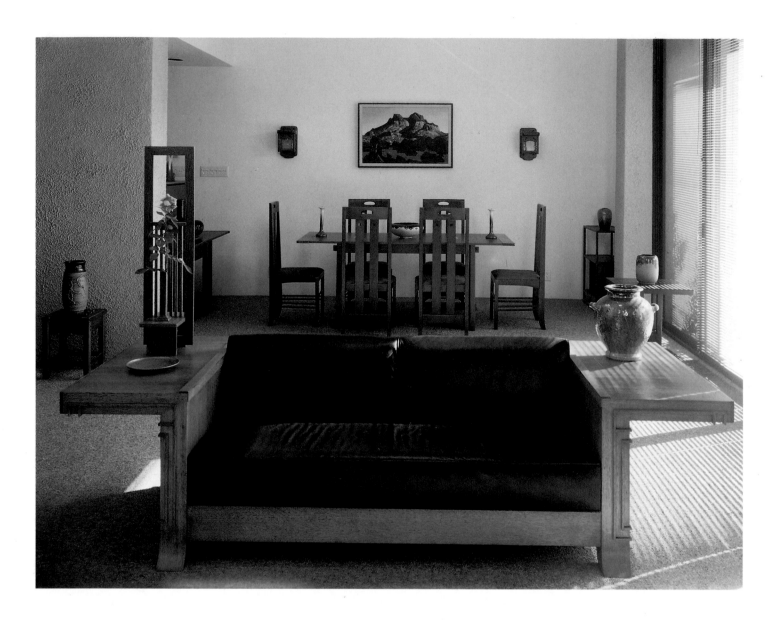

family. There was, consequently, an Arts and Crafts style for virtually every object used in daily living as well as a positive duty to arrange and decorate a house to contribute to the family's health and morality. Just after the turn of the century, *The Craftsman* clearly set down the standards to be used in selecting home furnishings for everyday use. People were to choose things "that frankly state their purpose and honestly meet the needs which they were intended to supply without affectation" of either crudeness or historic grandeur. These objects were to be arranged within rooms that each had a character all their own.

Contemporary blinds and industrial carpeting are unobtrusive elements in the loft-style, Arts and Crafts-decorated home of Randell Makinson. An architectural historian, Makinson believes that the timeless designs of the movement—exemplified by a Frank Lloyd Wright-designed settle reproduced by Heinz and Company and a Coly Vulpiani table, far right—can easily be adapted to meet modern needs.

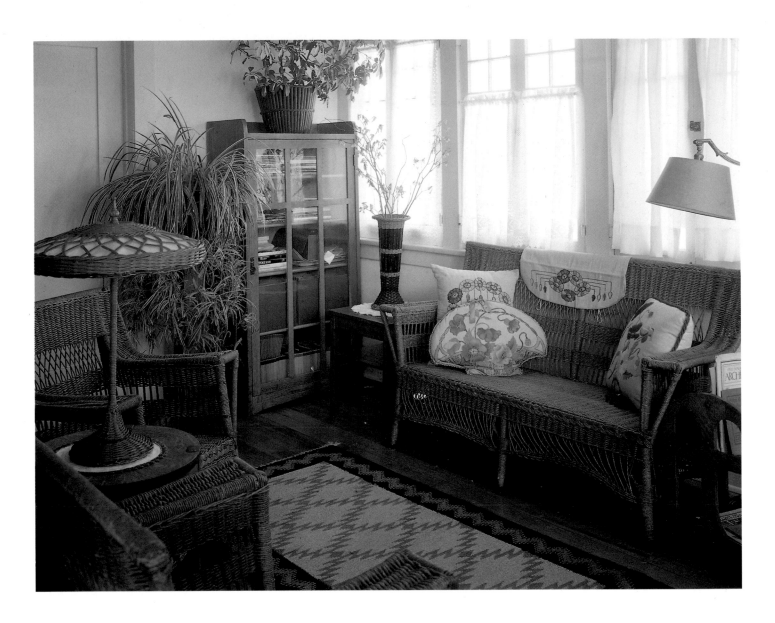

In the upstairs sitting room of Ron Bernstein's Los Angeles home are a matching wicker sofa and chairs. The dominating motif of the furniture is a square back and square arms. Color is added to the room by multicolored pillows on the sofa. The bookcase in the corner is by Limbert. The rug is a Gustav Stickley zigzag design.

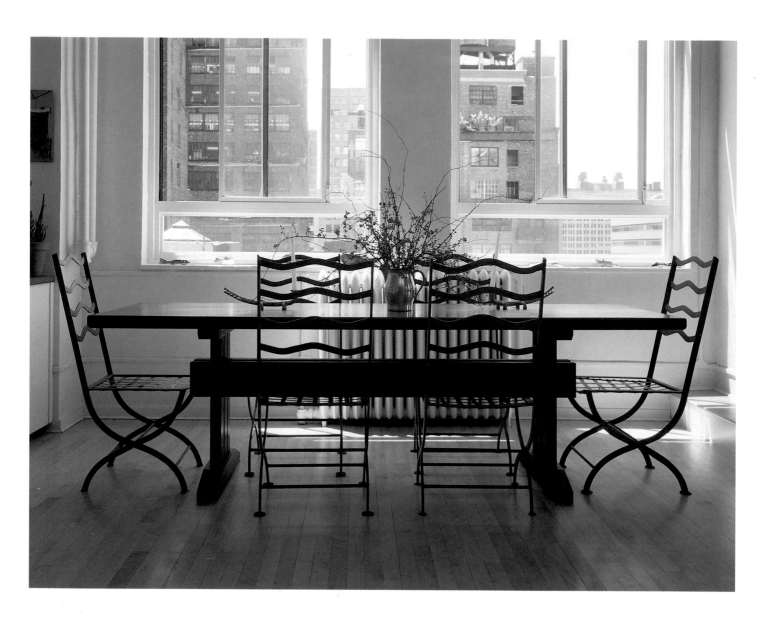

Gustav Stickley once explained his philosophy of the living room. To him, it was "the executive chamber of the household where the family life centers and from which radiates that indefinable home influence that shapes at last the character of the nation and the age."

The right kind of home was important both for the family and for the country as a whole, not least because it was a center of learning where children acquired their first and most enduring life lessons, including an early appreciation of quality. Seen in this light, the obsessive concern with selecting the proper furniture and decorations, which today seems at best fussy, is more understandable.

Built-in cabinetwork was a hallmark of the Arts and Crafts style that was particularly applicable to the living room. In architectural terms, these

A modern table of Brazilian mahogany by Peter Read features Arts and Crafts stretcher and legs, above. Graceful metal garden-style chairs add a whimsical, relaxed touch.

Use of architectural glass came to fruition during the Arts and Crafts movement. In this California dining room, right, Mission-style chairs and termination of the plate rack at the molding add to the authenticity of the setting.

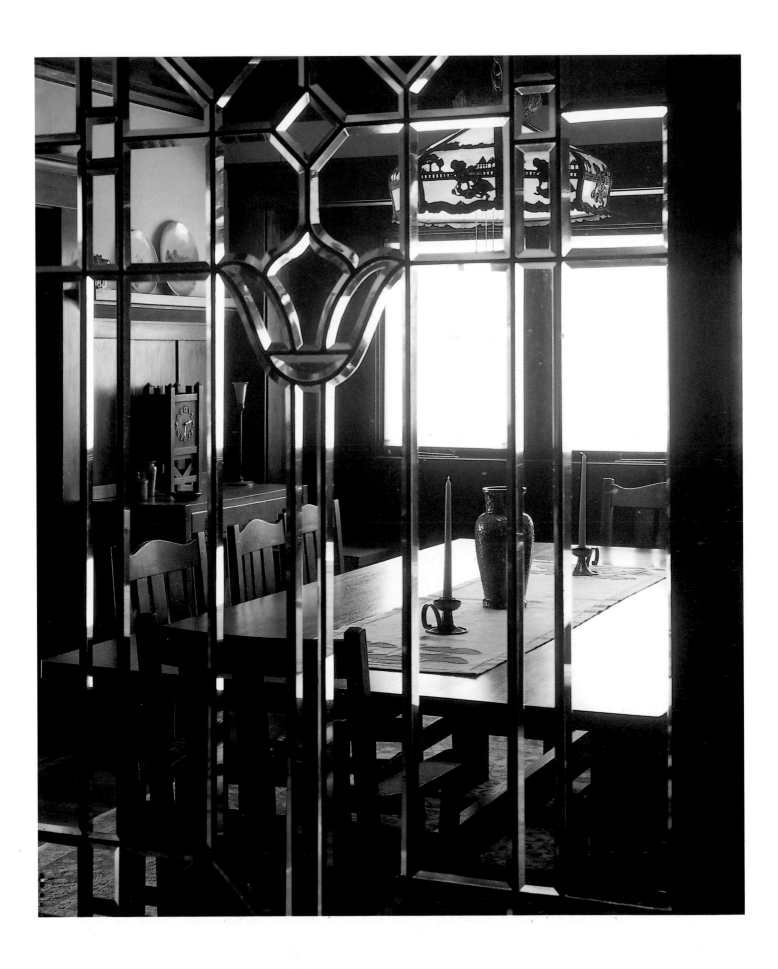

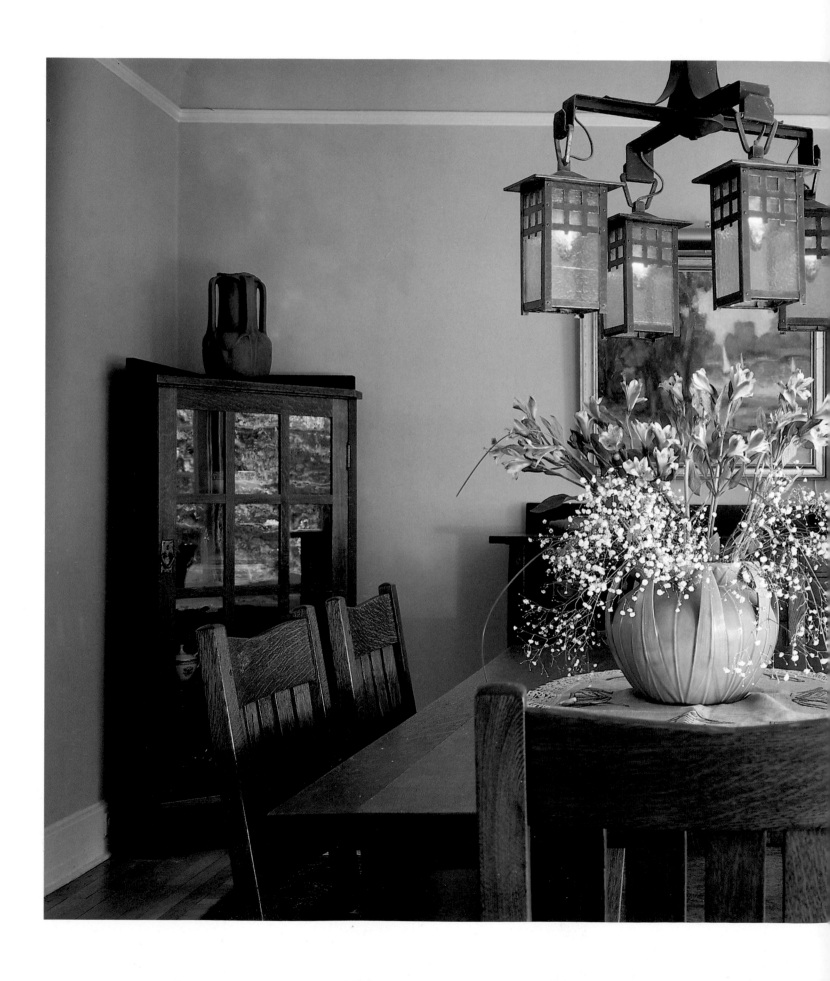

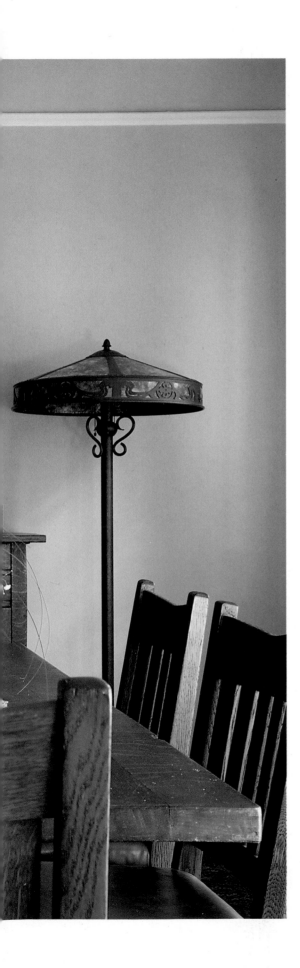

built-ins were anchoring devices that emphasized the interrelatedness of furnishings to structure.

Of special interest are inglenooks, which were cozy seating areas, often with a lower ceiling than in the rest of the room, and generally located adjacent to a fireplace and hearth. They were as desirable in a luxurious "bungalow," designed by the Greene brothers, as they were in a modest cottage built by a working man using plans from a mass-circulation magazine. Window seats were another favorite device. They provided a comfortable spot from which to enjoy the view that Arts and Crafts designers worked so hard to provide through careful siting of homes.

The simple furnishings that Stickley and other designers produced for the living room included the classic settles, Morris chairs, glass-front bookcases, taborets, desks, and tables in a variety of geometric shapes that today we associate with quintessential Arts and Crafts interiors. Often, all or part of a wall was given over to an arrangement of shelves for displaying favorite books and bibelots.

Contemporary collectors find that these furnishings complement large-proportioned rooms. Those with limited living space have discovered that by choosing smaller pieces—taborets, drop-leaf tables, ladies' writing desks, drink stands, side chairs, and even children's rockers—they can create an Arts and Crafts atmosphere without having to accommodate the pieces of massive proportions.

A corner cabinet glass front reflects light from the room and the window beyond. The magnificent ceiling-hung fixture is of the period. Arts and Crafts vases are wonderful receptacles for spectacular floral displays.

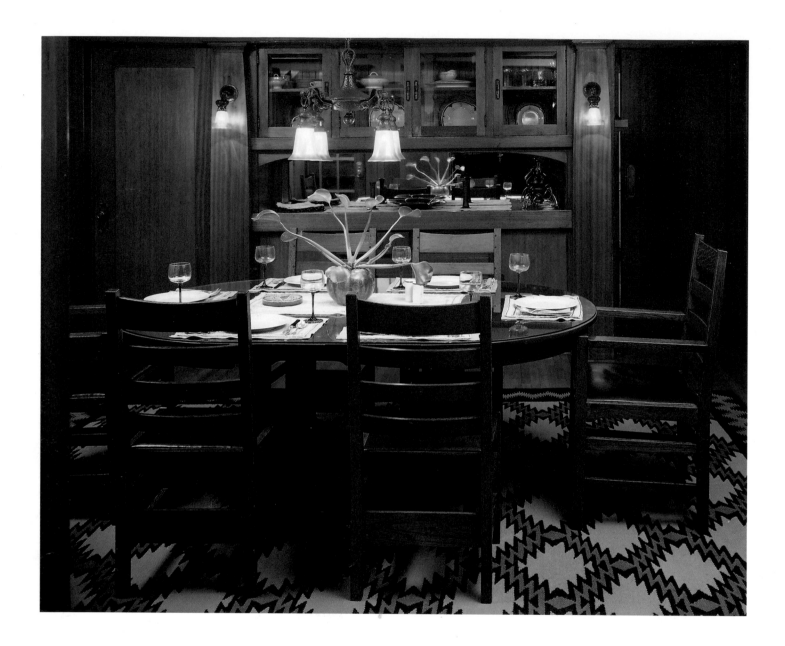

The dining room of Ron Bernstein's Los Angeles home contains a Gustav Stickley dining table and six chairs. It sits on a large zigzag-patterned Gustav Stickley rug in yellow and gray and banded in orange. The fixture over the dining table is a Handel with Quisel shades.

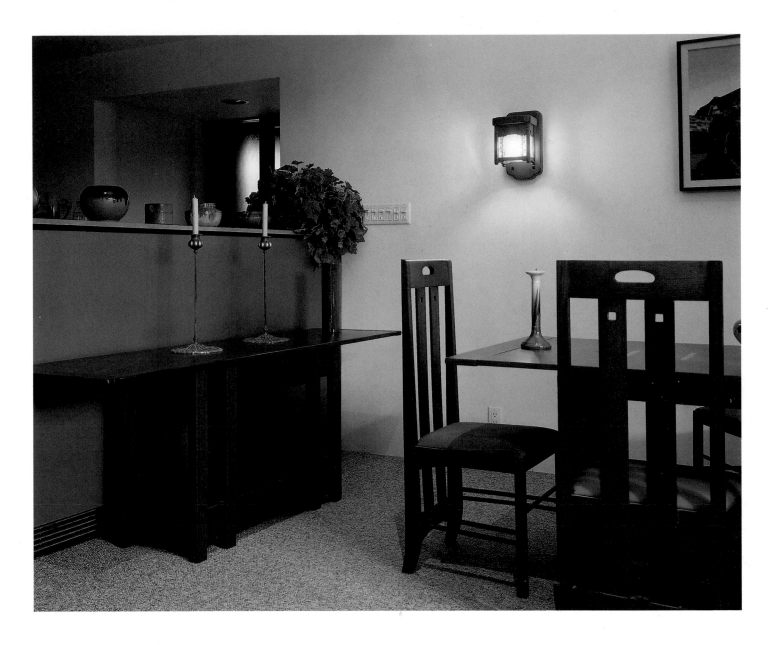

Because of its role in family life, the dining room was considered one of the most important rooms in the house. An impressive dining table—round or rectangular—surrounded by high-backed chairs was the focal point of the room. The imposing nature of the chairs was meant to encourage a sense of ceremony at mealtimes.

Shedding a glow over the table would be a decorative lighting fixture, perhaps with a stained-glass shade in the style originated by Louis Comfort Tiffany. Another favored choice was a copper-framed fixture with a mica insert. When not in use, the dining table most likely stood bare, except for a decorative centerpiece of pottery or metal, a floral arrangement, a pair of candlesticks, or a silver bowl set in the middle of the table.

Greene and Greene originally conceived this table design for library use, but it also works well in the dining room; this reproduction piece is by James Randell, as is the server, at left. The chairs have an especially fascinating provenance. They are Italian reproductions of C.R. Mackintosh design.

Functional requirements for storage and serving were taken care of with a freestanding or a built-in sideboard, often massive in proportion. The well-known Stickley sideboards were available in a variety of sizes with drawers for silver and space to display and store large serving pieces.

This typical arrangement of an Arts and Crafts dining room serves us just as well today as it did during the height of the period. Because many homes today have an open plan, larger pieces such as sideboards don't need to be squeezed into enclosed spaces. Some collectors substitute book-cases or china closets for the sideboard.

Arts and Crafts kitchens were quite compact in comparison with others of the day. Less space was devoted to them because they were efficiently arranged, well lit, and equipped with the latest labor-saving appliances, such as a refrigerator and a stove with a hood, an innovation that made it possible to clear the kitchen air quickly.

"We believe in having the kitchen small, so that extra steps may be avoided, and fitted with every kind of convenience and comfort, with plenty of shelves and cupboards," wrote Stickley. He explained in his decorating book of 1909 that it was especially important for a full range of labor-saving devices to be installed, since the lady of the house was more likely to be doing her own housekeeping as good help got harder to find.

In the living room of Ron Bernstein's Los Angeles home, also pictured from a different perspective on page 53, the furnishings represent perhaps the fullest extent in his home of the unity of the decorative arts of the movement. Looking toward the fireplace on the right is an L. & J.G. Stickley settle after a Voysey design. In the corner behind it is a mahogany Charles Rohlfs table, upon which sits a Tiffany turtleback lampshade and turtleback lamp base. Adjacent to the settle is a Lakeside Crafts smoke stand, and next to it is a Lifetime umbrella stand. Behind the centrally located Limbert table is a cutout Limbert chair in mahogany; adjacent to it sits a Gustav Stickley taboret. On the left wall is an L. & J.G. Stickley slantfront desk and a side chair made by the Michigan Chair Company. The severity of the oak furniture is offset by the green and yellow rug in pine cone design, which is accented by the textiles on the settle, pottery, and lighting.

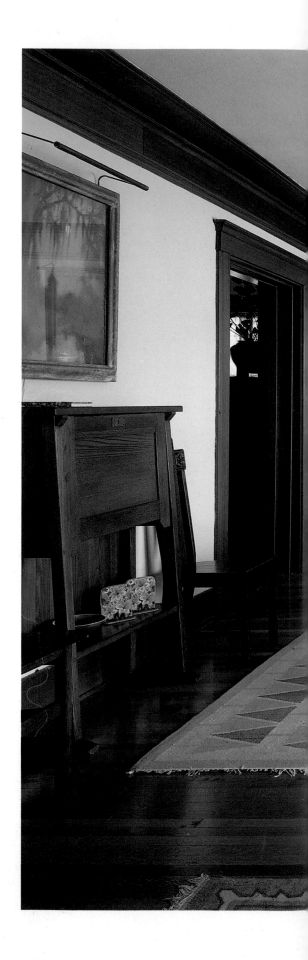

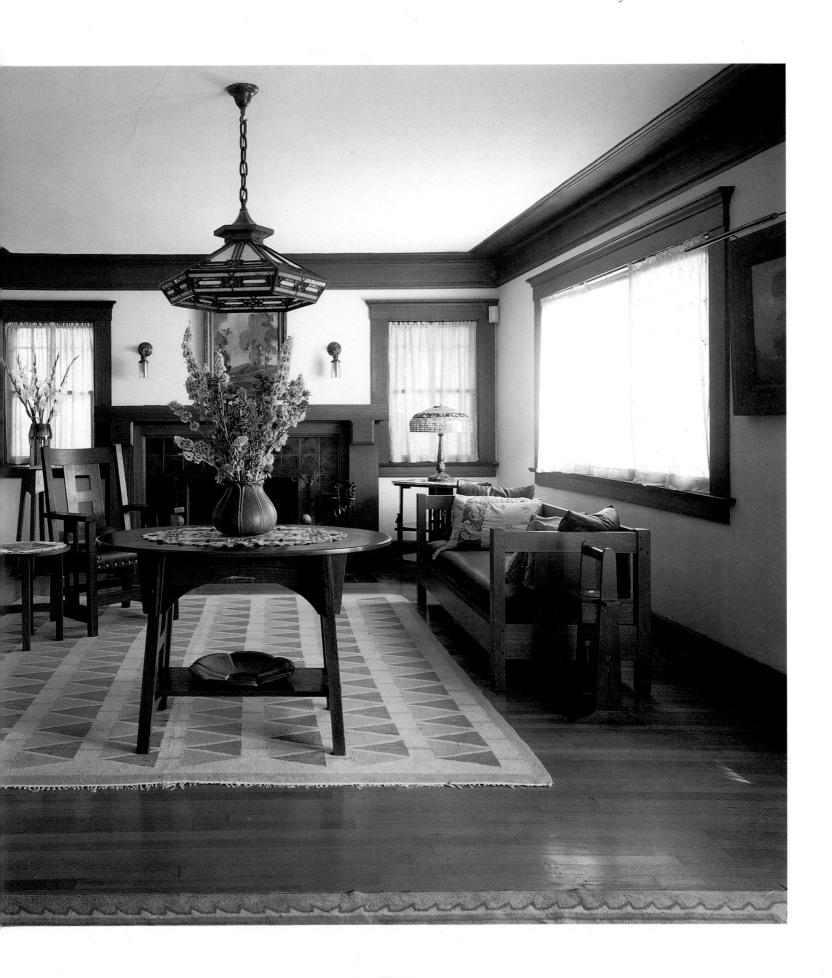

While today the emphasis is on larger kitchens with such features as work islands and areas for informal family meals, the Arts and Crafts aesthetic is certainly still applicable. The proliferation of modern conveniences makes storage even more of an issue than it was at the beginning of the century. An Arts and Crafts–inspired solution to kitchen clutter is to create a visually unified system of simply detailed wooden cabinetry designed to contain and even disguise appliances behind doors. A settle or high-back hall seat propped against a kitchen wall, fronted by a wood-top library table, creates an instant "breakfast corner." Kitchen hardware and lighting fixtures made of copper and brass glowingly evoke the Arts and Crafts aesthetic.

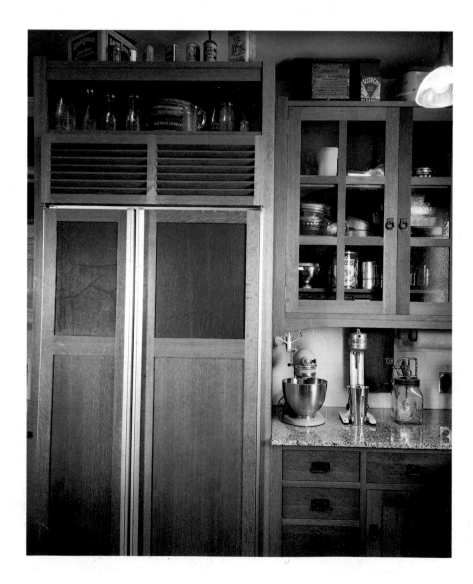

Built-in cabinetry of today with glass-fronted doors of the Arts and Crafts tradition combines the best of two worlds in this kitchen, left. Butterfly details in the wood floor are purely decorative in this northern California kitchen, right. The studded copper hood over the stove is typical of hearth detailing in Arts and Craft-era fireplaces.

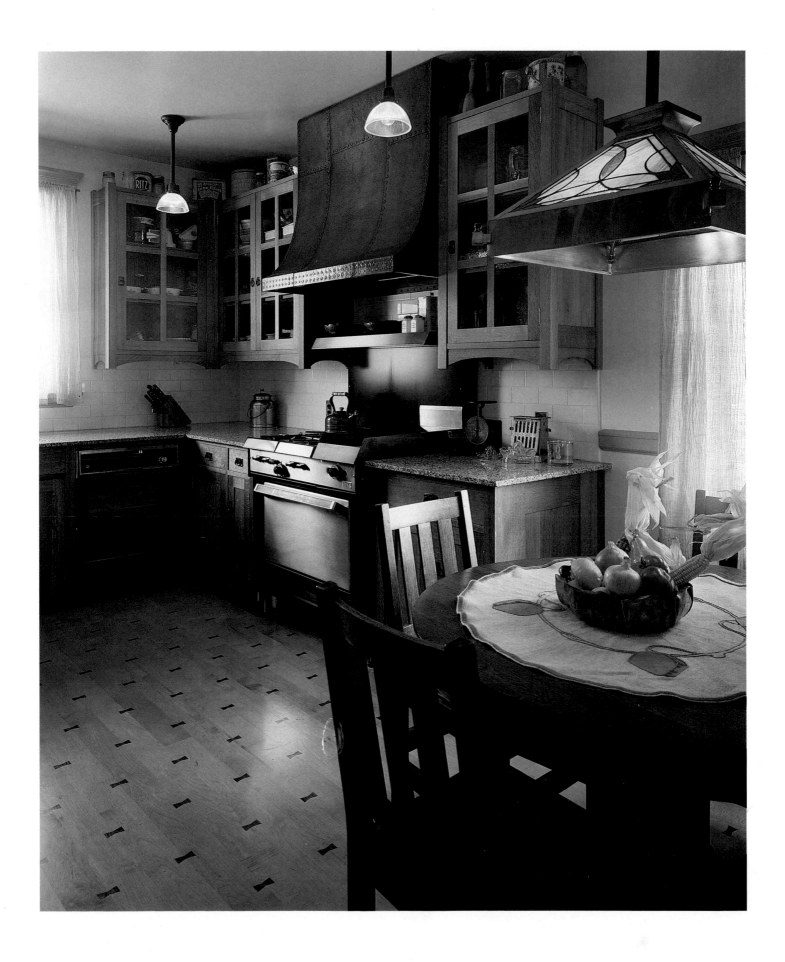

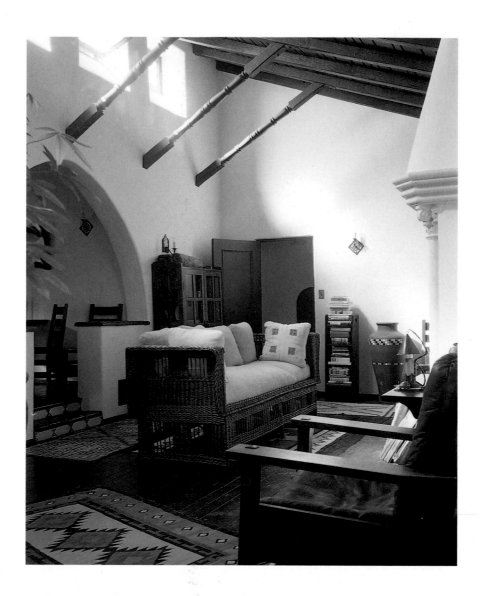

Architecture of the California missions inspired the design of this interesting Los Angeles home, above. The area rugs show off the beautifully maintained wood floors.

Smooth textures of the leather upholstery and Oriental area rug contrast with rough-textured linen-weave settle cushions and Berber-style carpeting in a rambling, turn-of-the-century home, right.

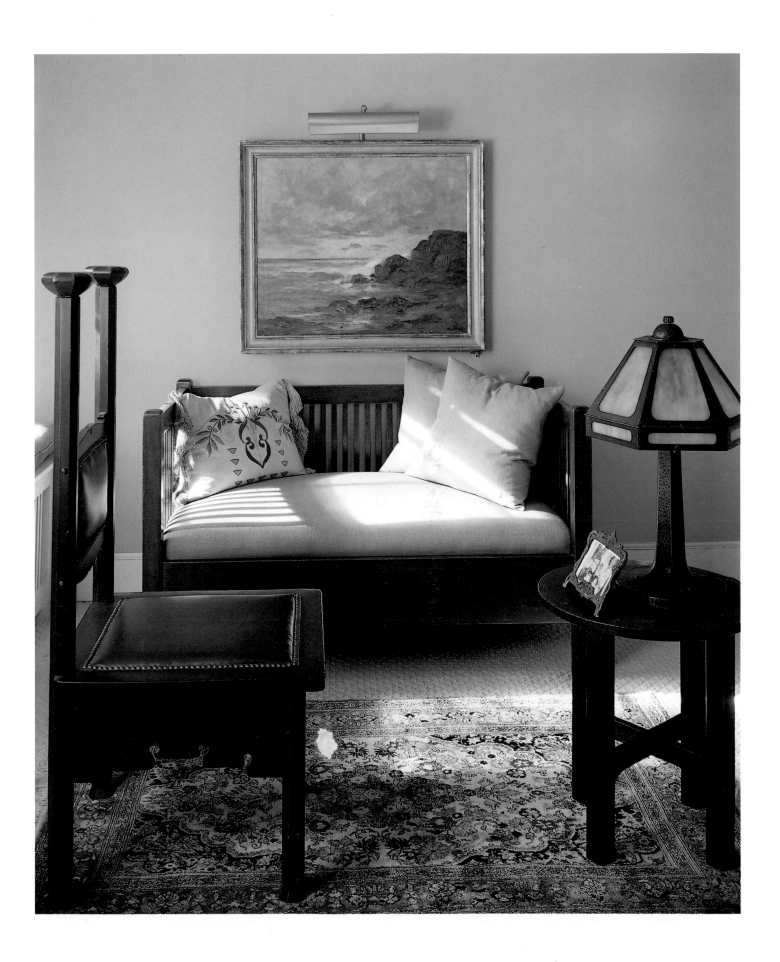

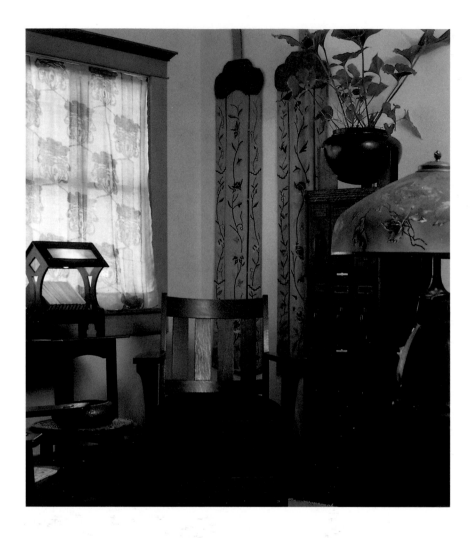

In the study of Ron Bernstein's Los Angeles home, a mahogany file cabinet is in the right-hand corner; upon it sits a Prairie School hand-hammered jardiniere. Facing forward is a Limbert chair. In the foreground of the right corner is a Handel reverse-painted lamp. The furniture sits on a Gustav Stickley open-honeycomb-design rug. The window coverings are stenciled in a linen poppy design in red and tan.

Arts and Crafts bedrooms tended to have a more utilitarian feeling than did other rooms of the house. They were designed to admit plenty of sunlight and air, had an uncluttered quality, and were simply furnished with sturdy wood furniture.

A display advertisement for a Craftsman-style master bedroom suite in oak featured twin beds, a double dresser, and a tall bureau as well as a dressing table, a cedar-lined cabinet for shirts, and two rocking chairs. The textiles for the room, which could be purchased through Craftsman departments at retail stores, included a pair of brownish-gray linen bedspreads embroidered in white with a zinnia design, cotton curtains in yellow with embroidered rose and green blossoms and orange leaves, a dresser scarf in Flemish linen with a ginkgo leaf appliqué, and a plain wool rug—uncomplicated designs meant to evoke nature.

Contemporary collectors often find that Arts and Crafts bed frames are not large enough to meet their needs. As a consequence, they might adapt

This house survived the Berkeley fire of 1923. The Morris chair at right is a reproduction; the chair at left is an original by Gustav Stickley. The wainscoting ends in molding at shoulder height—an ideal exhibition space for framed art.

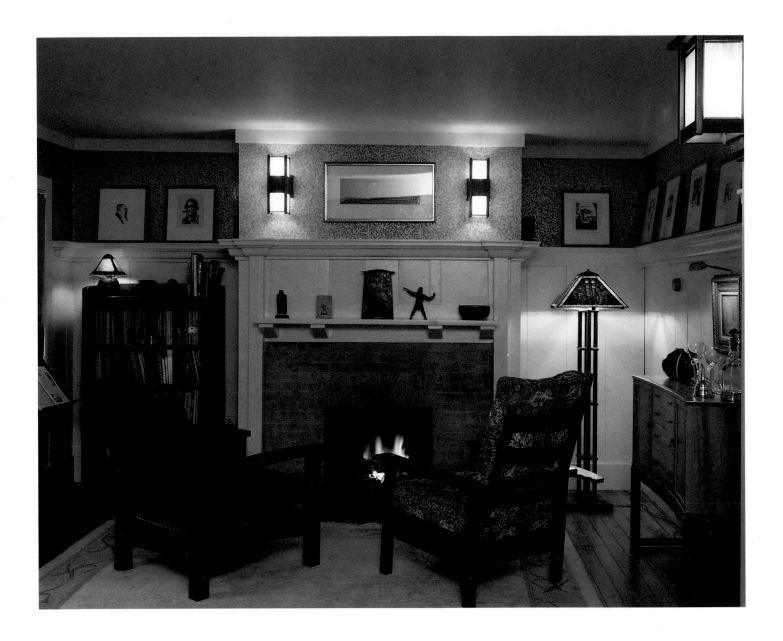

only the headboard and baseboard of an Arts and Crafts original or purchase a reproduction sized for today. Another way to evoke the feel of Arts and Crafts in a bedroom is to combine period willow wicker furnishings—lampshades, armchairs, and even settles—with modern beds and dressers. Period-inspired textiles and objects can also create the illusion of an authentic setting without incurring the expense of acquiring the furniture. That classic furnishing of the Arts and Crafts period, the three-section folding screen—in wood panels with burnt-on floral motifs or partial sheepskin covering, as well as in a wood frame with canvas, tapestry, or grass-cloth panels—is also perfectly at home in the bedroom. Placed in a corner, it re-creates the romance of an old-fashioned dressing area.

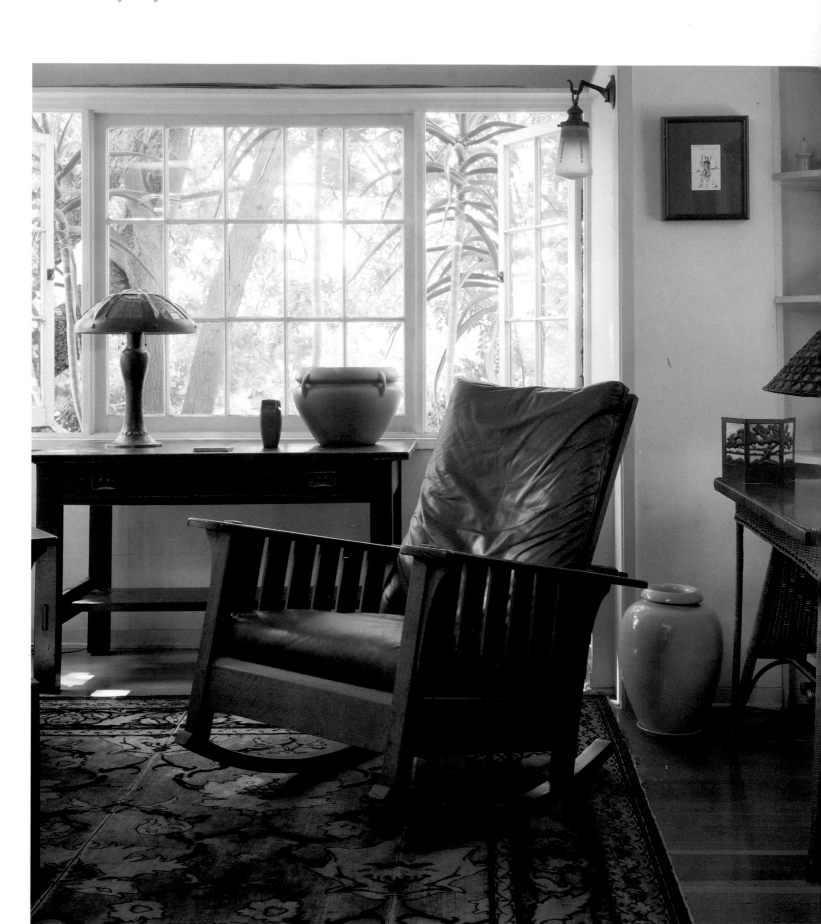

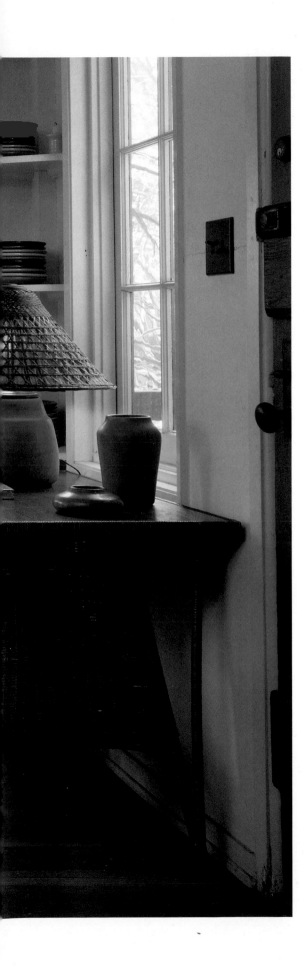

The Walls and Floors Arts and Crafts theorists prized honesty above artifice and were in favor of using all materials so that their innate qualities were revealed. The idea of giving walls a faux finish was not a popular one. However, as is true of decorating in all eras, these doctrinaire rules could easily be ignored in specific situations. People then, as now, decorated by eye and by feel, rather than by doctrine.

Wood grain was always a favorite treatment and in many instances wood paneling was the hands-down choice. A wood background was ideal for a "friendly, unobtrusive setting for furniture, draperies and ornaments," *The Craftsman* informed its readers. The type of wood varied according to what was locally available—redwood in California, oak everywhere, and chestnut, ash, elm, maple, beech, birch, and gum, according to their availability and the tastes of the householder. Oak was Wright's preferred wood both for furniture and interior woodwork. He used oak often in the horizontal dimension and emphasized this through the application of thin oak strips to surfaces of furniture and woodwork. These moldings would catch the light and create interesting shadows, which also reinforced the horizontal dimension and, therefore, provided another form of unification with the architectural scheme.

A wicker desk and lampshade, as well as Fiesta ware, add a light touch to a study. Unusual collector's items are wonderful additions to Arts and Crafts furnishings.

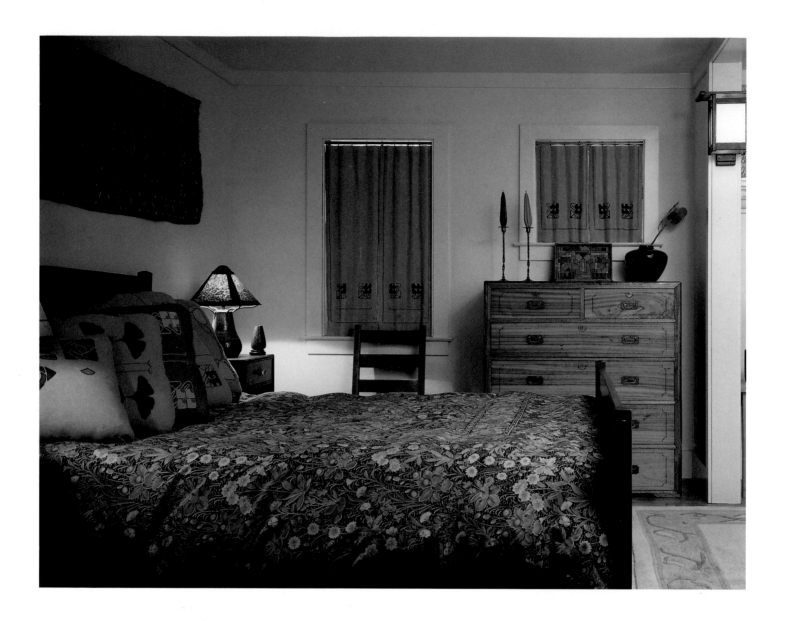

A genuine oriental campaign chest—the first antique acquired by the owners of this early-twentieth century home—displays Roycroft candlesticks. The simplicity of the chest's design makes it a perfect match with Arts and Crafts objects. Embroidered curtains and cushions are by the contemporary textile artist Dianne Ayres, who is based in Berkeley, California.

At the beginning of the era, it was typical to divide a wall into three parts and then treat each part differently. Starting at the floor, the first portion of the wall stopped about waist height. A midsection ended at shoulder height and was surmounted by a top section that went to the ceiling.

On the lowest portion of the wall, a wood paneled dado was characteristic. Paint in a woodsy brown or leafy yellow-green color or a sturdy wallpaper with an unobtrusive pattern were equally suitable treatments. The midsection of the wall might be covered with a decorative paper or possibly be painted. The upper section could be given importance with a stenciled or pictorial border executed in wallpaper, tiles, or paint.

Despite the fact that William Morris was a designer of wallpaper, architects such as Wright did not approve of it and didn't use it. *The Craftsman* also revealed a bias in favor of original wall treatments—such as handpainted murals and stenciled designs. However, wallpaper was an acceptable treatment and wallpaper companies advertised in the magazine.

At the turn of the century, friezes (today we call them borders) were printed to match virtually all repeating patterns and grew ever wider, writes Catharine Lynn in *Wallpaper in America*. In many rooms, wood paneling was extended far above the dado's old chair-rail boundary and a pictorial or geometric pattern frieze topped it. Or, instead of wood paneling, the border could top an unobtrusive wallpaper stripe or a textured solid-color "ingrain" paper (that was thicker because of the addition of cotton and woolen rags to the paper pulp). Yet another idea was to paint three-quarters of the wall before topping it with a pictorial or abstract pattern border.

Pictorial and plain tiles were used extensively during this era and were applied to fireplace surrounds and walls or laid so as to create borders on walls and floors. Sometimes—especially in halls, dining rooms, and libraries—wood paneling was extended up to about shoulder height in wainscoting. Typically, walls also were ornamented with baseboards and wood or plaster cornices.

The idea of using color to create a peaceful mood and quiet atmosphere arose during the Arts and Crafts movement. Morris's color schemes, which were subtle blends of subdued and stronger tones, were admired because they were quiet and didn't detract from the rest of the room. As a writer of the day explained, they created an "atmosphere." Favored colors of the

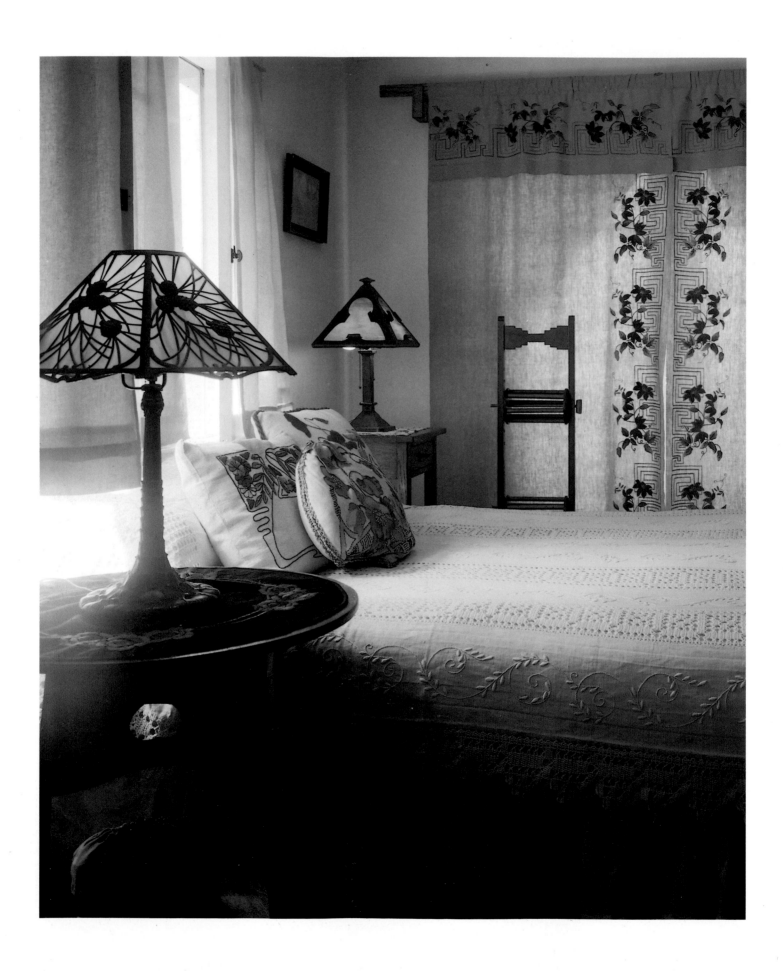

In the master bedroom of Ron Bernstein's Los Angeles home, left, his large collection of textiles dominates. High on the back wall are embroidered curtain panels in a red poinsettia design, which are set against a Greek key embroidered in chenille. The bedspread is embroidered in panels that alternate with crewel work designs. For additional color, there are embroidered pillows on the bed. In the lower left-hand corner sits an embroidered sewing bag. The end table in the foreground is English, indicated by the heart cutout design. The side table in the back is by White Brothers for the Grove Park Inn.

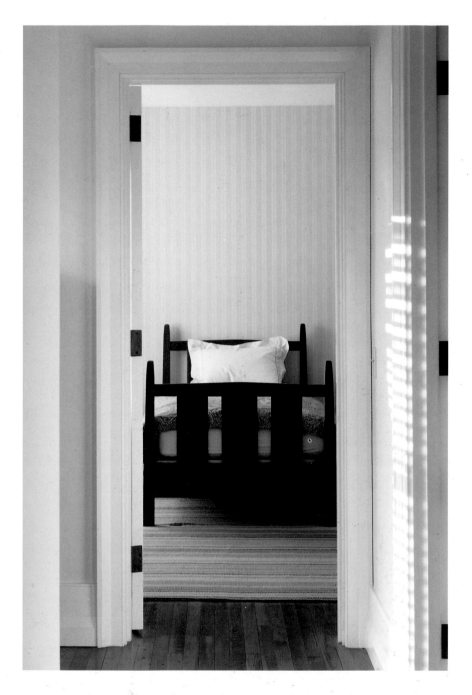

A Stickley bedstead is set beautifully against subtly striped wallcovering, right.

American movement were often based on natural dyes, with earth tone colors as well as indigo blue, greens of every hue drawn from nature, ocher, and a grayed purple among the selections.

As the years went on, walls became plainer and ultimately were often treated as a single surface, as is typical in modern rooms. White walls eventually became fashionable—a great change from the Victorian era, when white was considered suitable only for utilitarian spaces. The greater use of white helped to lighten the overall effect in rooms.

Windows were also considered an important wall element. They were treated simply with gathered unlined curtains that hung from plain wooden or metal poles. These curtains usually were made of simple materials. Leaded-glass windows were popular as another decorative accent.

Stained-glass windows during the Arts and Crafts era often included flowing Art Nouveau design motifs, which is not surprising considering that Louis Comfort Tiffany, America's most prominent practitioner of Art Nouveau, was also famous for magnificent art glass windows. Tiffany's colorful opalescent windows depicted naturalistic scenes of great beauty. Such windows were selected by those who could afford them for their Arts and Crafts–style homes.

The Arts and Crafts aesthetic also extended to the floor. Wooden floors warmed with area rugs were one choice for the living room and dining room. Linoleum and encaustic tile were hard-wearing selections for kitchens and entryways. William Morris regarded fine Oriental rugs as works of art and often displayed them on the wall so that their patterns could be admired.

Other floor coverings considered suitable for Arts and Crafts rooms were braided rag rugs—a relic of the colonial American past—sisal rugs, Native American rugs, and drugget rugs, which were heavy felted wool or wool and cotton rugs. Such rugs are still widely used today. Many contemporary Southwestern textiles, in particular, draw on timeless designs that could just as easily have been used during the Arts and Crafts period.

The Arts and Crafts interior is clearly not a curiosity of its own time. Its furniture, accessories and design tenets work as beautifully in the present as they did in the past. Whether we take a purist or eclectic approach to designing with Arts and Crafts today, we are rewarded with a home infused with a simple yet remarkably rich aesthetic.

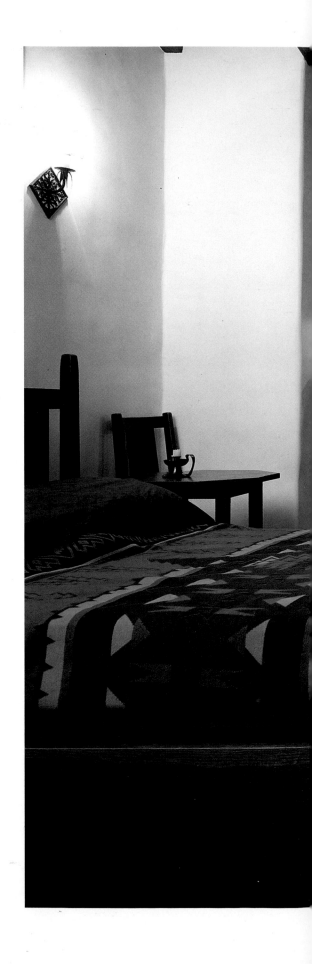

Displayed on a period bed, this brilliant-colored blanket demonstrates that bright colors are certainly permissible in the Arts and Crafts bedroom. A hand-wrought-iron curtain rod adds a Craftsmanlike touch.

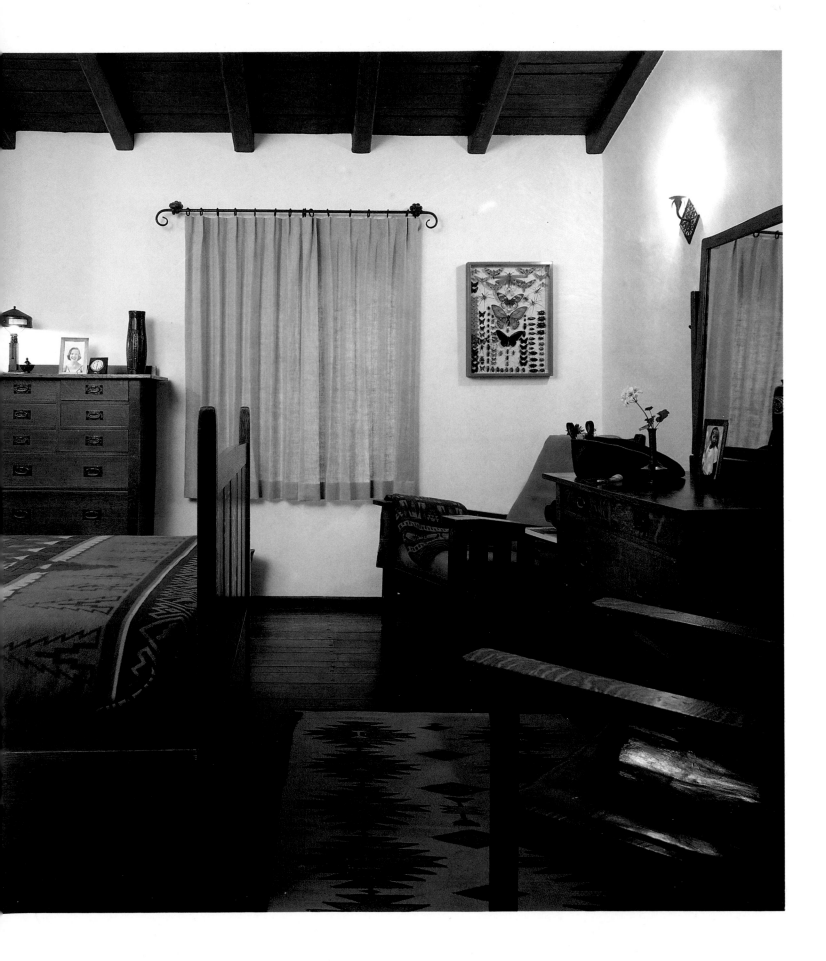

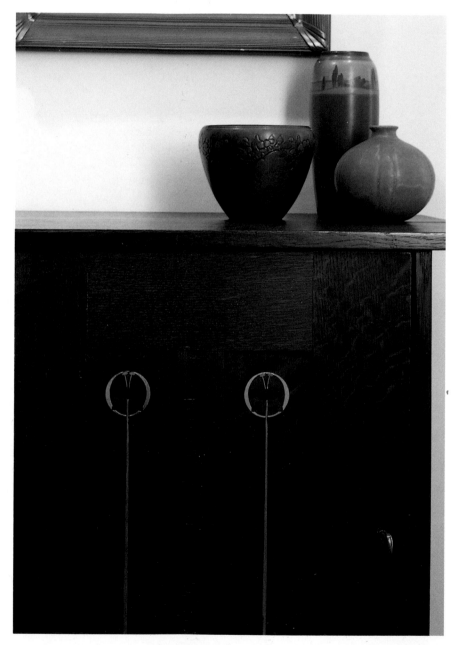

An inlaid design makes this Harvey Ellis music cabinet particularly valuable.

Chapter Three

FURNITURE

❧ *Even though the Arts and Crafts style was a complete design aesthetic—if not a way of life—it was through its furniture that most people gained an awareness of the style, not only in the present, but also in the past.*

At the turn of the century, as now, furniture was designed, manufactured, and sold in a variety of ways. At the top level, there were the well-known architects, such as those of the Prairie and California schools, who designed furniture as part of a totally integrated plan for a luxury residence. There were also designers who catered to a wealthy clientele of Arts and Crafts enthusiasts from coast to coast.

By the spring of 1902, the Arts and Crafts style—or, as

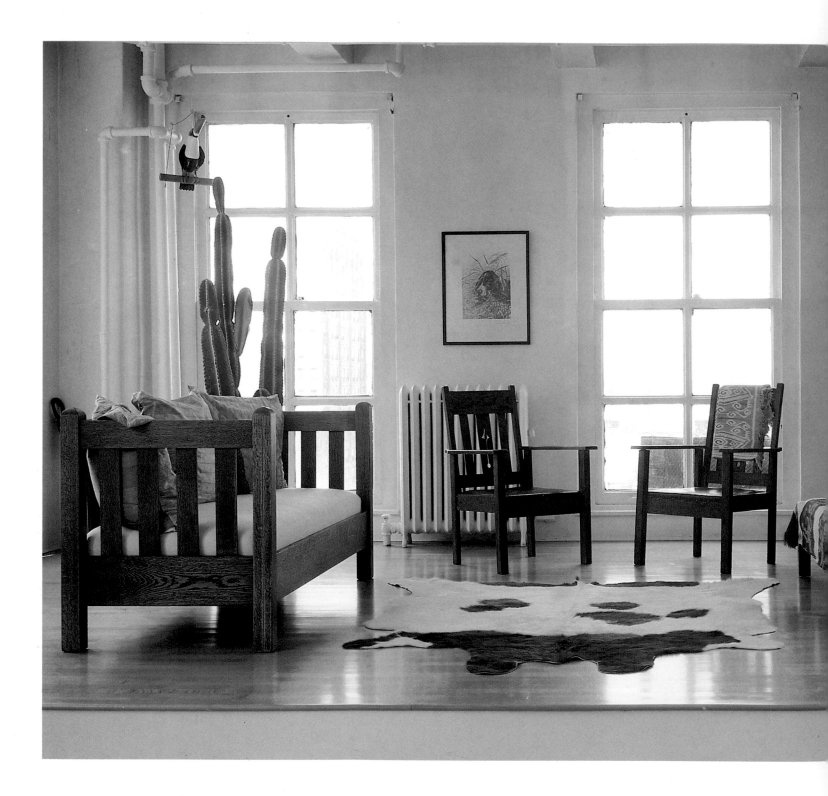

Details such as cacti and an animal skin rug suggest the Southwest or the tropics, but belie this apartment's location in the center of Manhattan. The simple arrangement of furniture highlights its strong, geometric form.

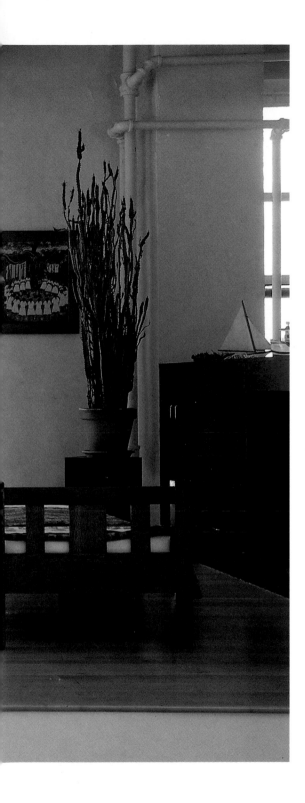

it was often called, the Mission style—had become the latest decorating fad in the United States. A furniture trade publication reported to its readers among furniture retailers that "dealers can scarcely get enough to supply the demand." At the height of the furniture's popularity, lesser versions of original designs were available through mass-market catalogues and in department stores, making Arts and Crafts a viable style for everyone— not just the province of the elite.

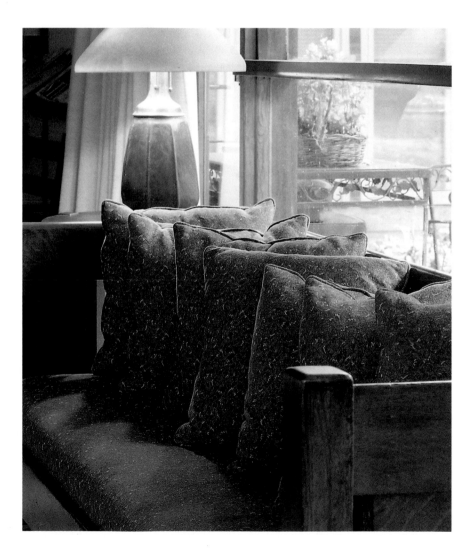

Soft velvet upholstery is atypical to Arts and Crafts, but lends a comfortable feeling.

Arts and Crafts Classics

ஃ Now that the Arts and Crafts aesthetic is again enjoying popularity, collectors need to educate themselves to the variety of furniture available. Each major designer's furniture bore his or her unique stamp. Yet characteristic pieces tended to crop up in the work of many individuals.

Settles In the deliberate use of an anachronism no doubt meant to conjure up an idealized past, furniture makers referred to sofas as "settles," and offered a number of different types. The best-known style featured a plain oak frame and back. Dimensions varied from small, almost delicate settees to massive pieces forty inches deep and more than eight feet long. It was typical for these pieces to have a single long seat cushion and loose back cushions, commonly covered in leather.

Another type of settle was a high-backed, all-wood piece that resembled a church pew. Perhaps this physically unforgiving type of seating—whose form was not obscured by upholstery—has contributed to the style's modern reputation for being "uncomfortable."

Chairs Yet another characteristic seating design was the Morris chair, an easy chair that became a signature item of Arts and Crafts furniture and was offered by a number of manufacturers. Owning a Morris chair was as close as many Americans ever got to participating in this aesthetic movement. The first Morris chair was marketed in 1866 by William Morris & Co. It seems that the company's business manager, Warrington Taylor, was impressed by a chair that he had found in a carpenter's shop in Sussex, England. He sent a sketch to Philip Webb—Morris's in-house architect— who refined the drawing. In the architect's new design, the easy chair featured a movable back that could be set at different angles, an early example of the recliner. Morris offered the chair in an ebonized and a plain wood frame with a cushioned seat and back.

Even before it came to the United States, this comfortable chair was very widely copied in England. In America, Gustav Stickley, for one, introduced seven Morris chair models, with minor differences. He began marketing them in 1901 and promoted the largest model as "a big deep chair that means comfort to a tired man when he comes home after the day's work."

A modern Arts and Crafts-inspired bench by Randolph Laub of Santa Fe and a Deco-style wrought-iron coat-rack make an urbane combination in this Manhattan apartment, created by Claus Rademacher Architects.

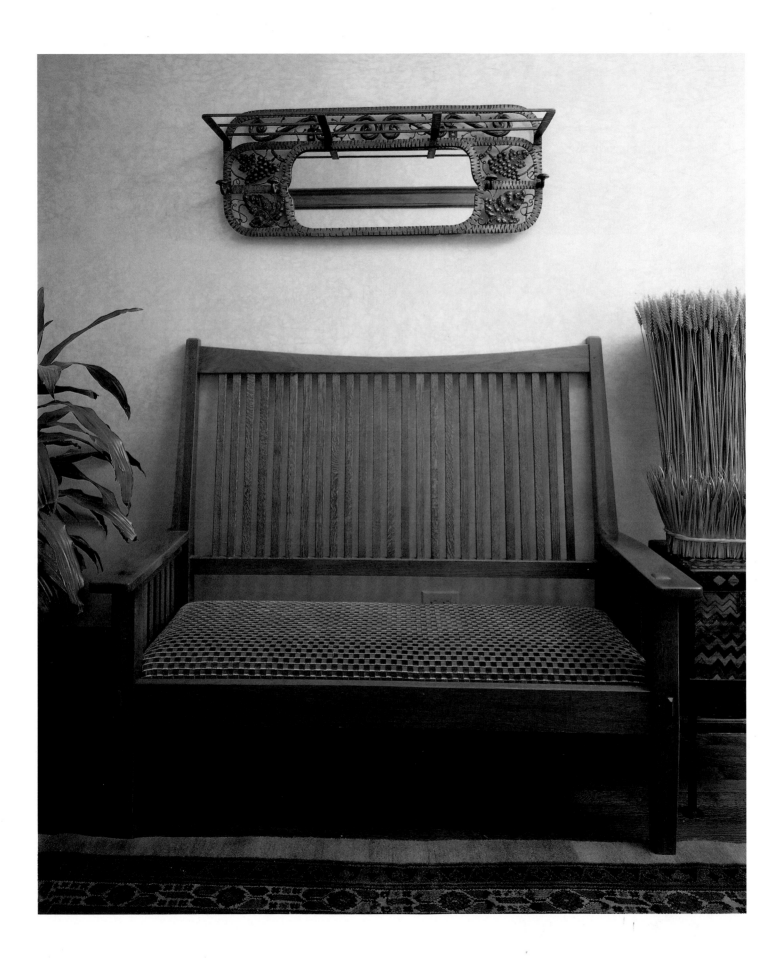

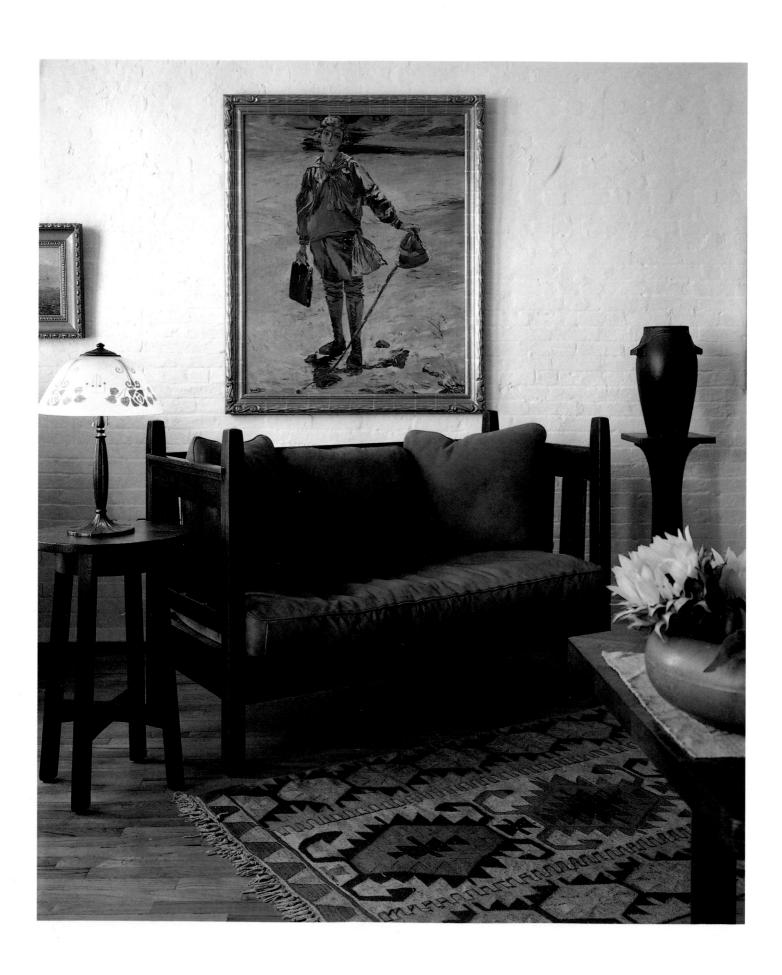

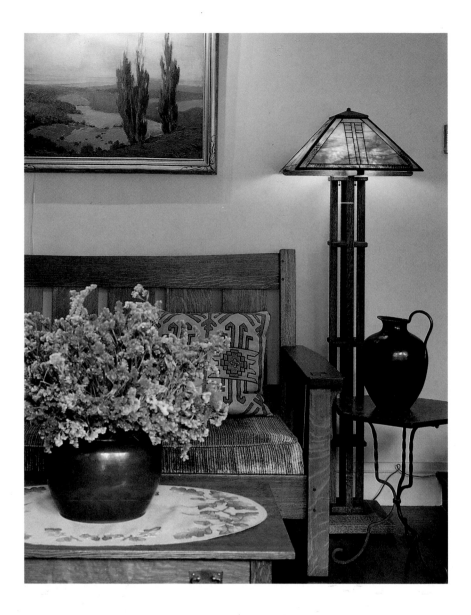

Left, a figural painting by Karl Yens is a focal point above a small Gustav Stickley settle. To the left, a Handel lamp rests on an L. & J.G. Stickley table. The pedestal at right displays a monumental Rookwood urn.

Lighting by Michael Adams is of his own design yet is nevertheless in period character. On a period table of unknown provenance sits a Van Erp pot. A 1927 painting by Anthony Buchta evokes a natural theme, right.

The simple Mission dining chair—an American design with a rush seat and legs connected to one another via a plain stretcher—was another characteristic piece of the movement. A controversy erupted over who should get the credit for marketing the first Mission chair and, by implication, for introducing Mission furniture. It seems likely that a New York furniture manufacturer named Joseph McHugh was the first mass-producer of the chair, which was based on a Spanish-style original that furnished early California Franciscan missions. As early as 1894, McHugh marketed an inexpensive Mission-style chair at the Popular Shop in New York. As with the Morris chair, many companies made similar chairs, which were sold all over the United States.

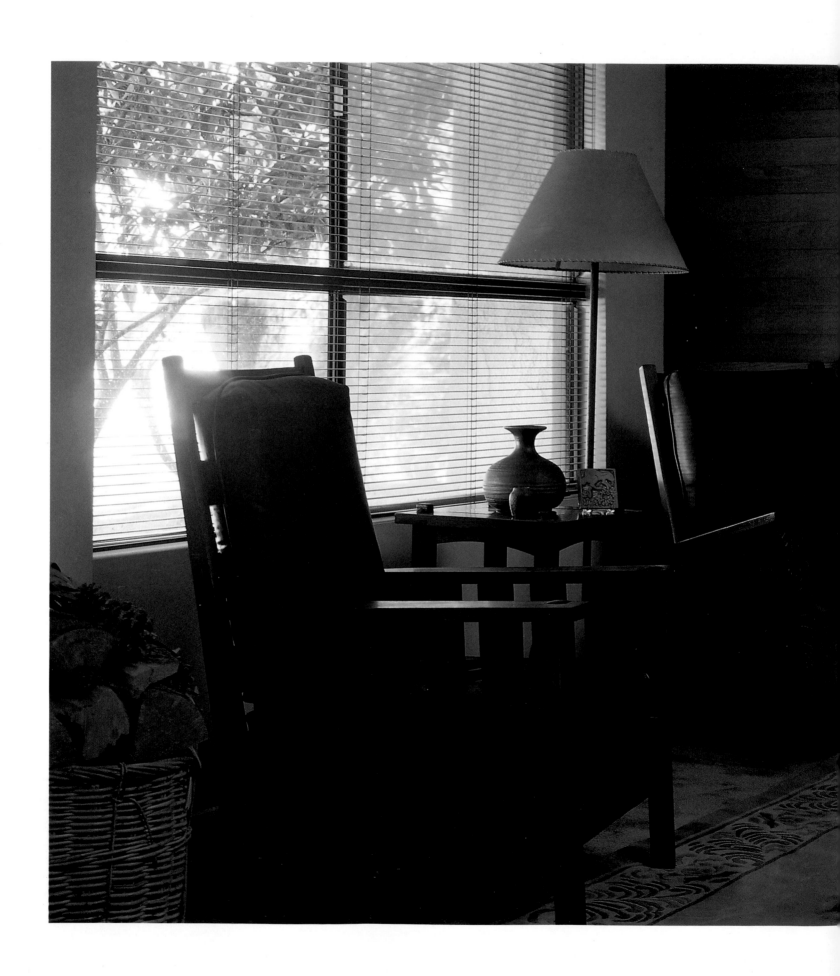

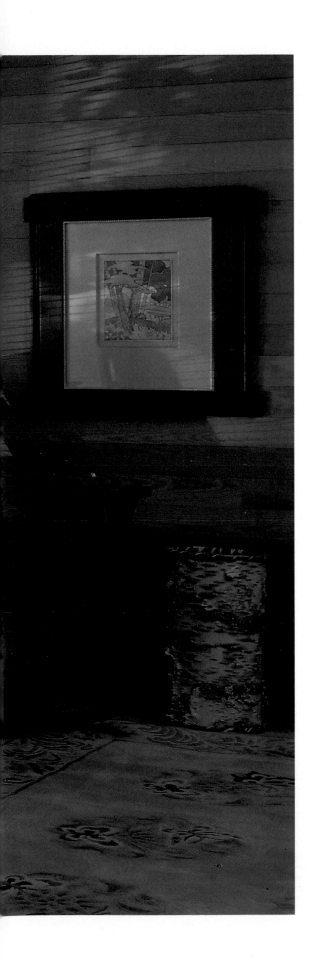

Tables Tables were varied to meet needs for every room of the house. They ranged in size from fourteen-inch-diameter taborets to round tea tables with a convenient bottom shelf to drop leafs to massive library tables. The library tables, in particular, came in a variety of forms, from hexagonal designs that comfortably allowed six to sit around them to long, rectangular models that could also serve as dining tables. Library tables were widely produced, and collectors today use them as coffee tables (in cut-down form), lamp tables, and dining tables.

The buffet server is a piece strongly identified with Gustav Stickley, although it, too, was offered by many makers. The piece was available as a small-scale server with an open bottom shelf and two shallow drawers for flatware or a massive buffet with numerous storage compartments.

Desks The Arts and Crafts style held a special appeal for individuals of an intellectual bent, so it's hardly surprising that desks and bookcases were among the most commonly offered furniture. There were many desk models to choose from, including flat, leather-topped desks with drawers below and fall-front and rolltop models. Proportions varied from delicate ladies' writing desks to massive pieces.

Unique desks were especially prized. Some of the most unusual desks were made by the designer Charles Rohlfs. One dating from about 1900 is a double pedestal desk. The massive oak piece featured extravagantly carved decorations on drawer fronts and side panels. Two vertical posts at the rear of the desk supported the top section with twelve drawers and additional pigeonholes. Another Rohlfs original—a small fall-front desk made so that it swiveled—was described in *House Beautiful* magazine as looking like a miniature Swiss cottage when the piece was closed.

Marvelous patinas on oak Morris-style chairs adds greatly to their value. These designs, mass-produced in the period, are available to contemporary collectors.

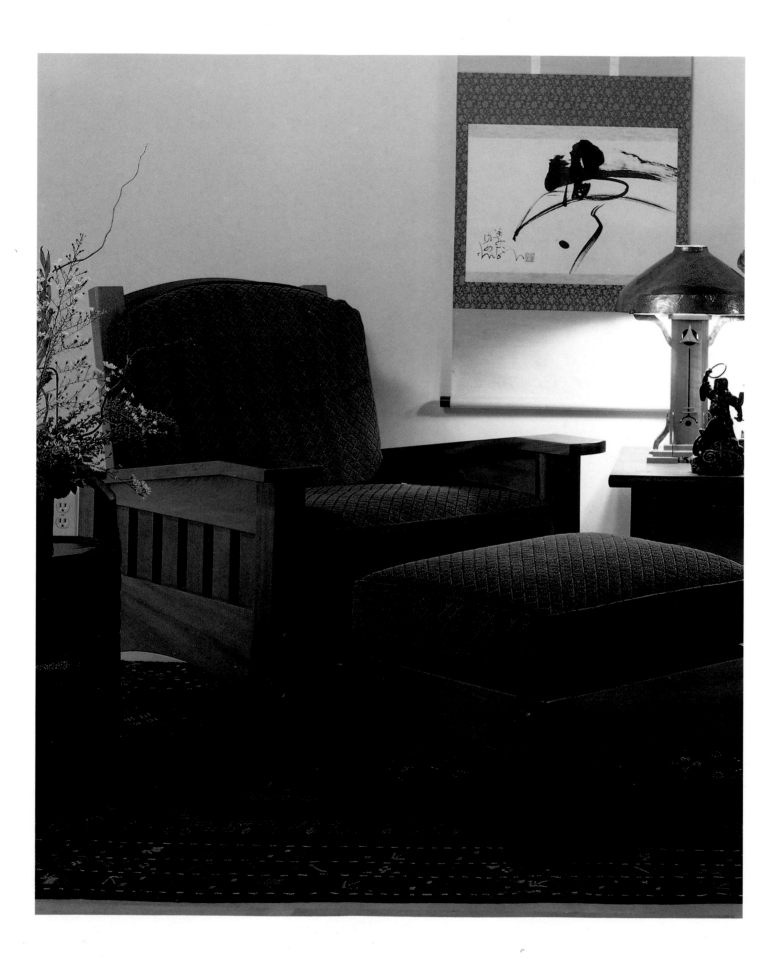

Collector's Choice

Though they evoke Greene & Greene, a Honduras mahogany easy chair, otto-man, and lamp table with mortise-and-tenon construction are modern pieces by the Berkeley Mill and Furniture Company, which also made the white maple cabinet. A lamp by Christopher Wright is made of oak with a copper shade. A scroll by Shioh Kato and bowl by contemporary California woodworker Robert Stocksdale complete by the mix.

Serious Arts and Crafts collectors must acquaint themselves with the then leading lights of furniture design and how they both influenced and diverged from the mainstream.

Although much of the Arts and Crafts furniture was severe and un-adorned, the extraordinary creations of Charles Rohlfs are proof that this was not always the case. One of the movement's more colorful characters, Rohlfs had been a successful Shakespearean actor before he married in 1884 and moved to Buffalo. There he engaged in furniture making as a hobby, turning out his first pieces for his own home. This led to orders from friends and acquaintances and eventually to worldwide fame and a custom furniture business in which he employed as many as eight assistants. Rohlfs's furniture has been described as stylistically closer to Art Nouveau than to the more severe Arts and Crafts style. A number of his pieces, such as the previously mentioned desks, rely on carving and surface ornament for their effects. However, his use of oak, mortise-and-tenon joinery, and gothic and northern European folk art motifs—as well as his philosophical point of view—are all elements that place him within the American Arts and Crafts movement.

Like Rohlfs, Arthur and Lucia Mathews, the husband-and-wife team who operated the Furniture Shop in San Francisco from 1906 until 1920, made unique pieces that represented a more varied set of influences than just the English Arts and Crafts style.

It is said that the impetus for the growth of their custom home furnish-ings business was the demand engendered there by the need to rebuild after the earthquake and fire of 1906. Their shop, which employed be-tween twenty and fifty artisans, depending on the backlog of orders, executed a great variety of work, from small accessories to complete interiors. Their furniture is considered representative of a specifically California style within the overall Arts and Crafts movement.

Furniture was among the numerous products made by the Roycroft Community, an odd mix of commercial enterprise and artist colony, orga-nized as a profit-making venture by Elbert Hubbard in East Aurora, New York. Roycroft furniture was "the most beautiful because it is the simplest furniture, and is made by artists and not by mechanics and machines,"

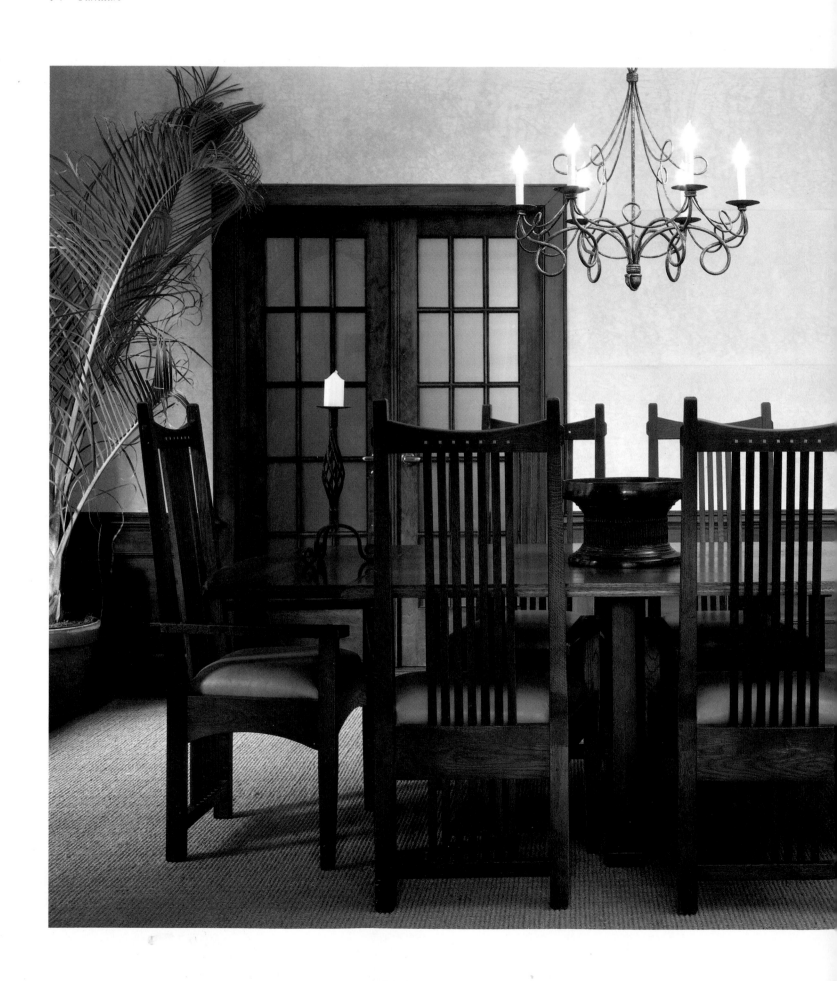

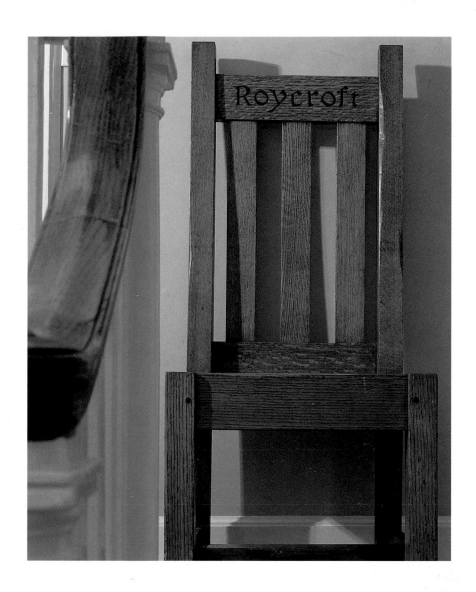

Arts and Crafts furniture makers such as Roycroft developed characteristic trademarks, above, which differentiated their pieces from others of similar design.

In a Manhattan dining room designed by Claus Rademacher Architects, left, a French Art Deco chandelier lightens overscaled Arts and Crafts-inspired table and chairs by Santa Fe artisan Randolph Laub.

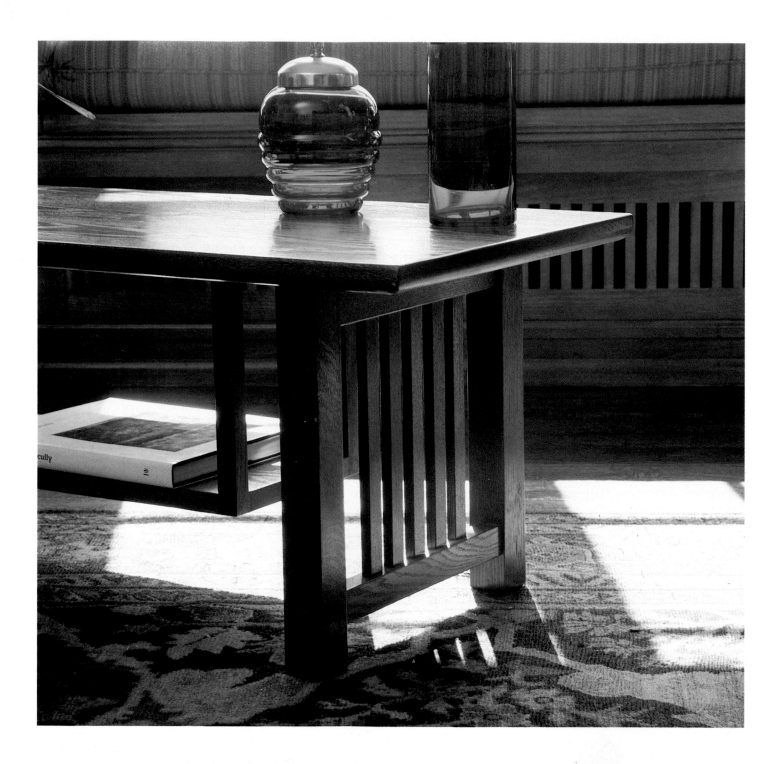

Above, a Limbert bookstand acts as a display piece for contemporary art glass.

*The design element of the tapering bracket distinguishes a signed Limbert desk, right.
The modern chair and halogen floor lamp were selected by interior designers Hilda
Langdon and Kristina Lindstrom.*

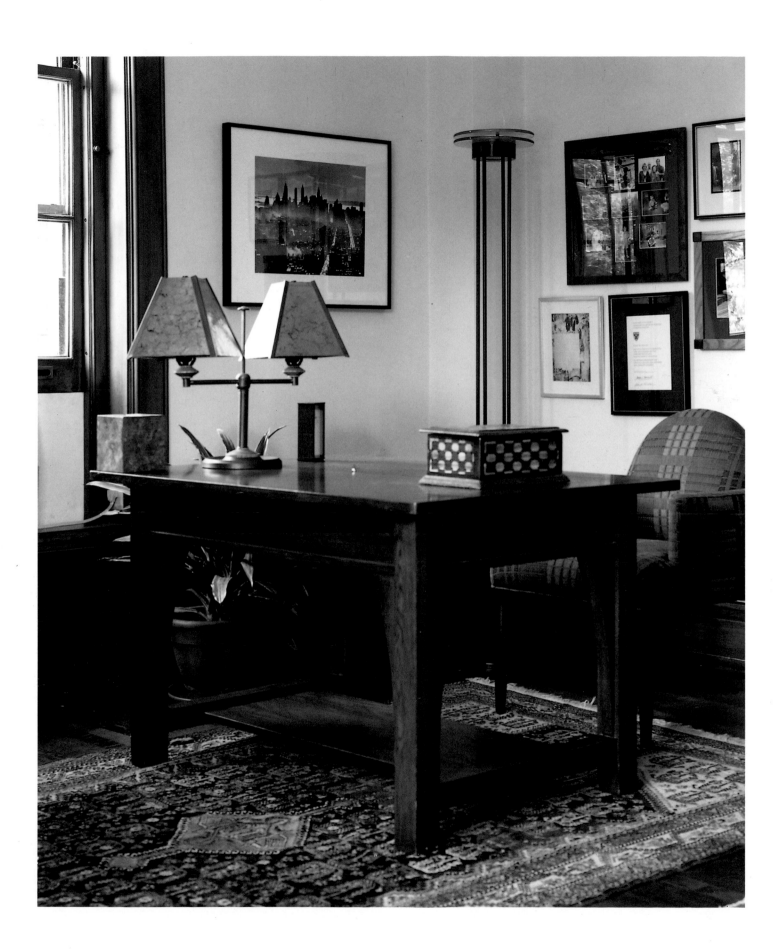

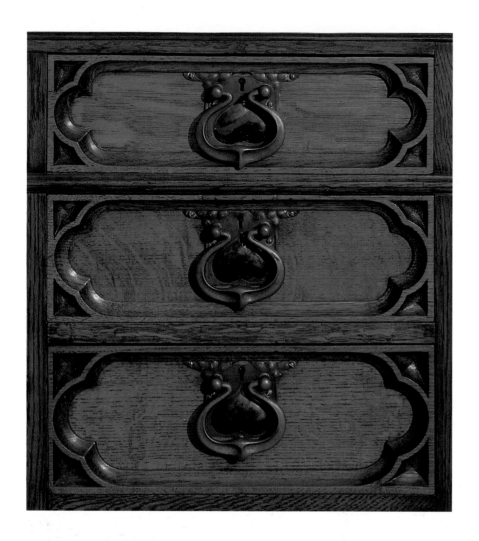

An English gothic revival desk, above, is enlivened by hardware with colorful enamel inserts inlaid like precious stones.

In a Manhattan apartment with views of Central Park, right, window seats and grille woodwork were custom-designed by Claus Rademacher Architects. Plush contemporary seating by Donghia was selected for the room by interior designers Nilda Langdon and Kristina Lindstrom.

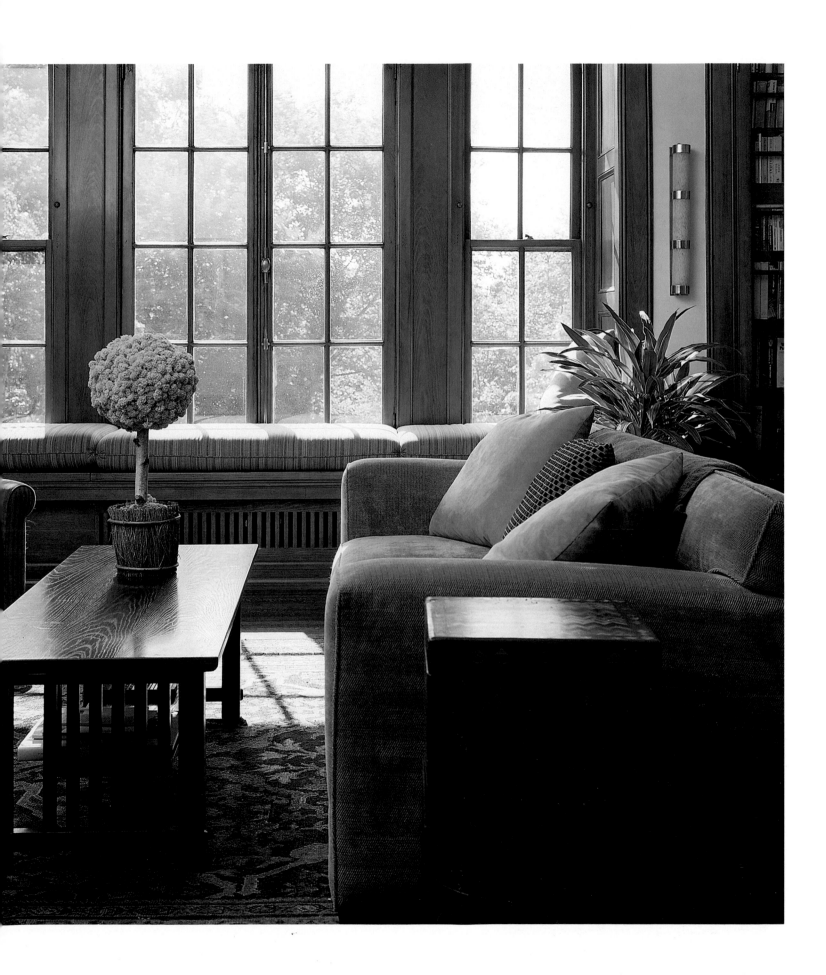

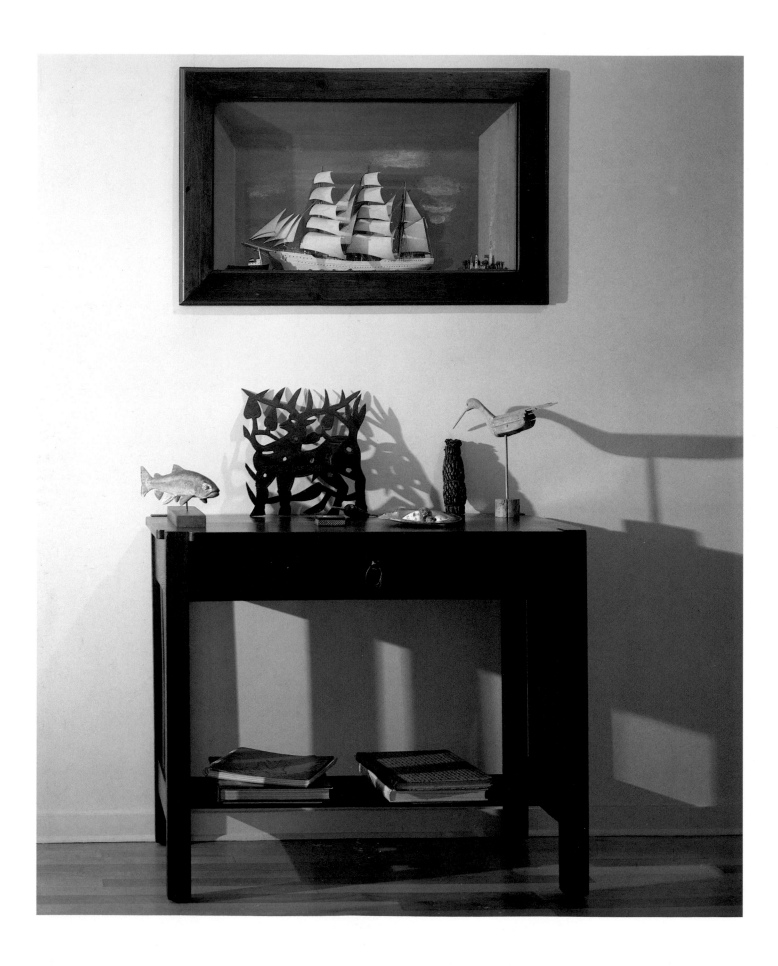

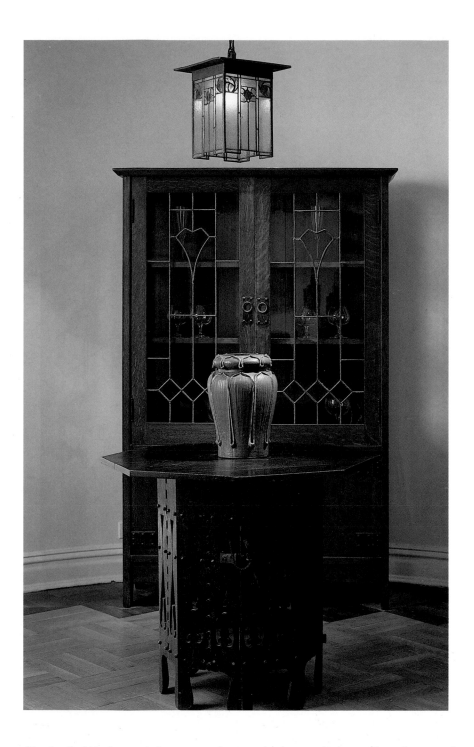

The unobtrusive quality of Arts and Crafts furniture makes it an ideal foil for extraordinary objects, left, collected by a world traveler with a special interest in the sea.

Charles Rohlfs designed this intricately carved taboret, which may have been used originally as a smoker's cabinet. A stellar Grueby vase is positioned at center. Other fine examples of the Craftsman aesthetic are the Stickley cabinet and lantern.

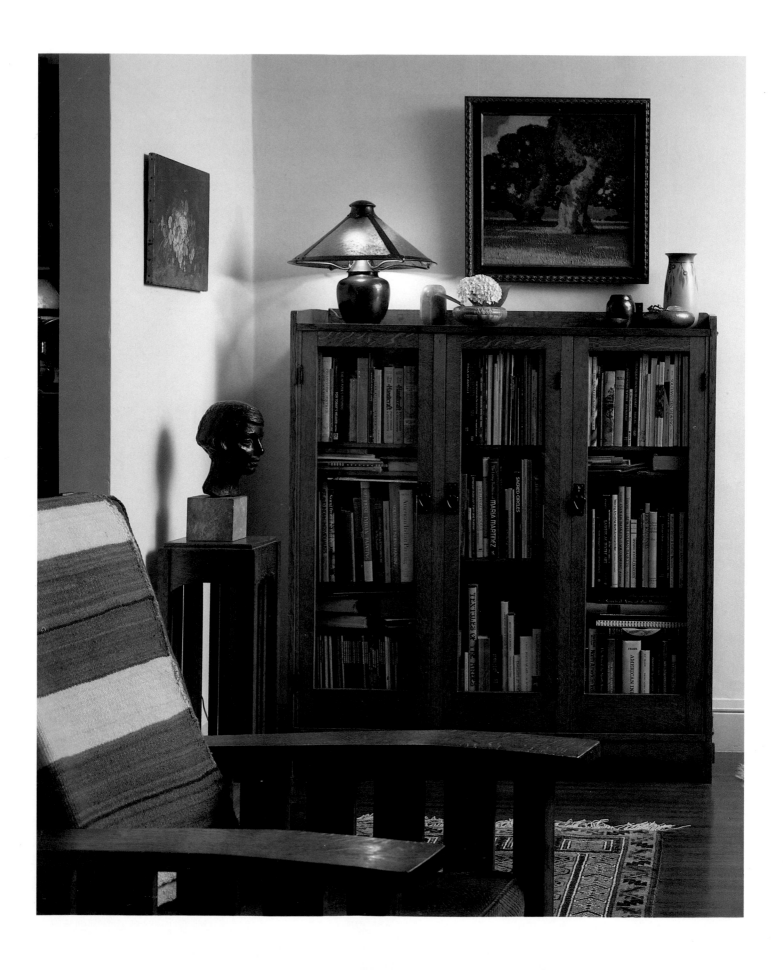

wrote Dard Hunter in a letter three weeks after joining the group. "It is solid and just what it appears to be—no shams, no veneer."

Hunter, one of Roycroft's most illustrious "graduates," went on to revive the craft of papermaking, writing a book on the subject that is still read today. While at Roycroft, he had a hand in making furniture with which the Roycroft Inn, a hotel operated by Hubbard, was furnished. The pieces were sold to tourists, who visited in droves, and after 1901 it was also marketed via mail order.

The Roycroft furniture was among the most rustic and medieval looking of all Arts and Crafts designs. Pieces such as the Ali Baba bench were designed to look as if they could have been crafted in the distant past with primitive hand tools. A characteristic bit of self-promotion, which today contributes to their charm, was the legend "Roycroft" that was prominently emblazoned across many pieces in gothic letters.

The Princeton exhibition catalogue, *The Arts and Crafts Movement in America 1876–1916*, edited by Robert Judson Clark, summarizes the importance of Hubbard and the community as follows: "Never before had mass advertising been used to make people conscious of books, simple furniture and small household items as objects of aesthetic value . . . Elbert Hubbard popularized a sincere, if sometimes plebeian, version of the ideals of William Morris."

Surviving furniture made by the Mathews, Rohlfs, and Roycroft has become highly collectible today. But even in its own time, it achieved a notoriety that placed it in a different category from the mass-produced pieces purchased by the bulk of the middle class.

No other Arts and Crafts furniture is so widely collected today as the pieces by Gustav Stickley. Stickley was unique in being able to straddle the line between the class and mass markets. He shipped his furniture to stores all over the country from his manufacturing plant in the Syracuse, New York, suburb of Eastwood. And architects such as Wright and the Greene brothers advised their clients to buy Stickley furniture if they couldn't afford architect-designed originals.

A minor manufacturer of furniture when he left on a trip to England and France in 1897, Stickley returned to his upstate New York home imbued with a new goal: To make furniture based on the needs of the present rather than copies of what he now saw as the empty forms of the

Glass-fronted bookcases are ideal to protect a library. A Morris chair gets a different look with a Southwestern textile.

past. Stickley's new designs were simple rectilinear pieces in quarter-sawn oak. They were inspired partially by the English furniture he had seen on his trip and read about in international art magazines such as *The Studio*, which published articles on the work of designers like Arthur Heygate Mackmurdo and M.H. Baillie Scott. But there were other influences at work, as well, including simple country pieces made by American cabinet-makers in the seventeenth and early eighteenth centuries and the quiet, unornamented furniture of the nineteenth-century Shakers.

While he was influenced by others, Stickley also brought his own sense of proportion and function to his new furniture, according to David M. Cathers, author of *Furniture of the American Arts and Crafts Movement*. Stickley, says Cathers, was the only designer who consistently depended on craftsmanship, proportion, and the color and grain patterns of the wood for his entire decorative effects. His pieces are free of the "eccentricity, preciousness and extraneous detail so often seen" in other furniture of the period. Stickley's early furniture is characterized by massive tenon and key construction and great simplicity. He evolved his own hardware, which included primitive-looking cast-iron hinges and brass, iron, and hammered copper escutcheon plates.

Dining room storage pieces can be beautiful as well as functional. This sideboard has handwrought hardware.

Stickley continued in business from 1900 to 1916. Over the years, his furniture gradually became more graceful. Heavy chamfered boards that served as the backs of early case pieces gave way to laminated oak panels. The mortise-and-tenon detailing appeared less frequently and when it was used the tenons were more likely to end within the mortise rather than piercing it in a keyed construction. In later work, he enhanced his furniture by matching grain patterns and by using some veneers.

Although he died less than a year after coming to work for Stickley, the architect Harvey Ellis contributed to these changes, which continued even after Ellis's death. Stickley hired Ellis, an experienced designer, early in 1903 to work on *The Craftsman* and to design furniture. Ellis's light touch, inspired, it is said, by the work of Charles Rennie Mackintosh, can be seen especially in case pieces with features such as overhanging tops, bowed sides, and graceful arching aprons, as well as in the inlaid decorations of pewter, copper, and wood.

The term "Craftsman" was coined by Stickley to distinguish his furniture from the offerings of other commercial makers who were mining some of

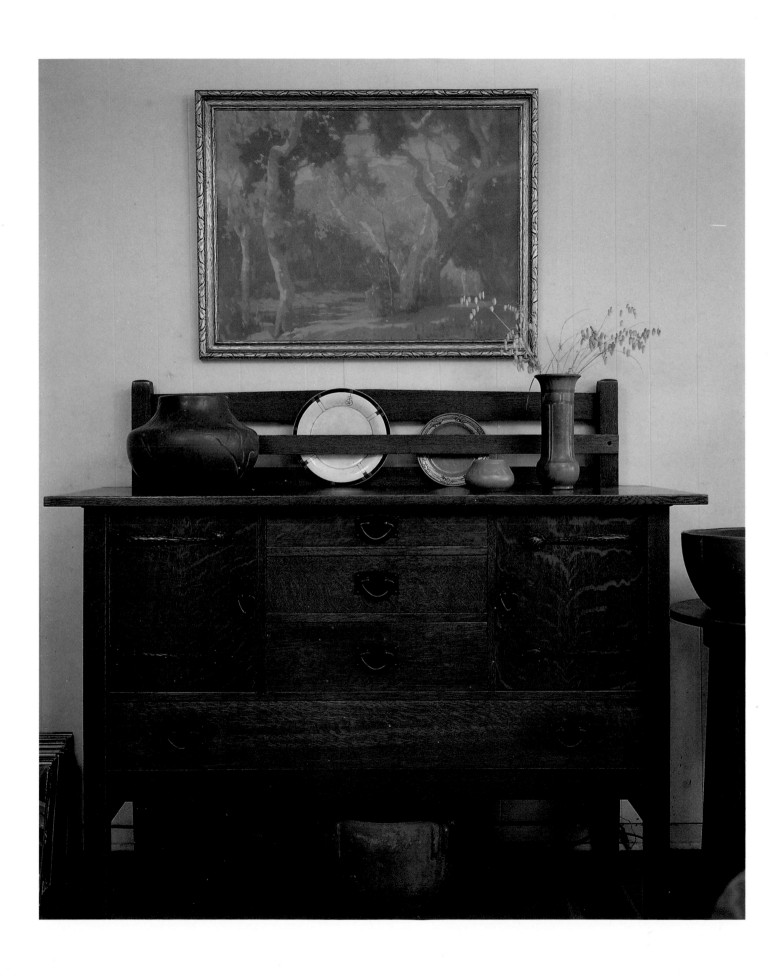

the same veins. Stickley first marketed his new Craftsman pieces in 1900 in the traditional way, by showing the line at the wholesale furniture market in Grand Rapids. The prestigious Tobey Co. of Chicago bought his designs for its retail outlet, promoting the furniture under the store's own name. In less than a year, however, he was selling his furniture under his own name, and giving Grand Rapids a wide berth. But many of the Grand Rapids manufacturers—the city, by the turn of the century, was home to at least forty furniture firms—were also offering pieces in the Arts and Crafts mold in response to public demand.

The Grand Rapids furniture went by a variety of stylistic names, including Mission, New Art, Straight Line, and Arts and Crafts, and the manufacturers gave their lines specific names such as Quaint, Lifetime, and Handicraft. The best pieces, says decorative arts historian Sharon Darling, "were characterized by straight lines, solid construction, and a dull finish." The preferred wood was white oak, fumed to a dark shade with ammonia or given a weathered grayish-brown "aged" finish, and then waxed to impart a quiet sheen. Decorative straps, hinges, and escutcheon plates of hammered brass, copper, or pewter on furniture enhanced the appearance of age and hand craftsmanship on case pieces. Similarly, sturdy cushions covered in linen or leather emphasized the rustic utility and simplicity of various models of the seating.

A glass-fronted bookcase by Gustav Stickley is complemented by a painting by Edwin Deakin. The unusual woodbasket by the fireplace features a copper lining by Dirk Van Erp, for which the owners found a wicker surround.

Also well thought of today is furniture offered by Stickley's own brothers, who were experienced furniture manufacturers and had been his partners in earlier ventures. Besides Gustav's firm, there were two other companies bearing the family name. The Stickley Brothers Company in Grand Rapids, Michigan, was organized by Albert and John George Stickley in 1891. By 1897, Stickley Brothers had established a London showroom and factory, where parts were assembled into furniture for sale in England. L. and J. G. Stickley, organized by Leopold and John George Stickley, was located in Fayetteville, New York, and opened in 1902. That firm produced Mission-style oak furniture under the Onondaga Shops label.

The furniture of the Charles P. Limbert Company has survived to be highly collectible today. Besides his Dutch Arts and Crafts case pieces, seating, occasional furniture, and lamps, Limbert also marketed a line of rustic seating with frames of hickory branches with the bark left on and

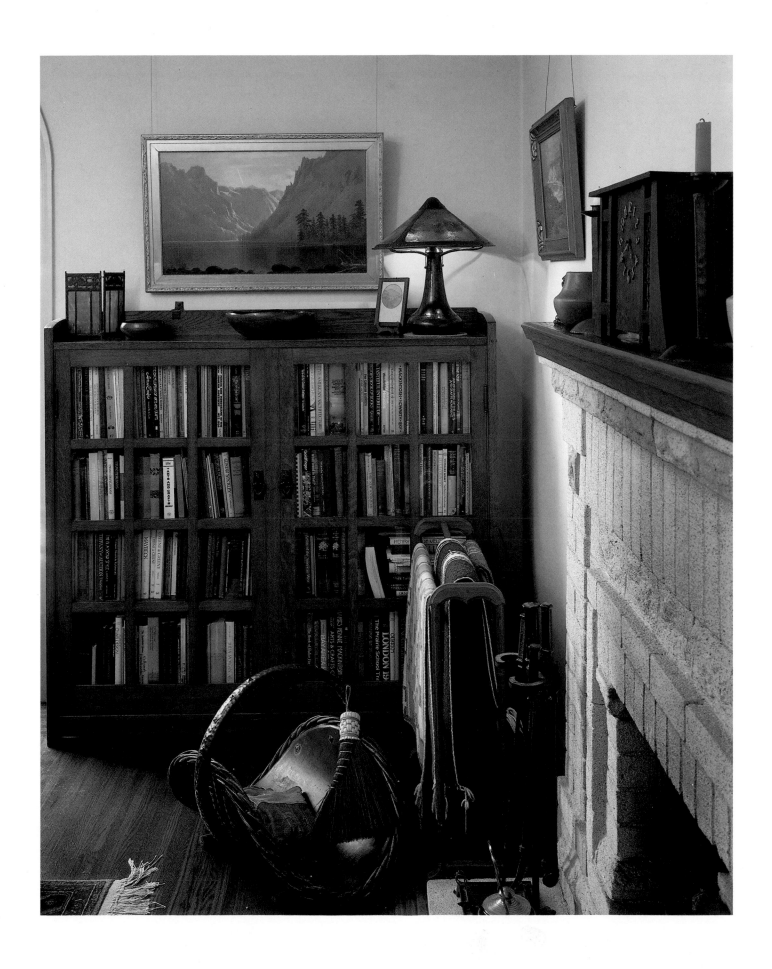

seats and backs woven of strips of inner bark. But the Limbert case pieces have the characteristic exaggerated mortise-and-tenon detailing. Other features of Limbert pieces include tapering sides, square and oval cutouts, and butterfly wedges.

Inevitably, some versions of so-called Arts and Crafts furniture had little in common with the original idea. The style was as amenable to vulgarization as any historic revival style, it turned out, and "Morris chairs" with claw feet, lion's head arms, and machine-stamped ornamentation filled the stores and the pages of mail-order catalogues. In short, some copies were everything that the reformers were protesting against.

Taken as a whole, the furniture of the Arts and Crafts movement is richly varied. Though pieces vary widely in quality, each represents an aspect of the movement that changed the way we approach home design today.

The quiet dignity of this small-scale dropfront desk makes it a marvelous focal point at the end of a sunny corridor in a country house.

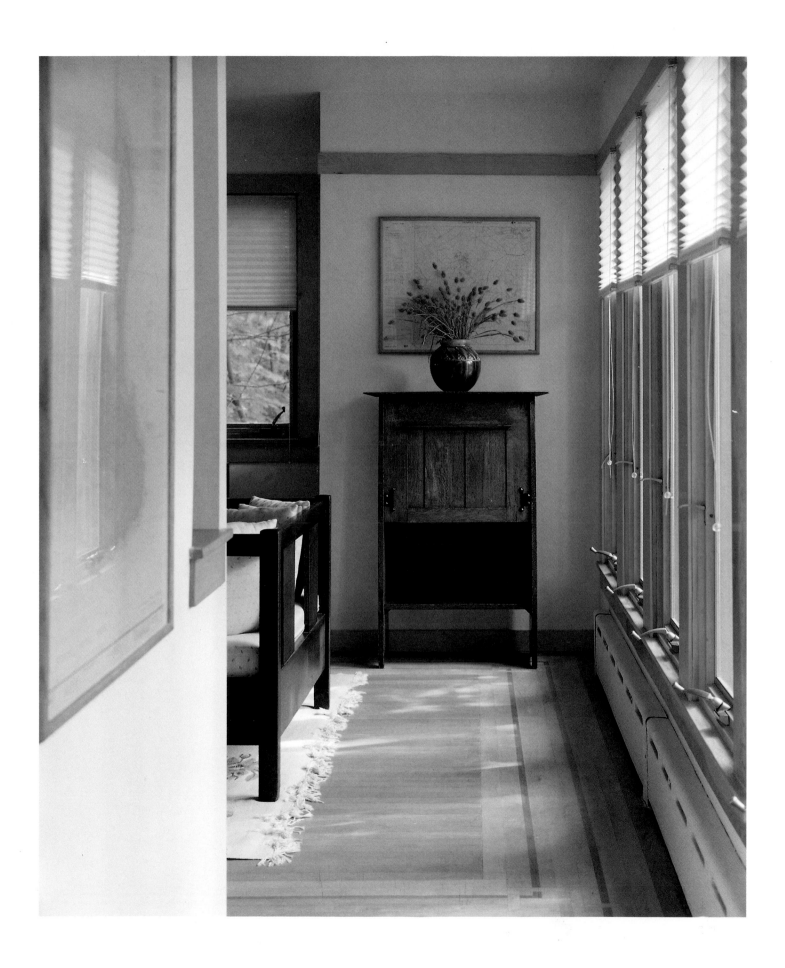

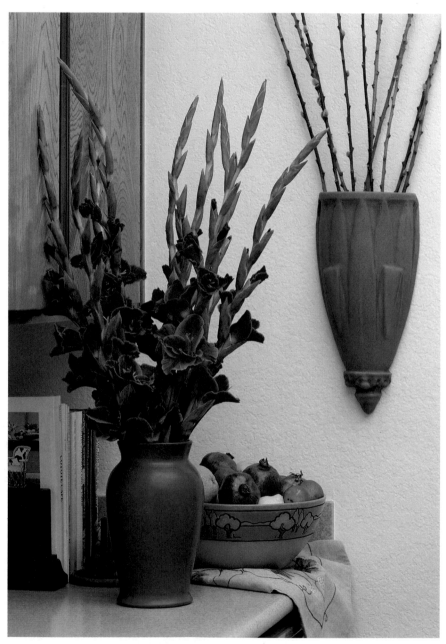

Art pottery makes a bold statement wherever it is displayed—even in the kitchen.

Chapter Four

OBJECTS AND ACCENTS

The architectural critic Reyner Banham has made an interesting point about what he considers the undeserved reputation of Arts and Crafts interiors for being dark and gloomy. This erroneous idea comes, he says, "from the fact that the once-mellow radiance of wood tones lost the jeweled highlights of copper, brass and embroidery" when the accessories were removed. Leaded-glass lighting fixtures, polished silver vases, and ceramic artwares also added an essential vitality. Where interiors are complete, as in the Gamble house, in Wright's fully restored masterpieces, and in modern rooms assembled by collectors today, the style finds pure expression and is warm and livable.

The Crafted Home

❧ The Arts and Crafts aesthetic invested even humble forms of decoration with a quiet richness. To beautify their rooms, homemakers could choose from a wide array of accessories, such as copper fireplace hoods, hand-forged iron fireplace tools, leather umbrella stands and buckets, and colonial American artifacts. Patchwork quilts, Russian peasant embroidery, handwoven Irish linen doilies, and the hand-embroidered work of the mistress of the house were all proposed as alternatives to mass-produced fabrics and accessories.

American Indian crafts, including rugs, baskets, and Navaho blankets, were a favorite accessory in Arts and Crafts homes. These objects were highly valued both for their natural, raw materials and their associations with a romanticized American past. Indian baskets, both originals and copies by enthusiasts who could study the craft in a wide variety of classes, were employed as waste paper buckets, letter trays, sewing baskets, and as purely decorative containers on tables and mantels.

In the Arts and Crafts era, there were also important departures from the past in the design and manufacturing techniques of lighting, architectural metal, silver vessels and flatware, ceramics, and printing and bookbinding. With such a rich array of objects to choose from, the contemporary collector can assemble inspired settings in the Arts and Crafts style.

On the landing of a two-story loft, a Greene & Greene library table displays a lamp in period character. A framed photograph by Dr. Ben Mirman brings a touch of the classical—in the form of Michelangelo's "David"—to the Arts and Crafts interior.

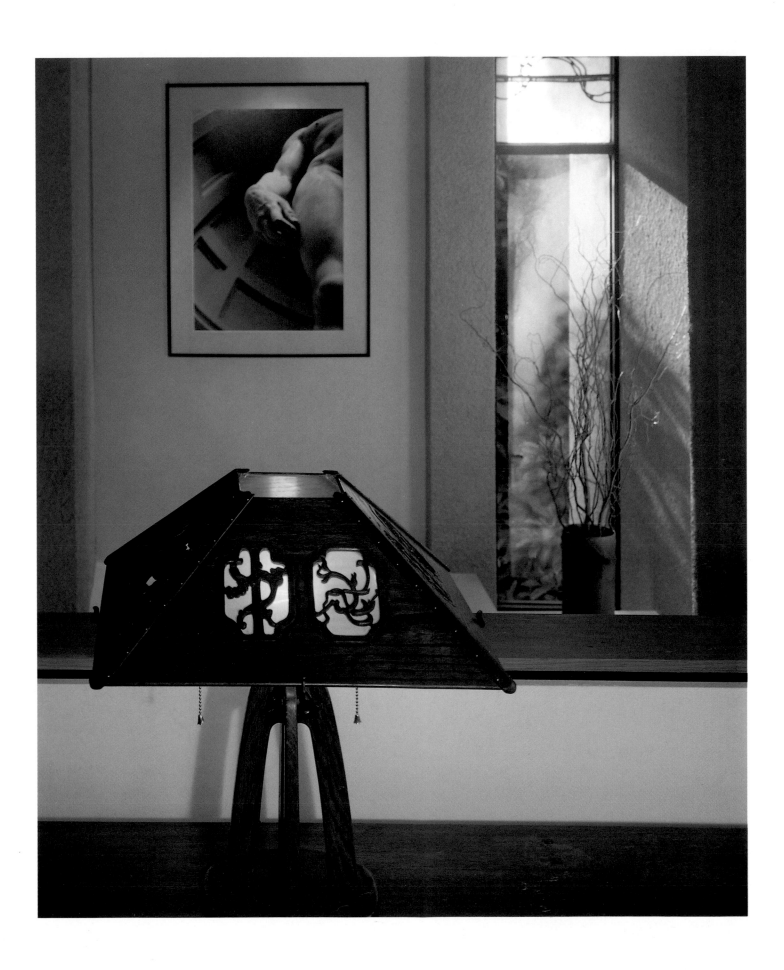

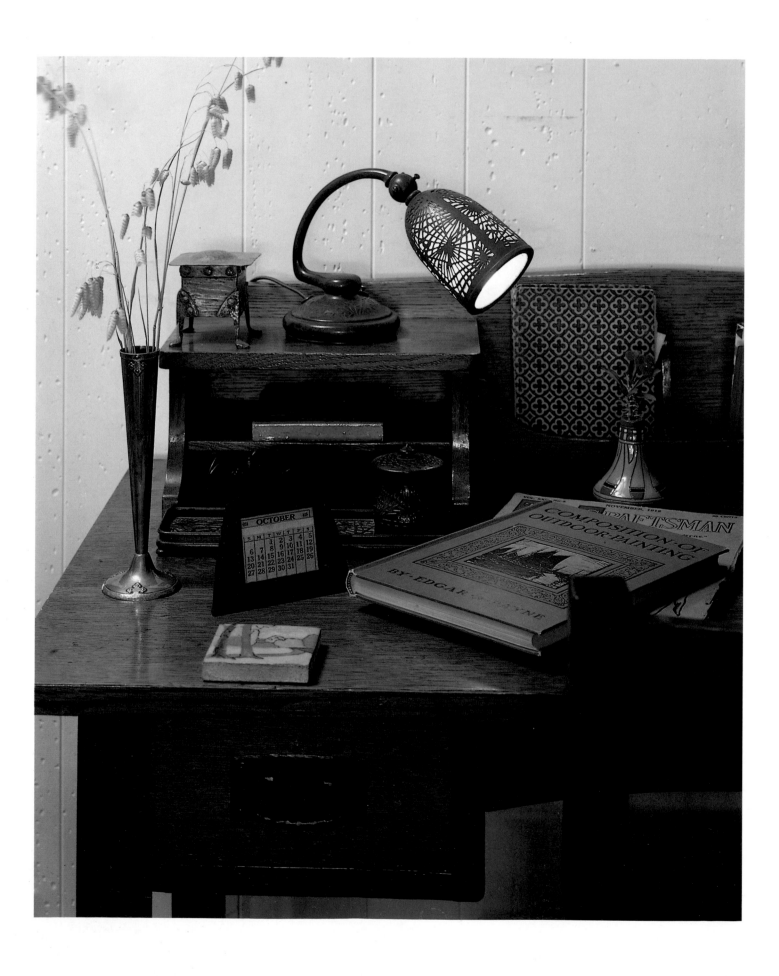

Details of Design

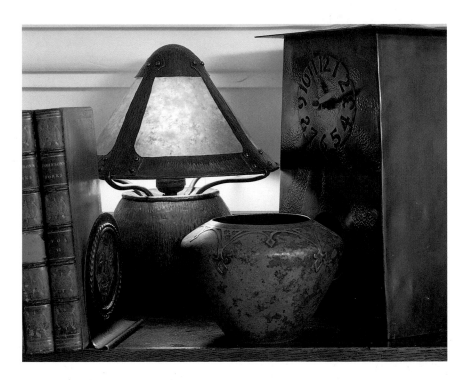

Right, authentic Roycroft leather-backed bookends portraying the faces of tragedy and comedy lend an air of authenticity to a reproduction lamp.

Desk accessories from another era are the finishing touches in this den, left.

∾ *Lighting* Incandescent electric lighting was introduced in 1879, when Thomas Edison made the first practical incandescent light bulb. The innovation of the electric light worked its way down to become one of the middle-class domestic comforts over the next several decades. In fact, by 1902, twenty years after the first lighting system came into being in New York City, there were 3,600 power companies operating in the United States. The elimination of the need for oil reservoirs, gas pipes, and dangerous open flames inspired designers with new ideas for lamps and lighting fixtures.

Louis C. Tiffany's brilliant Art Nouveau lamps complemented Arts and Crafts furnishings and were popular with those who could afford them. One line of lamps paired Tiffany shades with ceramic bases by the Arts and Crafts pottery firm of Grueby & Co. Besides the originals by Tiffany himself, there were many look-alikes available from other sources at somewhat lower prices.

Gustav Stickley, the Roycrofters, and some of the Grand Rapids furniture companies also designed and marketed fixtures and lamps. These lights combined ceramic or oak bases with stained-glass or mica shades and

In a book- and record-filled dining room, an oversize wood carving by Charles Sumner Greene depicts the boatyard of Carmel, California. On the dining table, a Dirk Van Erp kerosene lamp is actually in use.

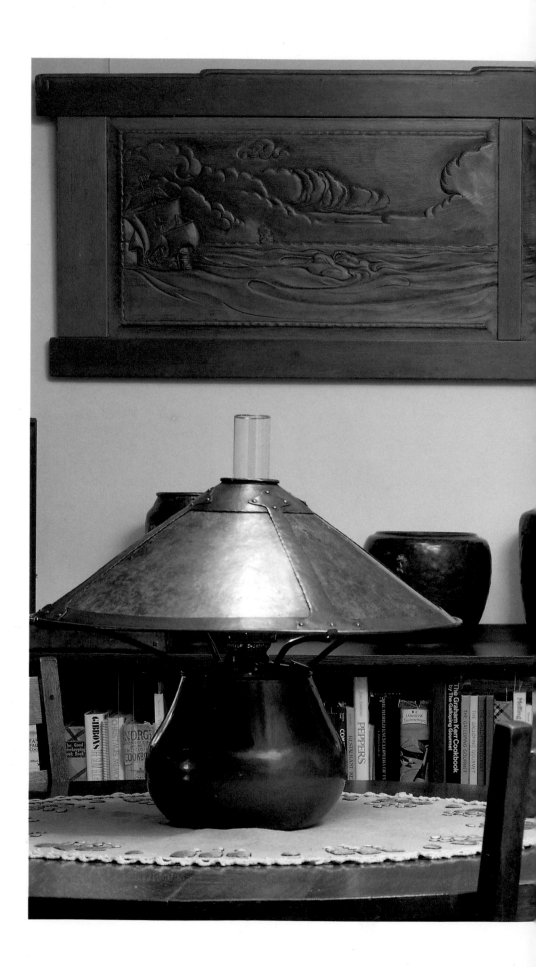

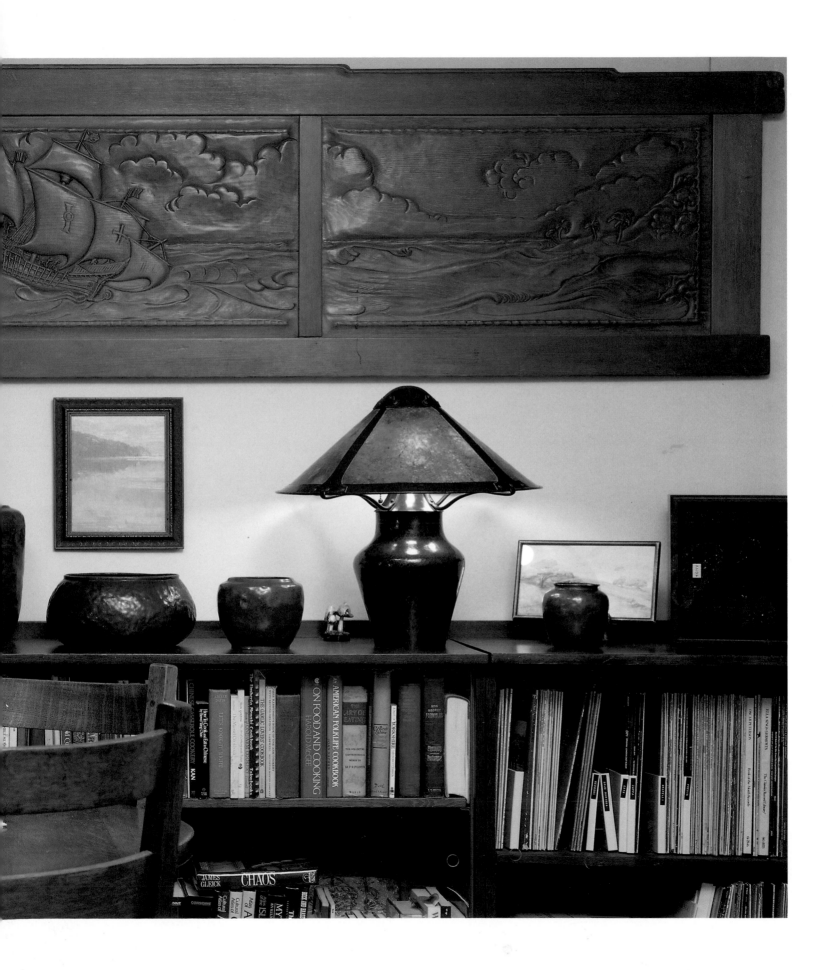

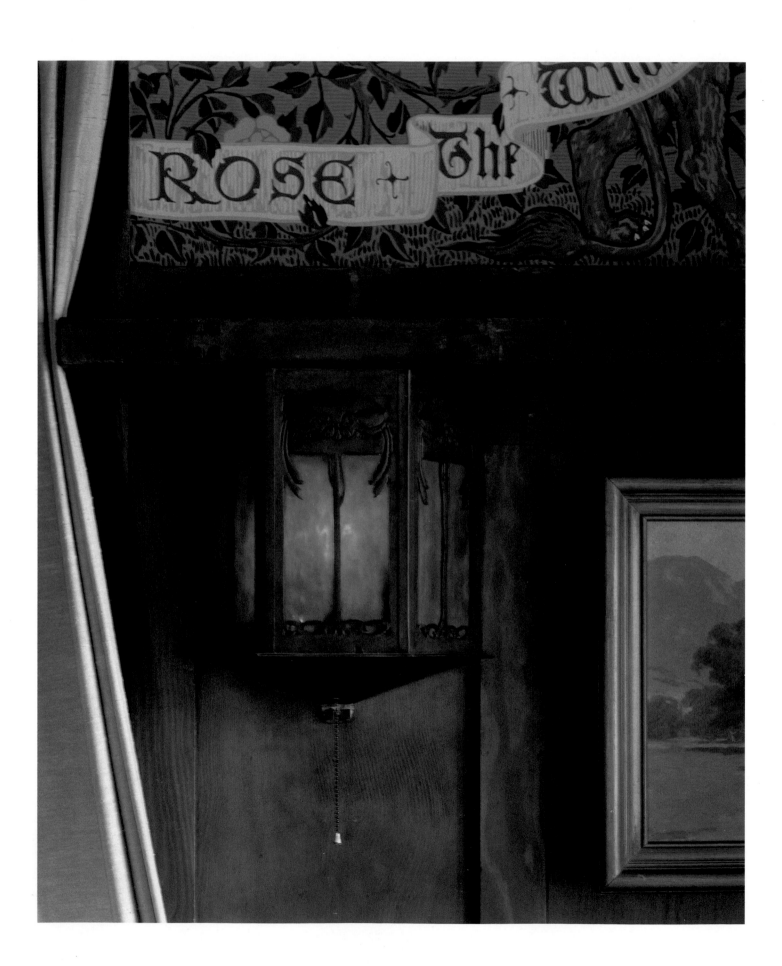

During the Arts and Crafts era, printed mottoes were commonly applied to textiles and directly on walls. The detail, left, is a reproduction of a Walter Crane design for Bradbury and Bradbury.

Right, stained-glass windows, an impressionistic landscape painting, a floor lamp with an art glass shade, and large pottery urns all attest to this home owner's love of the aesthetic.

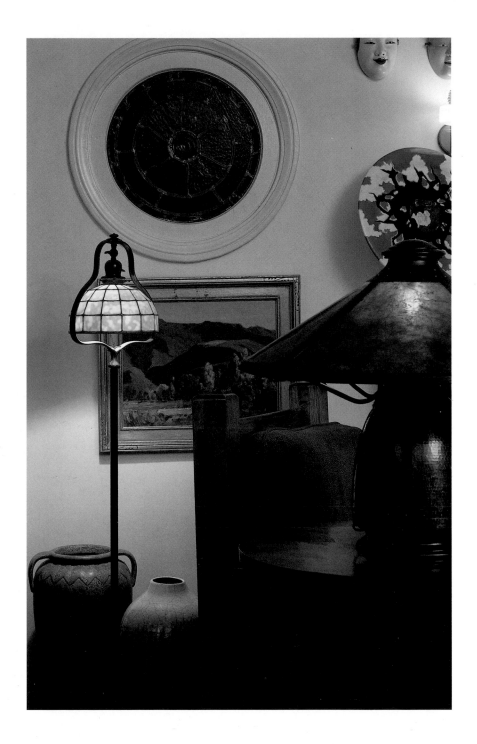

iron, copper, or brass hardware.

Architects such as Wright and the Greene brothers designed custom lighting. Wright, in particular, preferred indirect lighting because of its tranquil effect. He often hid the light bulb behind a translucent screen, one of rice paper or art glass panels, to create a soft glow, which he felt duplicated nature. Wright sometimes added a wooden grille (as in his own Oak Park dining room, described in Chapter Two) for the decorative

effect. As early as 1898 in the Robie House in Chicago's Hyde Park, he employed a rheostat to permit control of light in the living room and dining room, according to David Hanks, author of *The Decorative Designs of Frank Lloyd Wright*.

The work of serious craftsmen was also pictured in national magazines and marketed to a wide clientele. These craftsmen included Robert R. Jarvie of Chicago, who made candlesticks and lanterns in brass, copper, and bronze, as well as silver hollowware and trophies, and Dirk Van Erp of San Francisco, who made lamps and accessories. Van Erp's lamps, which consisted of hammered copper bases and shades of translucent mica (also called isinglass) treated with shellac to give them an amber cast, are today among the most celebrated Arts and Crafts objects.

This coppersmith, who emigrated to the United States from Holland and settled in the San Francisco area, exemplifies the Arts and Crafts ethos. He arrived at his extraordinary handmade designs, which were executed with consummate workmanship, through a slow process of trial and error. Van Erp crafted his early copper pieces from shell casings that he brought home from the Mare Island Naval Shipyards, where he worked. At first, he gave these away to friends; he later sold them through craft shops and fairs. The positive reception to them encouraged him to give up his job and to open the Copper Shop in 1908. The lamps that he began to market around 1911 achieved an almost immediate success.

Ceramics Arts and Crafts ceramics were specifically created to complement the style's architecture and furniture. The simplification noted in the other decorative arts also applied to this medium. Conventionalized abstractions of floral and vegetative patterns began to replace the traditional realistic depictions of nature on the surface of tiles, vases, lamp bases, and dinnerware. The very shape of containers changed so that many resembled abstract plant stalks, the color of celery. Ceramists began to consider the ceramic object as an organic whole, in which both shape and surface worked together.

One of the first companies in the United States to develop a line of art pottery in addition to its utilitarian wares was the Chelsea Keramic Art Works of Boston, organized by James Robertson. Robertson had emigrated to the Boston area from Scotland in 1859 and secured employment

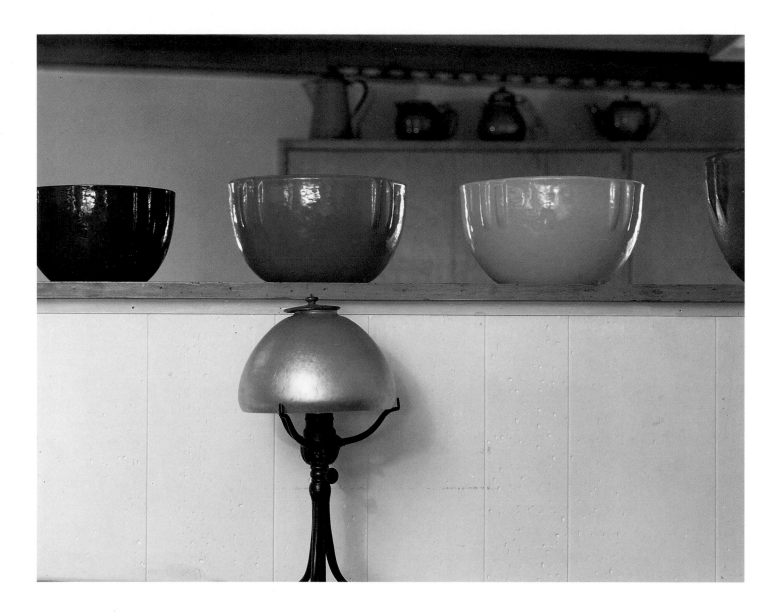

in the ceramics business. He was the fifth generation in a line of potters. The family firm was established in Boston in 1865 and was restructured in 1872 to include Robertson's sons, Hugh and Alexander. Though tiles were the senior Robertson's specialty, it was Hugh Robertson's contribution that is best remembered. He was the first American potter to treat pottery glazing as an art form in its own right, says Elaine Levin, author of *The History of American Ceramics*.

Hugh Robertson developed a number of beautiful glazes: deep sea green, apple green, mustard yellow, and turquoise. But it was his red glaze—which duplicated the Chinese *sang de boeuf*, or oxblood glaze—that was and is most highly valued. Four years of somewhat obsessive experimentation to the exclusion of other pursuits resulted in the firm's bank-

Varied combinations of textures add interest to period interiors. Gorgeous, shiny glazes are colorful counterpoints to textured, low-gloss surfaces.

ruptcy in 1889. Robertson was given a reprieve when wealthy backers set him up as manager of the Chelsea Pottery—later called the Dedham Pottery when the company moved to that Massachusetts city. It was at Dedham that Robertson perfected distinctive dinnerware with a crackle glaze and a handpainted border. One of the most famous Dedham patterns, avidly collected today, features a cheerful border design of plump rabbits who appear to be chasing one another in a circle of merriment.

The development of overglaze and underglaze painting techniques was another landmark that helped free American pottery from the Victorian decorative excesses into which it had fallen. International expositions served as the catalyst for these new developments. As in architecture and furniture construction, Americans eagerly sought to catch up with the rest of the world. After viewing virtuoso displays of Chinese glazes and French china painting at Philadelphia's 1876 International Centennial Celebration, many ceramists—including Hugh Robertson and Mary McLaughlin, an important Cincinnati ceramist—threw themselves into experiments to discover the secrets of the wares they admired.

Abstract botanical patterns on textiles and pottery are pleasingly harmonious. Floral and leafy motifs were almost always "conventionalized" rather than represented realistically in this aesthetic.

Although technical advances were closely guarded commercial secrets in Europe, Americans were often generous in sharing their knowledge with others. McLaughlin experimented with underglazing techniques, for example, and announced her discoveries publicly, which led to a rash of articles in magazines of the day and to amateur china painting classes.

The transformation of hobbyist into professional was another general pattern that was important in Arts and Crafts ceramics. The Rookwood Pottery, which became a highly successful ceramics company, had its origins as an amateur pottery club. Founded in 1880 by Maria Longworth Nichols, a wealthy society woman in Cincinnati, Rookwood attracted attention because its leader and many of its workers were women and because it was promoted as a business that subordinated profit to artistic expression. Although the amateur and art angles made excellent copy, Rookwood soon became a sophisticated enterprise under the able management of William Watts Taylor, who was hired as general business manager in 1883. Taylor had a three-point plan for making Rookwood a household name: standardize the product line, market products through fashionable stores, and offer what people wanted, as determined by market surveys. He promoted the idea of collecting the firm's wares and

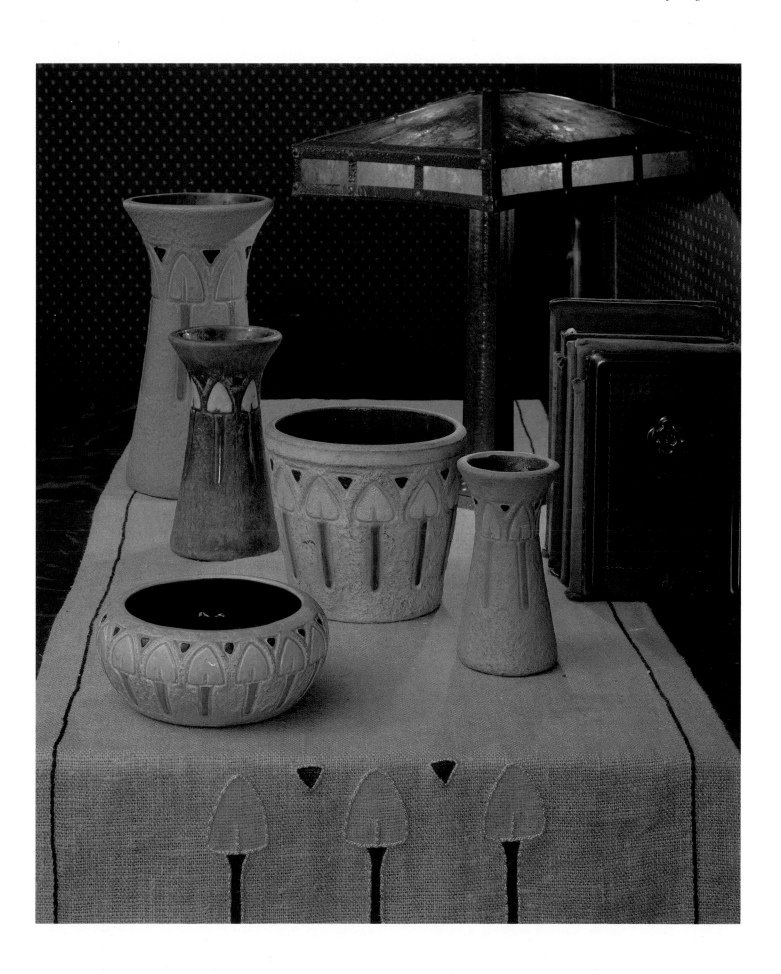

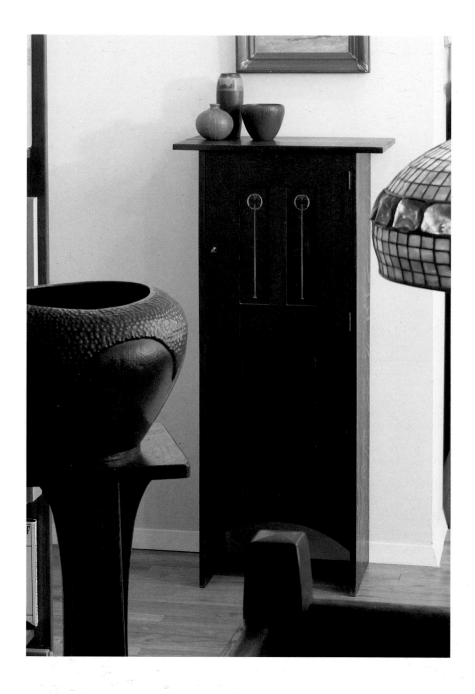

Left, the large hand-hammered acorn-shaped bowl is believed to be the work of Dirk Van Erp. These vessels remain as sought after today as in his own time.

Along with clocks, art photographs—particularly those depicting Native Americans—capture the simple yet powerful imagery of the movement.

published information on the artists to keep the public interested. He also provided star employees with travel perks and scholarships. Rookwood, for example, awarded ceramist Artus Van Briggle a three-year stipend to enable him to study in Paris.

William Grueby was another innovator in the Arts and Crafts mold. A practicing ceramist, he became fascinated by the matte glazes he saw on French pottery exhibited in Chicago at the World's Columbian Exposition in 1893. He returned to Boston, opened his own business, and experimented for five years in order to perfect his own matte glazes, which he

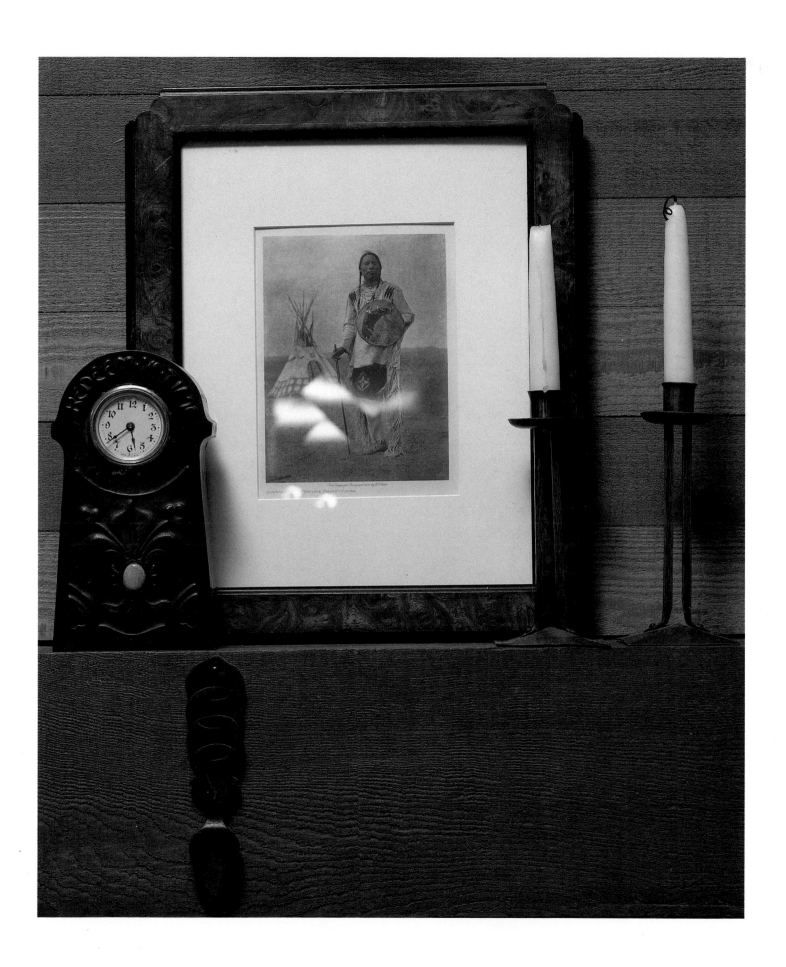

introduced on vases in 1898. Grueby perfected a variety of colors, including yellow, aqua, and pink. But it was the Grueby green—a rich, multi-hued glaze that has been compared to the variegated green on some varieties of watermelon—that became a sensation.

Gustav Stickley was one of Grueby's admirers. Stickley not only collaborated on joint exhibits of his furniture and Grueby's pottery at trade fairs, he also frequently showed the Grueby vases and lamps in his magazine. The result was that Grueby's designs were widely copied, with mass-produced versions being offered at lower and lower prices. Financial problems led Grueby into bankruptcy in 1909, although the company was reformulated and continued to make tiles and architectural ceramics for more than ten years after that.

Another important name in matte-finished ceramic vases was Teco. William D. Gates founded the American Terra Cotta and Ceramic Company in 1886 in Terra Cotta, Illinois, near Chicago, in order to produce architectural tiles, which were in great demand. Gates later developed matte-glaze vases in classic architectural shapes, which he marketed under the Teco trade name. As a member of the Chicago Architectural Club (he also served as president of the Chicago Arts and Crafts Society), Gates called on fellow group members, including Wright and George Grant Elmslie, to design Teco shapes. However, the majority of Teco shapes were designed by Gates and his designers.

Though it had been in operation since 1805, Fulper Pottery—now avidly sought after by collectors—didn't create their wares in the Arts and Crafts style until 1910. Once they did get started, however, they quickly produced an enormous amount of pottery, inexpensive at the time. Their Vase-Kraft lamps, billed as "Art pottery put to practical uses"—borrowed the form of the more costly art-glass-shade lamps, but they used ceramics for both the base and the shade.

It is said that the disastrous Chicago fire of 1871, which destroyed so many wooden buildings, greatly encouraged the use of fireproof tiles in the new buildings erected after the blaze. Whether this is true or not, tiles were immensely popular in Chicago and also throughout the United States. They were used as decorative borders for walls, in flooring, for fireplace surrounds, and in myriad other ways, including interior and exterior trim for public buildings and residences.

Furniture sets the stage for the Arts and Crafts interior, but it is really the objects that make a comfortable home. In an Adirondack-style residence designed by the architect Jeremy P. Lang, a Dirk Van Erp lamp and copper tray and candleholders adorn the oak tabletop.

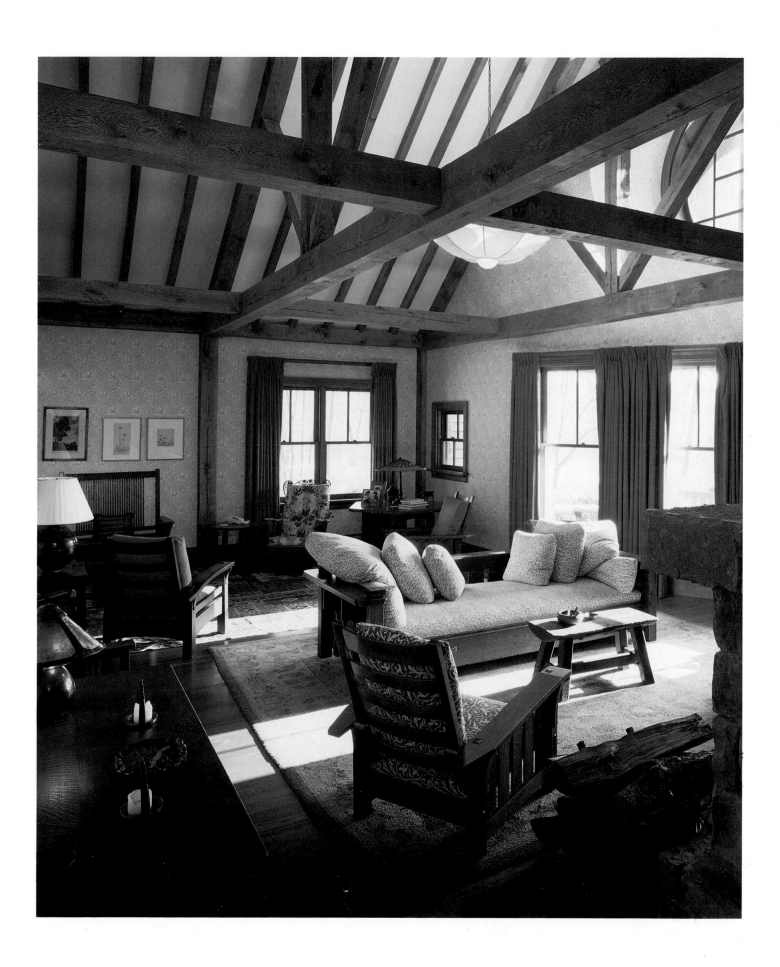

A rich variety of styles was introduced, ranging from early English and Pennsylvania German motifs in the work of Henry C. Mercer's Moravian Tile Works in Doylestown, Pennsylvania, to California flora and fauna, represented in tiles made by Ernest Batchelder in Pasadena. Batchelder's tiles were so popular with California architects, including Charles and Henry Greene, that author Elaine Levin says they adorned almost every home constructed in Pasadena between 1910 and 1928.

The movement's interest in social betterment schemes was carried out in a number of well-known ceramics enterprises. The Newcomb Pottery was organized by Sophie Newcomb College (a part of Tulane University) in New Orleans as a practical training program for young women. A program in Boston that originally went by the name of The Saturday Evening Girls and later was known as Revere Pottery gave young female immigrants training and employment. The principal output of the operation, Revere dinnerware and children's breakfast sets, enjoyed brisk sales for a short period. Though the enterprise lasted twenty-four years, it was never a commercial success. Marblehead Pottery of Marblehead, Massachusetts, and Arequipa Pottery in Marin County, California, both started as art therapy programs.

Making a profit and doing good are very often incompatible, as the stories of Marblehead and Arequipa amply illustrate. Marblehead was actually a hospital, and Dr. Herbert J. Hall decided to begin a pottery program there to offer diversion to patients in the sanitorium. The ceramist Alfred Baggs, who was hired by Dr. Hall to run the Marblehead pottery, soon found that the work was too taxing for the patients. Thereafter, the pottery was detached from the sanitorium. Baggs, a talented potter who went on to become an important educator in ceramics, turned it into an independent, profit-making operation. By 1908, it was producing two hundred matte-textured vessels per week, many in the signature color "Marblehead blue."

A similar chain of events took place on the other side of America. The potter Frederick Rhead was hired by Dr. Philip King Brown to run Arequipa Pottery. Problems soon arose, however, when Rhead began to hire outside help: the work of patients suffering from tuberculosis simply didn't meet his standards. Rhead was soon forced to resign, and his successor recast Arequipa along more modest therapeutic lines.

Even in the garden, the Arts and Crafts aesthetic finds expression. This lantern, by contemporary metalworker Tony Smith, features pagodalike overhangs and stained glass.

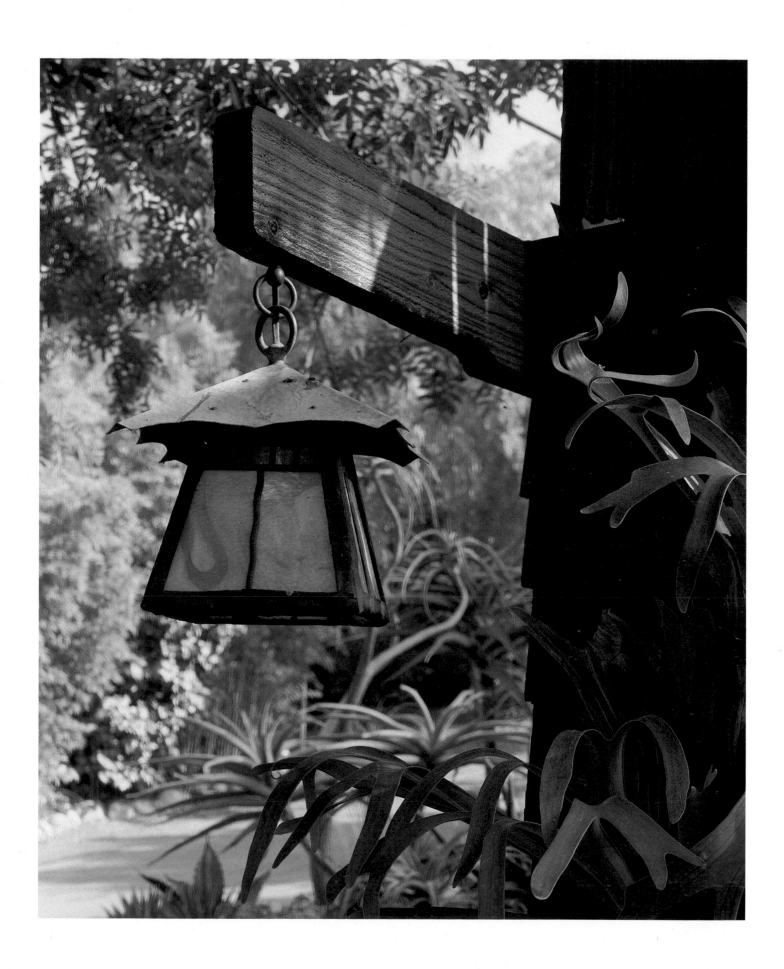

Especially in the field of ceramics, a number of successful ventures were run by women, many working in a highly individual way. There was the nationally renowned tile producer Pewabic Pottery, which was founded in Detroit in 1903 by Mary Chase Perry. Mary McLaughlin—the great Cincinnati competitor of Rookwood founder Maria Longworth Nichols—installed a kiln in her backyard and experimented with porcelain and glazes, reportedly much to the annoyance of her neighbors. She achieved international recognition for her work. Adelaide Alsop Robineau was also known throughout the world for her perfection of the technique of incising or carving porcelain.

Ceramists were undoubtedly among the most interesting, and unforgettable, personalities of the Arts and Crafts movement. The quintessential loner of the era was George Ohr, a native of Biloxi, Mississippi, who taught himself to throw pottery on a wheel and perfected his knowledge of ceramics in a two-year odyssey during which he visited potteries around the country. Ohr returned to Biloxi in 1883, built his own pottery, and began to market his work at local fairs. He advertised himself as "the greatest potter in the world" and marketed his work with bucolic flare, as follows: "The potter said un 2 clay, 'Be Ware' and it was."

Ohr deliberately cultivated a buffoonish presentation, which today is seen as a self-protective mechanism for coping with the world's lower estimation of his work compared to his own sense of its worth. It is said that he would suffer a change of heart as soon as he sold a piece, running after departing buyers who hadn't been put off by his high prices to demand that they return his work. This habit led to a saying in Biloxi: "Only the fleet own George Ohr pottery."

Ohr's feats at the pottery wheel are still considered virtually unequalled. His individualistic, ruffled, creased, pinched, and wrinkled shapes—ornamented with thin strips of clay twisted into handles and odd bits of decoration—were not greatly appreciated in his own day. However, his extraordinary glazes, which ranged from mottled tortoise shell to metallic pewter and black tones, were greatly admired.

He responded to ridicule by selling his serious pieces only reluctantly, and in 1906, he closed his pottery and put six thousand of his pieces in storage, where they remained almost, but not completely, forgotten. In 1972, a New York antiques dealer named James W. Carpenter purchased

Although this fireplace has a contemporary feeling, the andirons and fireplace tools are in the Mission style. On the mantel, unglazed, striated pottery is signed "Niloak," and was made in the Southwest at the turn of the century.

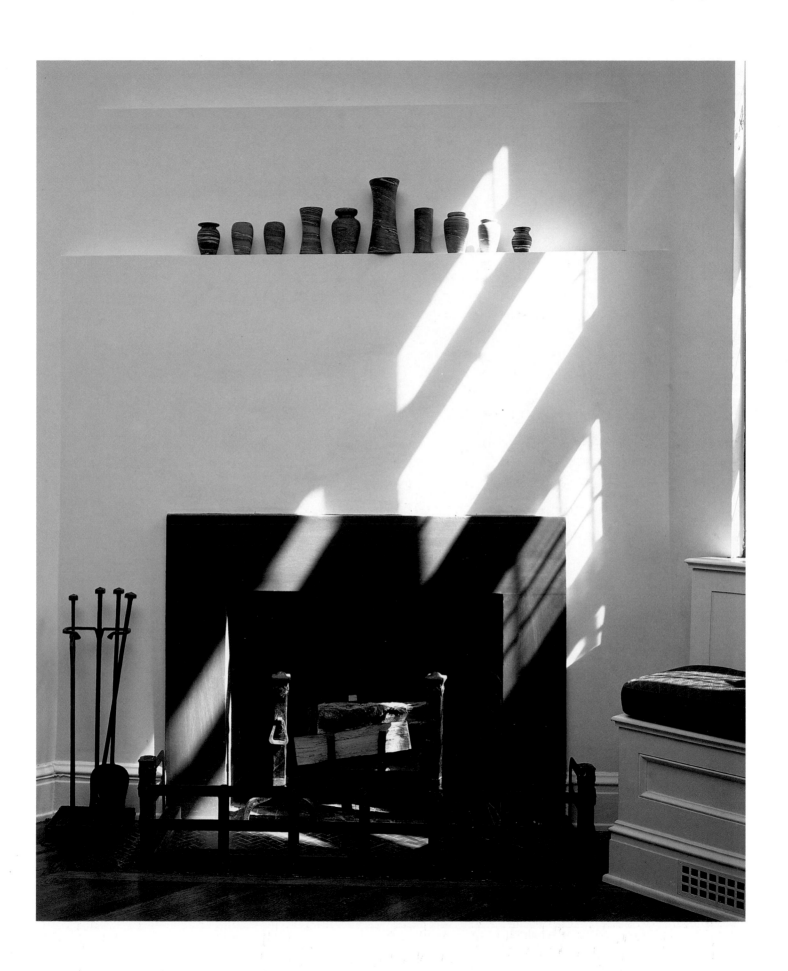

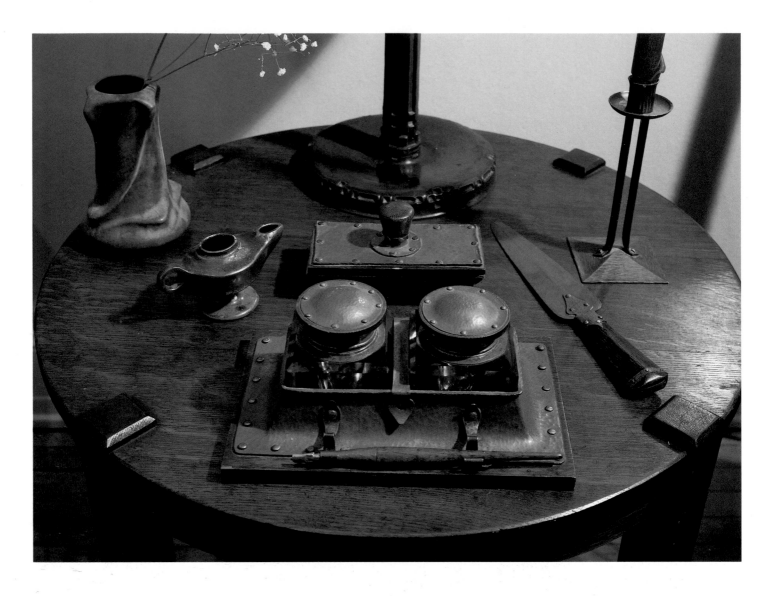

Above, a durable Arts and Crafts double inkwell, letter opener, and candlestick are still actively used by their owners. Strong hinges, copper and brass escutcheons, and a minimum of decoration characterize metalware of the era.

In this pleasingly simple composition, right, an Art Nouveau frame works surprisingly well with a turn-of-the-century landscape painting of Mount Tamalpais. Contemporary artisan Michael Adams created the lamp; other objects include a tea tile, period copper, bowl by Digby Brooks, and Van Briggle pottery.

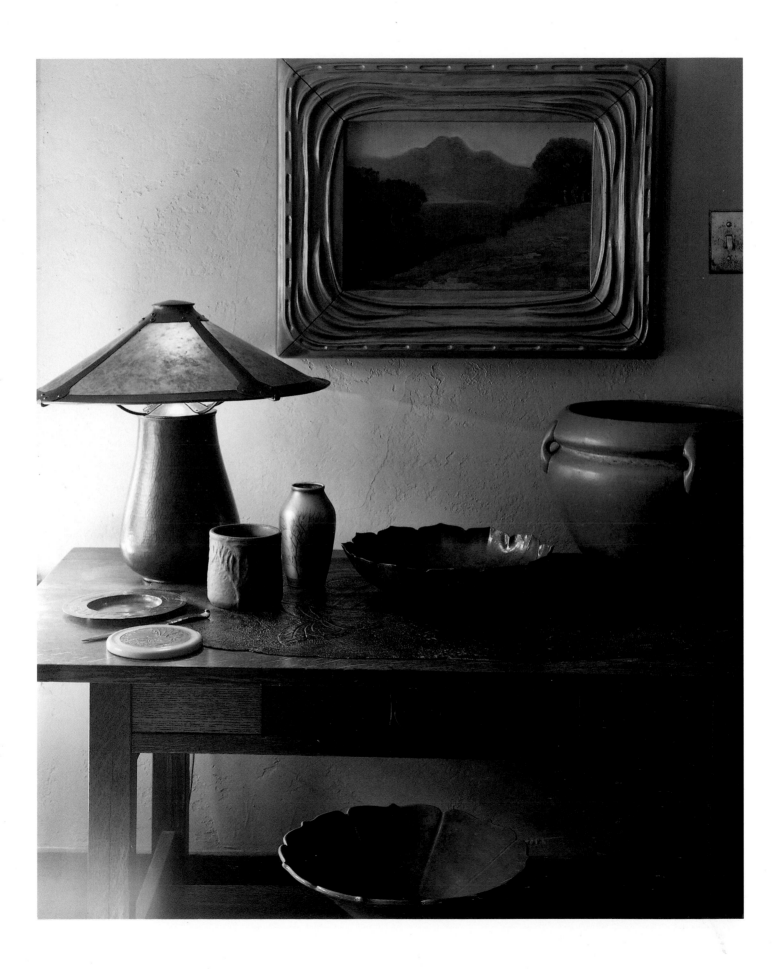

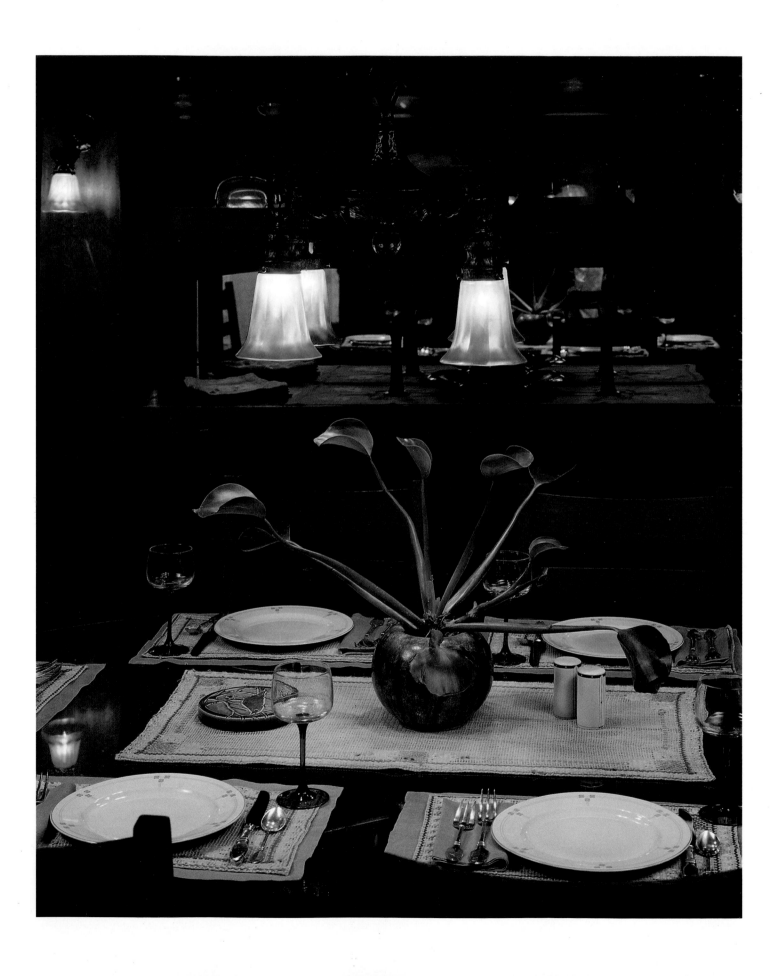

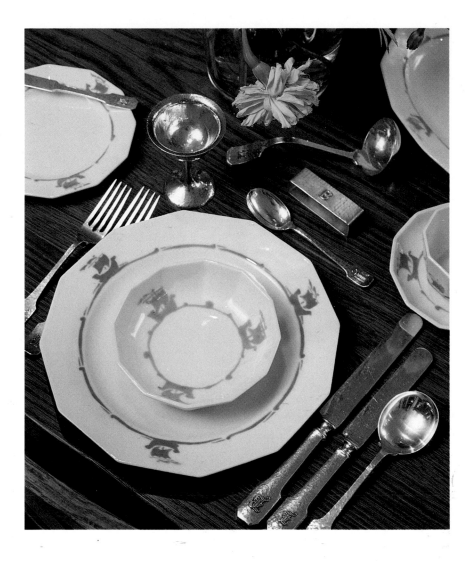

In the Los Angeles dining room of literary and film agent Ron Bernstein, left, the dining table is set with Stickley Brothers china. Sitting in the center is a Fulper vase, and next to it is a Rookwood tea tile.

Rookwood dinnerware and Shreve & Company gothic-inspired silverware—displaying the famous "Shreve Strap"—set an opulent yet restrained table, right. Settings in the era were far less ornate than in the preceding Victorian period.

the cache from Ohr's survivors for a reported $50,000 and released the works for sale. They were received with great fanfare by an art world now more appreciative of original expression. Ohr's confident prediction that his work would one day be highly valued had proven to be accurate.

Metalware and Tableware The Arts and Crafts style in metalware is distinguished both by the mark of the craftsman's hammer—whether real or factory applied—and by a variety of surface colorations achieved through the application of chemical patinas, often used to achieve an aged look. Studio craftsmen could use Augustus Foster Rose's *Copper Work* as a guide to working with copper; by 1931, it had gone through eight editions. Formerly considered suitable primarily for kitchen wares, copper became the Arts and Crafts metal of choice because of its low cost and superior workability.

Many craftsmen whose names are not well known today produced metal accessories with the characteristic hammer marks, patinas, and unornamented, simplified shapes. These more affordable pieces turn up from time to time in antique shops, along with pieces displaying well-known names like Stickley and Roycroft.

Both companies had extensive metalworking operations. Stickley's metal workshop, established in 1905, produced hand-wrought hinges, key escutcheons, and handles for Craftsman furniture, as well as lighting fixtures, fireplace hoods and tools, chafing dishes, desk sets, and other accessories. Roycroft's metal shop had opened before 1900, but it wasn't until 1908 that it enjoyed success. That was the year that Karl Kipp, a former banker and self-taught craftsman, transformed the metal shop into a successful operation, with a product line that ultimately numbered more than 150 items and employed 35 artisans.

Victorian silver hollowware and flatware had been ornate and heavy, often the result of mechanical processes introduced in the nineteenth century. The objectives of the Arts and Crafts metal shops were to return silver to its earlier status as a handicraft material and to replace ornament with a stylistic purity. This aesthetic could take one of three somewhat divergent forms: colonial revival styles, which were particularly evident in the Northeast; a modern English appearance, as developed by C. R. Ashbee, which was especially noticeable in Chicago, where Ashbee widely lectured; and an understated modernism, inspired by the work of Danish silversmiths such as Georg Jensen, which was also evident in the work of American silversmiths such as Clara Barck Welles. She, in fact, established the Kalo Shop in Chicago in 1900 and began marketing silver in about the year 1905.

The simpler style was not restricted to studio workshops. Under the influence of new ideas, the Gorham Manufacturing Company of Boston created its Martelé line of silver artwares. The company took more than two years to prepare for the new line, which was introduced to the public in 1898. One of the first steps had been to set up a school within the factory, where its best craftsmen were trained in forming and ornamenting silver by hand. The Martelé pieces were characterized by hammered surfaces to indicate the handmade status of the luxury wares.

Around 1900, Shreve & Company of San Francisco, a leading producer

William Morris was the first to elevate woven tapestries and other textiles to the level of fine art in the Arts and Crafts room. The textile depicting the ship above the fireplace is of the period. A lampshade echoes the theme, appropriate in this California coastal locale.

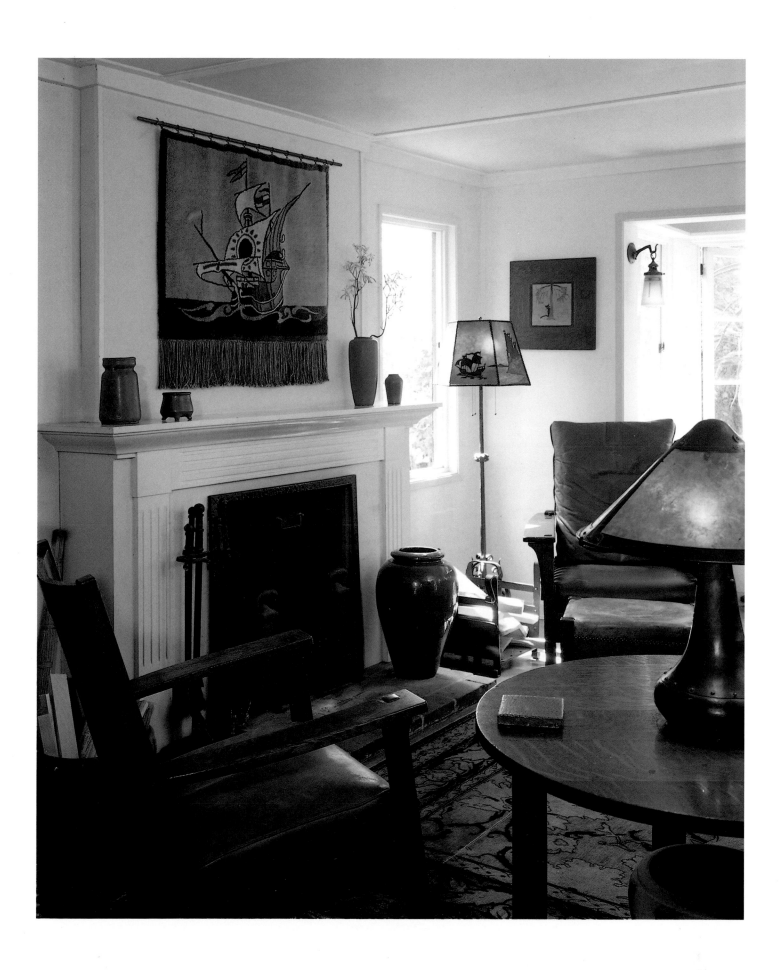

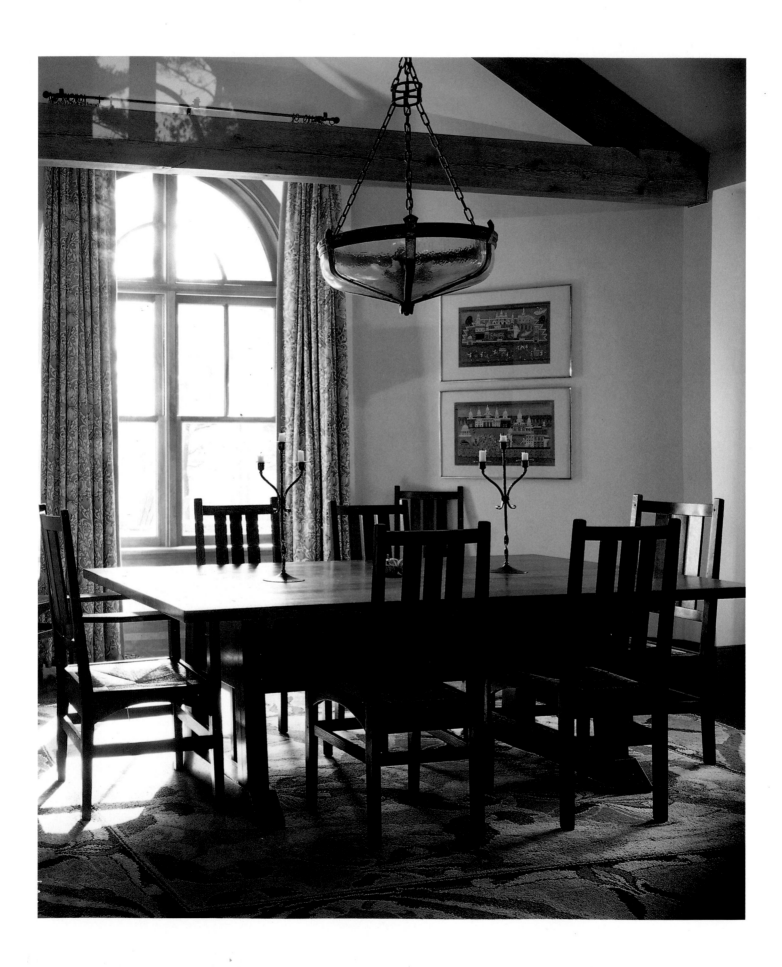

A detail of an embroidered textile owned by Los Angeles collector Ron Bernstein reveals workmanship.

In a home designed by architect Jeremy P. Lang, left, floral-print draperies hang from a simple wrought-iron rod. The rich, abstract gold, green, and orange carpet is a C.F.A. Voysey design.

of fine silver by the turn of the century, introduced several patterns for flatware and hollowware, which were named "XIV Century I" and "XIV Century II." The Gothic-inspired designs featured a studded band, which is sometimes known as the "Shreve Strap."

Some metal workers followed their own aesthetic and were influenced by locale. Clemens Friedell, an American who was trained as a silversmith in Vienna and who plied his luxury trade in Pasadena after 1910, incorporated the flora of California in his work. He was especially proud of a set of flatware embellished with California orange blossoms that he made for Los Angeles brewer R. E. Maier. For David B. Gamble, the wealthy Cincinnatian whose vacation house in Pasadena was designed by the Greene brothers, Friedell crafted a silver goblet in the shape of a California poppy.

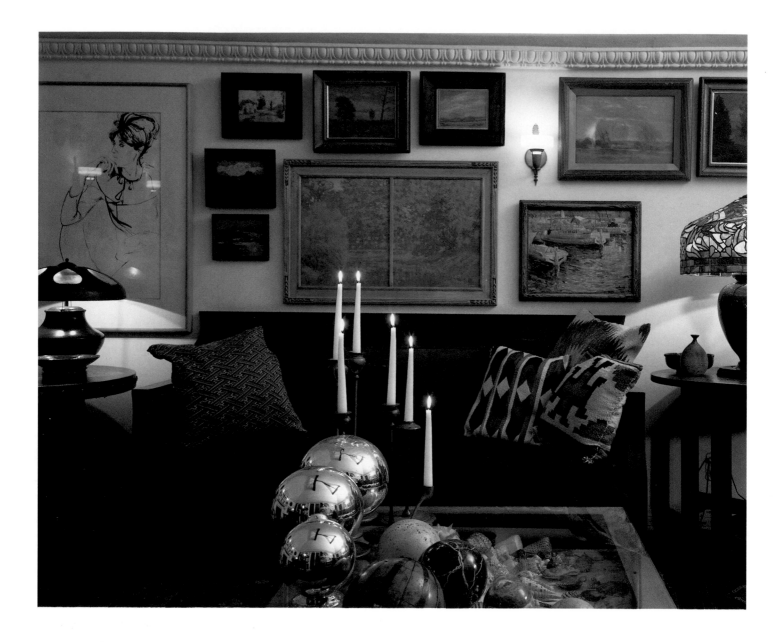

Throw cushions in vivid prints are among the best ways to enliven Arts and Crafts upholstered seating. The owners of this home also enlivened the mix with intriguing objects and fine art.

Textiles Compared to the Victorian style, the Arts and Crafts aesthetic was notable for a restrained use of textiles. For example, tables were left bare or covered with a simple runner instead of being covered with layers of fabric. Window treatments, table covers, and upholstery, no matter what their pattern and color, were made up simply and without frills. Leather was the preferred choice for upholstery. Suggested colors included brown, green, tan, fawn, yellow, or gray. Other suitable upholstery fabrics were natural-colored, rough-woven linens, and dull-finished silks. Translucent net, quiet cotton prints, and piece-dyed canvas were considered appropriate window coverings.

A craftsmanlike detail was to embellish these fabrics with hand-worked embroidery or appliquéd designs. The motifs were usually drawn from nature—pine cones, ginkgo leaves, and the dragonfly were some suggestions in *The Craftsman*. The magazine noted that "simplicity is characteristic of all craftsman needlework which is bold and plain to a degree." "As a rule," continued an article on textiles, "the finer and more delicate white table linens don't belong in a craftsman room any more than silks, plushes and tapestries in delicate colors. The scheme demands a more robust sort of beauty." The idea behind using textiles to decorate was that they should complement, but never overwhelm, a room's design.

Books and Illustrations Just as bookcases were important furniture considerations for the Arts and Crafts collector, the quality of the books that filled their shelves and illustrations that might hang over a nearby desk were equally significant. Nineteenth-century printing advances such as power presses, automatic typesetting, photographic reproduction, and cheaper paper and bindings made printed matter less expensive and more widely available to an ever more literate public. Books became standard household objects, meant to be admired as much as to be read.

William Morris led the way to reform when he founded Kelmscott Press in England in 1890, with the goal of returning the quality and individuality of hand craftsmanship to printing. The first Kelmscott Press book, *The Story of the Glittering Plain*, was published in England in April, 1891.

More than fifty small presses modeled somewhat on the Kelmscott original came into existence in the United States within a fifteen-year period from 1895 to 1910. The best-known was Elbert Hubbard's Roycroft

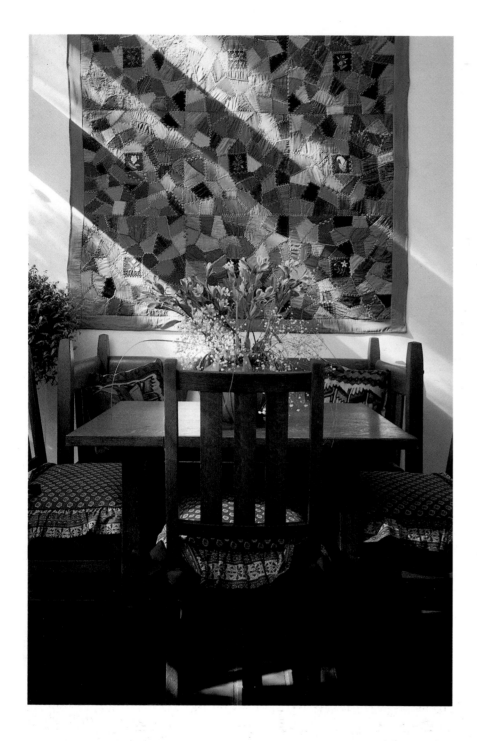

Meals had a ceremonial as well as a social function during the era. They were occasions for the family to gather.

A grand entry is one of the characteristic spaces of the Arts and Crafts house. In this Adirondack-lodge-style residence designed by architect Jeremy P. Lang, right, an imposing Tiffany ceiling fixture and wood beams create a lofty foyer.

Press in East Aurora, New York, which was successful from its formation in 1895 until 1915, when Hubbard died. According to historian Susan Otis Thompson, Roycroft books with their chamois bindings, handmade paper, old-style type, and hand-illuminated initials were a vehicle for bringing many Americans into contact with the Arts and Crafts style.

Besides the well-known Roycroft Press, other influential small presses included Merrymount Press, Riverside Press, Copeland and Day, and

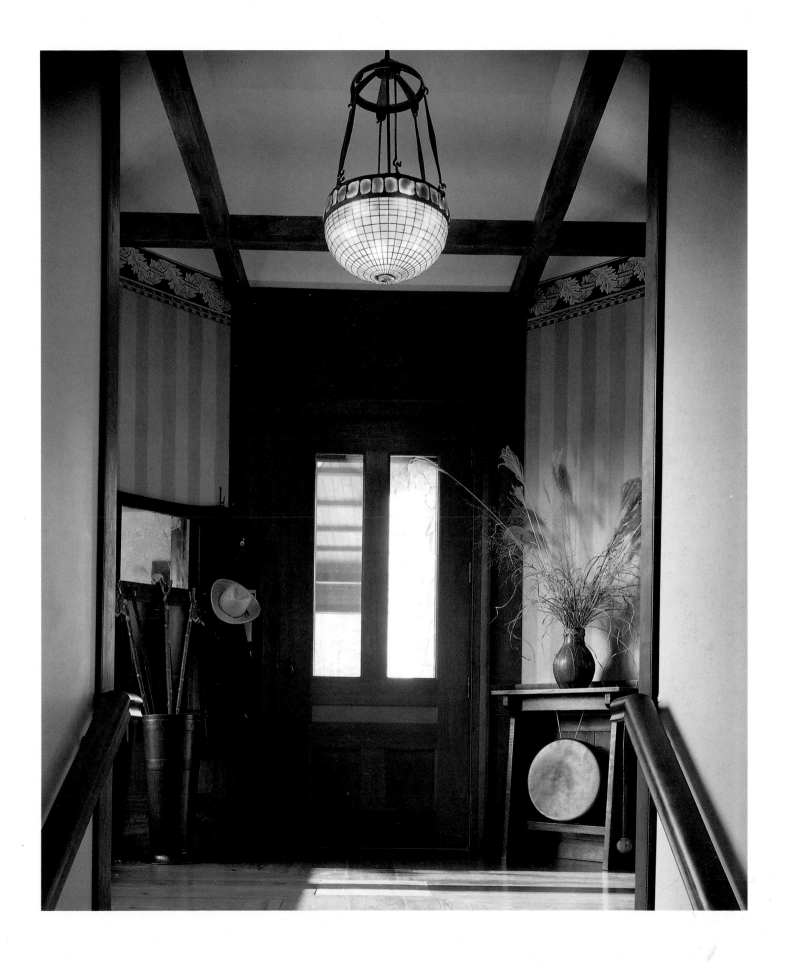

University Press of Cambridge, Massachusetts. But there were small enterprises all over the country—"from Wisconsin to South Carolina, from California to New Hampshire," writes Thompson in an essay in *The Arts and Crafts Movement in America: 1876 to 1916*.

The typical Arts and Crafts book in the United States was produced by hand with handmade materials and issued in a limited edition of numbered, signed copies. Bindings might consist of paper-covered boards, vellum with ties, or blind-stamped leather, conveying a medieval impression. Deckle-edged paper, a gothic-style typeface in heavy black ink, and decorative motifs created with red inks were the usual elements in these books. Sections often began with decorated initials and pages of text, and illustrations were given decorative borders.

Decorating in the Arts and Crafts is a far richer pursuit than adding

Screens were popular room accessories at the height of the movement. Some screens, such as the one at right, were simple oak boards with minimal decoration, usually wood-burned pyrographic designs; others were made of canvas or tapestry fabric. This screen enlivens a dull corner, but could also divide public and private space or separate a home office area from a family gathering spot.

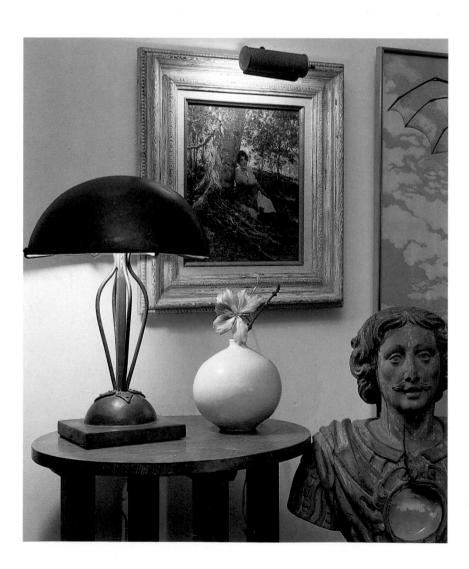

In the paintings of the Arts and Crafts era, the Eden-like natural paradise is a recurrent theme, left.

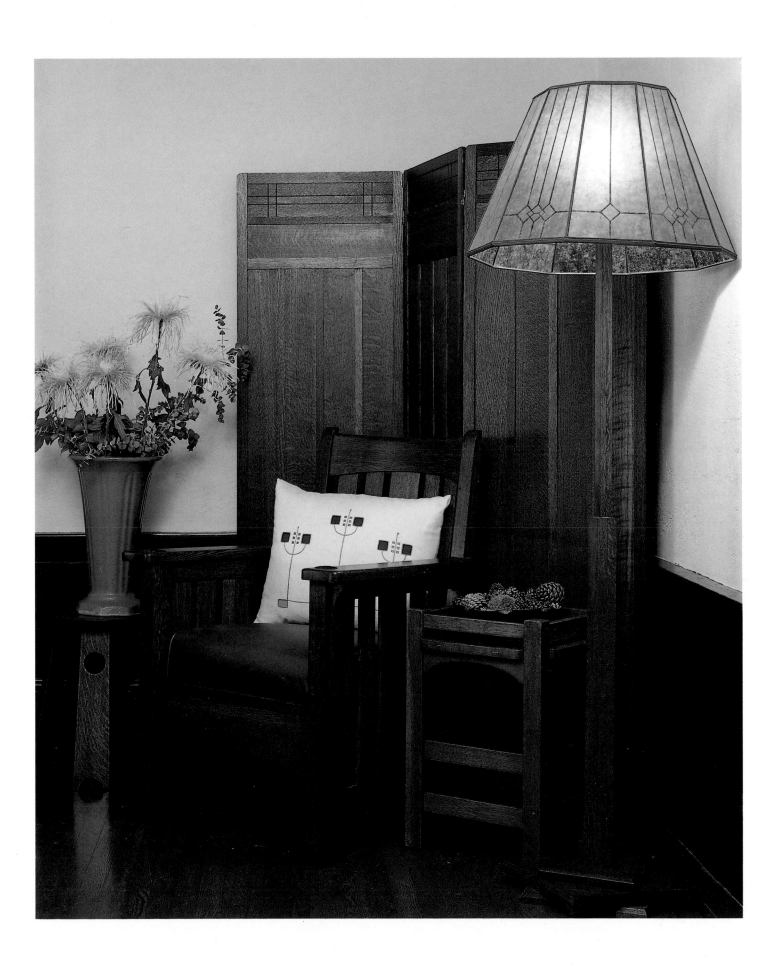

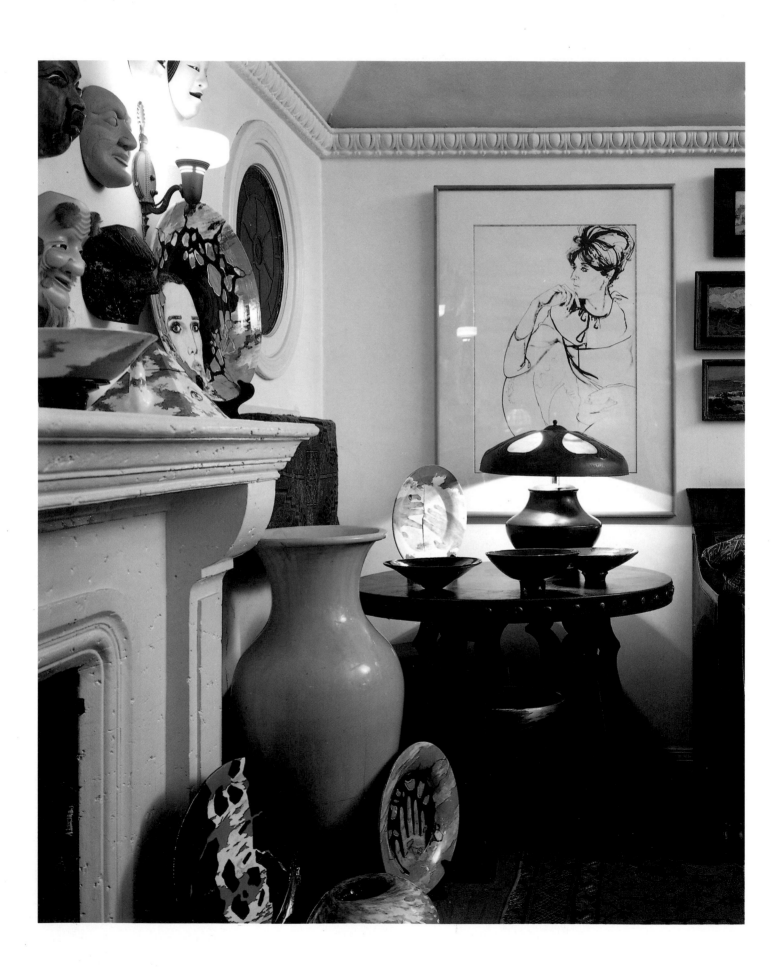

period furniture to a room: It involves carefully selecting from a wealth of fascinating decorative objects marketed to all segments of society from the 1890s and continued through the early teens of this century. Those objects, which today are so collectible, remain as a legacy of the era in which "the art that is life"—so called by Will Price of the Utopian community Rose Valley—was a dominating influence.

Women played a pivotal role in the movement—both as practitioners and collectors. The Arts and Crafts-inspired interior at left acknowledges female contributions, in both the ceramic plate and the framed artwork.

The Arts and Crafts aesthetic is flexible. In this study, right, a desk with classic hardware, Roycroft magazine rack, tile-decorated urn, and mica-shaded lamp create an authentic period environment, not at all compromised by this collector's rather unusual framed collection.

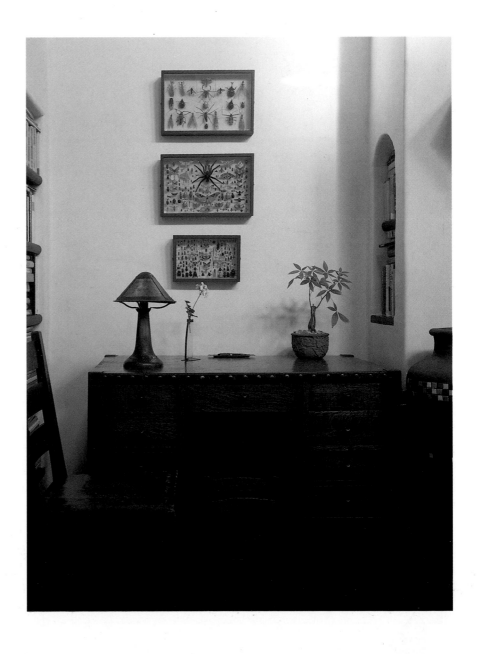

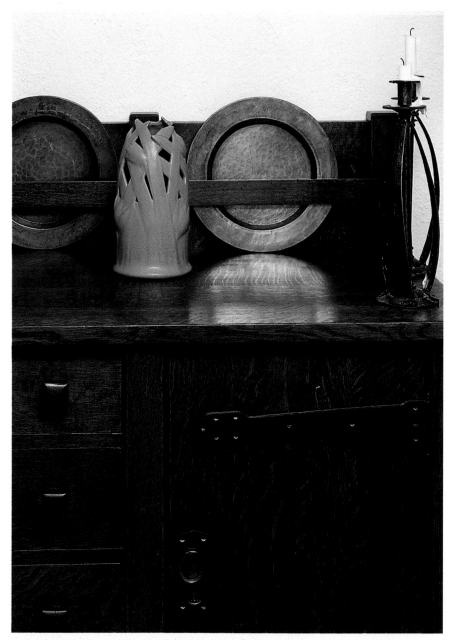

Period candlesticks, Roycroft plates, and a Teco vase are charming accessories.

Chapter Five

CASE STUDIES

❧ *Each of the residences presented in this visual portfolio represents a unique expression of the Arts and Crafts style. Some homeowners take a traditional approach to design, mixing American and English furnishings in authentic period environments. Others freely follow their own aesthetic, creating a visual foundation with larger pieces of Arts and Crafts furniture—such as settles and tables—and integrating their own collection of contemporary fine art and objects. Whatever the setting, Arts and Crafts furnishings provide enduring beauty.*

Tradition Meets Innovation

❧ The Arts and Crafts style is streamlined enough to be thoroughly modern, yet is entirely at home in such a traditional American institution as the colonial home.

Highlighting the versatility of craftsman furnishings, Beth Cathers and Nick Dembrosky have furnished their center-hall Dutch colonial with choice Arts and Crafts furniture, lighting, and accessories collected over more than a twenty-year period.

While Dutch colonial might not be the first style one thinks of for Arts and Crafts, the furnishings are a perfect choice for any setting in which rugged construction and natural materials predominate, says Cathers, a New York dealer in Arts and Crafts furniture and objects and co-author of *Treasures of the American Arts and Crafts Movement.*

In the couple's living room, a Stickley director's table is flanked by a Stickley screen, left, and a remarkable Rohlfs plant stand, right. In the foreground, a Stickley drop-arm reclining chair provides a comfortable spot for reading, enhanced by the soft glow of the nearby Van Erp lamp.

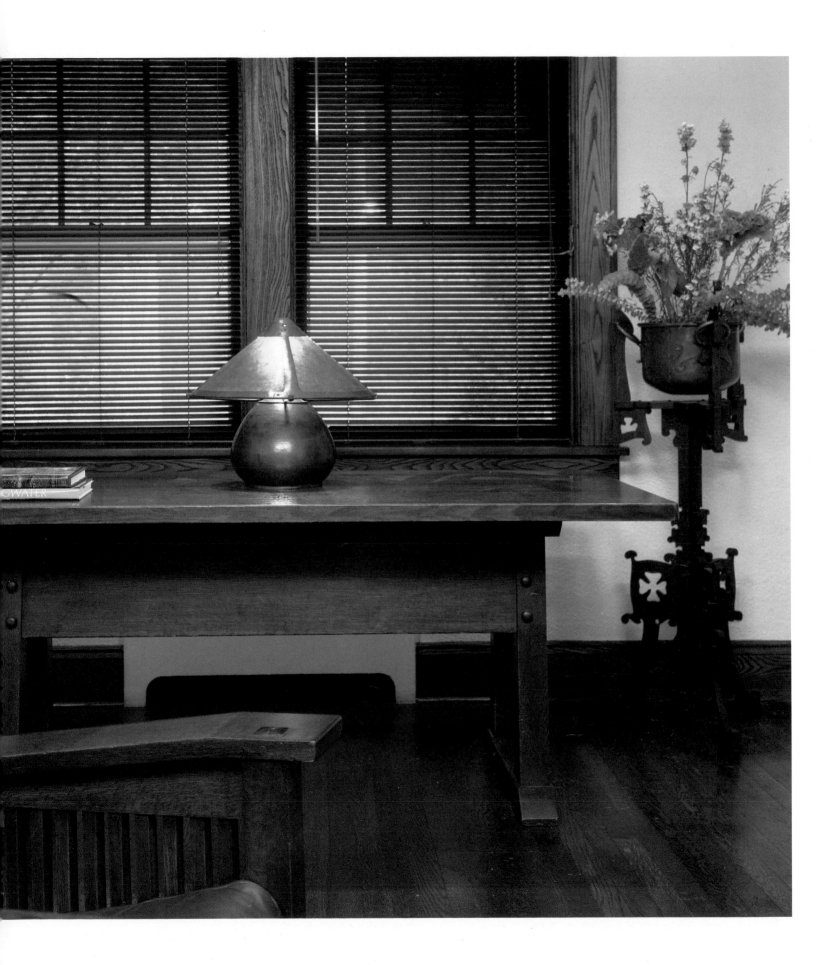

The massive stone fireplace in the living room lends itself particularly well to the Arts and Crafts aesthetic, as the hearth was considered to be an essential stylistic factor, particularly as espoused by Stickley. Each of the house's large, well-proportioned rooms has natural-finish oak floors and chestnut doors and moldings, reflecting the owners' appreciation for wood grain. Unadorned white plaster walls are the perfect backdrop against which to display the furniture in the commodious rooms.

In such an uncomplicated setting, features that might be lost in busier rooms—the patinas on the various pieces of furniture, for example—take on great significance.

"The finish is very important," says Cathers. "You don't necessarily see it in a single piece, but with six or eight, the differences add up to a decorative effect that exudes warmth."

Throughout the house, classic Stickley pieces are warmed by accent furniture created by such design luminaries as Charles Rohlfs and Roycroft workshops. Complementary objects and accents include lamps by Dirk Van Erp, art pottery, Navaho and Oriental rugs, and textured upholstery fabrics.

Cathers and Dembrosky have added midtwentieth century accessories, such as studio pottery and Japanese lanterns, to the mix. The sprightly, modern pieces are a pleasing counterpoint to the geometric lines of the furniture, says Cathers.

Small details are all important in Arts and Crafts interiors. In this couple's home, the textures of a hand-loomed mohair throw draped over a settle, the patina of a pottery glaze in the afternoon light, and the colors and patterns of Southwestern textiles enliven what is essentially a simple aesthetic with little ornamentation.

"Arts and Crafts is a subtle style that grows on you slowly," says Dembrosky. "It makes us feel at home, especially as we move into a more mechanized society. The pieces are historical, but also very modern."

Eclectic elements in the study include a Stickley cube chair and ottoman designed by Harvey Ellis, a Japanese lantern by Isamu Noguchi, and midtwentieth century studio pottery. Underfoot, the Navaho rug provides a dose of color.

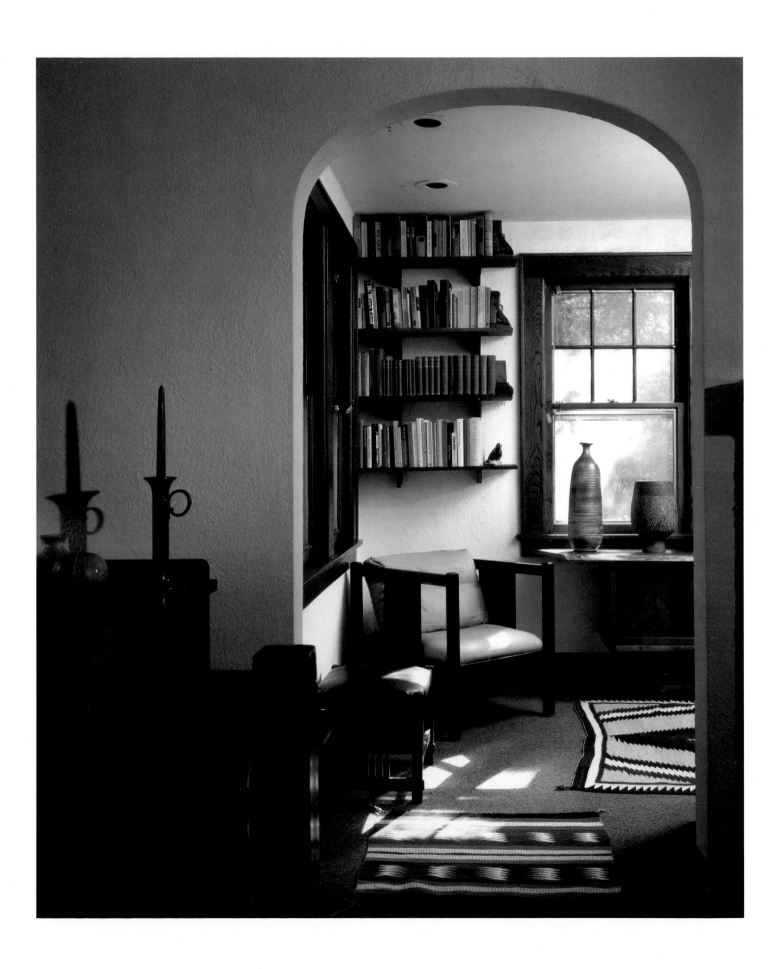

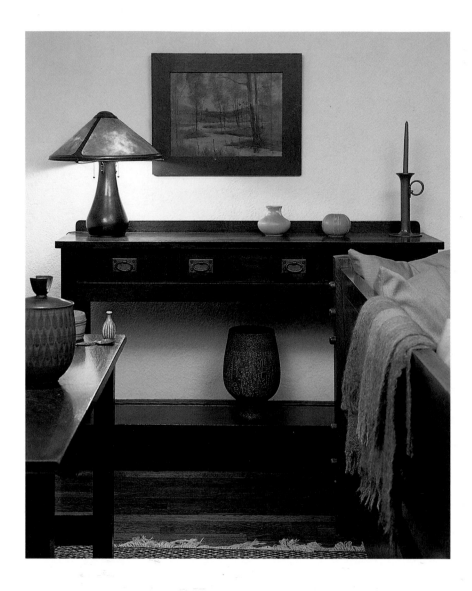

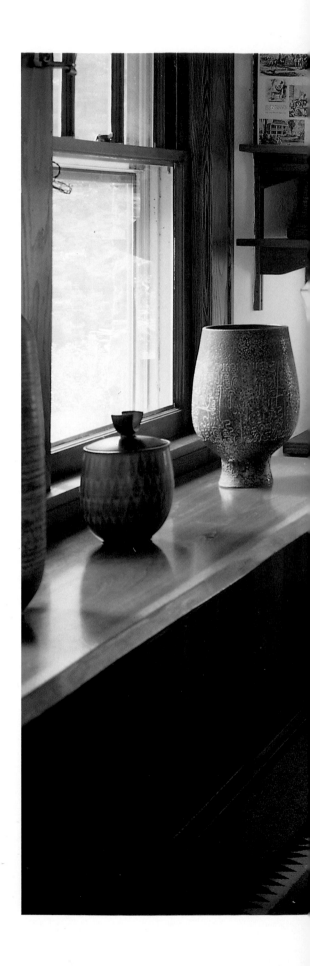

A copper lamp by Dirk Van Erp, Grueby pottery, and a candlestick by Robert Jarvie are the simple objects that Cathers and Dembrosky selected to adorn the Stickley server, above. The landscape painting is in a Roycroft frame, repeating the natural-wood theme so prevalent in this household.

Understated but far from plain, the study's white walls and chestnut moldings offer a quiet background in which the Arts and Crafts furnishings seem to glow. A George Nakashima sideboard topped with pottery exudes a Japanese feel yet harmonizes fully with the American-made furnishings, right.

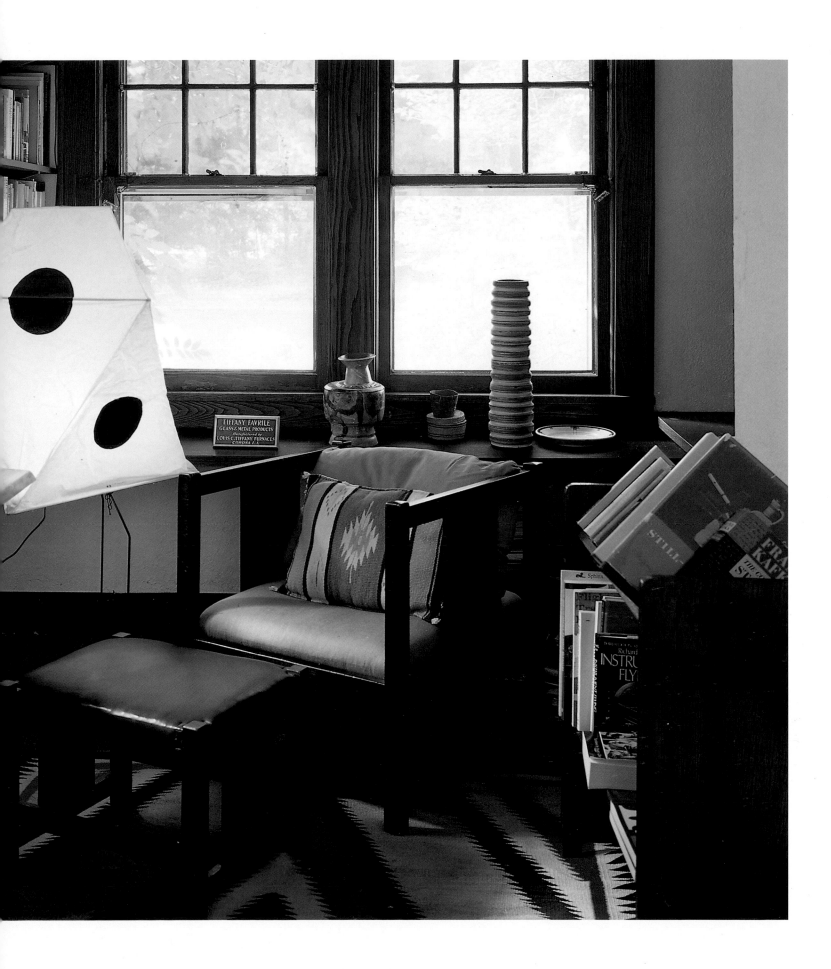

An Architect's Dream

Jimmy and Karen Cohen's upstate New York home, designed in Frank Lloyd Wright's Usonian style, provided the catalyst for their varied and carefully chosen Arts and Crafts collection.

Wright developed the Usonian format—here executed by his one-time student David Henken—to house middle-income families comfortably and yet stylishly. The Cohens' home incorporates characteristic, dramatic Usonian details: an open floor plan and expansive views of the outdoors.

"When we bought the house, we knew nothing about Arts and Crafts," recalls Jimmy Cohen. "We saw a settle by Gustav Stickley at an antiques show and we both thought that it would look great in our house." After the couple purchased the settle, they fortuitously learned that Gustav Stickley's furniture was used to furnish some of Wright's early houses. That settled the matter for the Cohens. They added more Stickley seating, tables, and dining furniture.

"This is a small house, so finding pieces that were small enough in scale was a challenge," says Karen Cohen. "Working with antiques involves hunting for exactly the right piece that fits the space you have available.

A classic reclining Morris chair becomes the ultimate in comfort with the addition of down-filled velvet cushions.

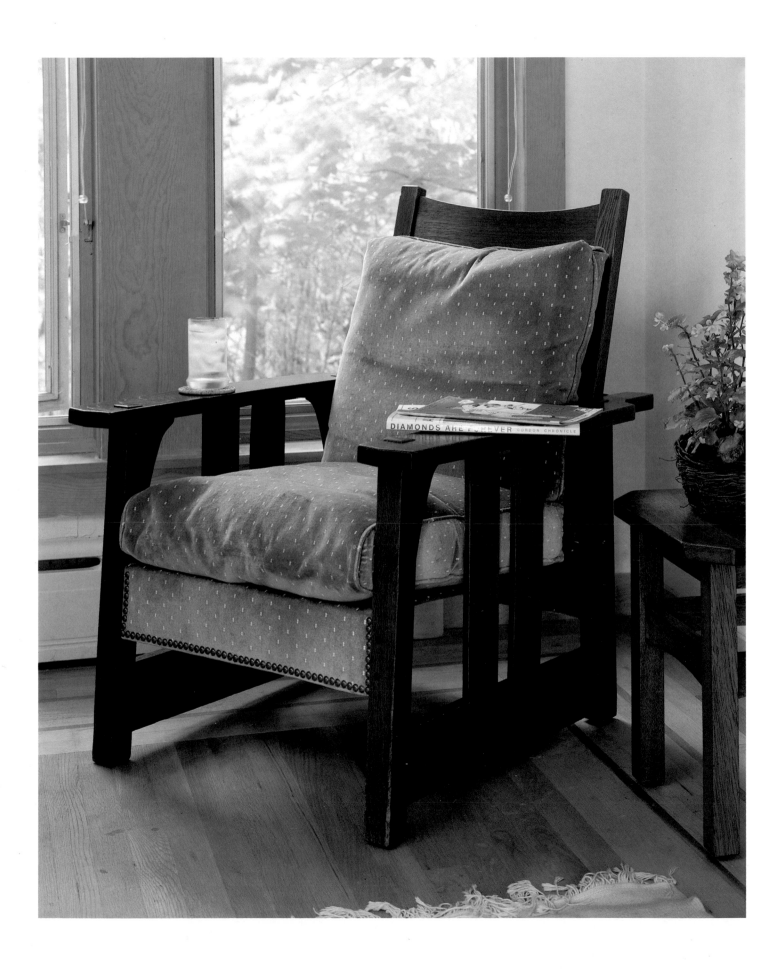

Some Arts and Crafts furniture needs a larger area than we had." Throughout the home, examples of smaller-proportioned period pieces abound: a high chair, a ladies' rocker, a ladies' writing desk, and a footstool with lovely inlaid woodwork are prized pieces in their collection.

Virtually every room in the house features exposed cypress-wood walls, floors, and ceilings. For variety, there is a brick wall in the dining room, where the bare floor is polished red cement, inlaid with brass strips to create the illusion of large red tiles. Because of the proliferation of these hard surfaces, the Cohens opted to soften the rooms' edges with textiles.

In the den—a later addition to the house that uses lighter wood detailing—they covered the settle cushions with a woven, textured fabric that suggests an American Indian motif and upholstered a Morris chair with green-dot-patterned velvet cushions filled with luxurious down. To maintain harmony between their home and the surrounding woodland, the Cohens selected textiles for the seating that evoke the colors of nature—greens, browns, and shades of orange.

Even the window coverings are in keeping with the Arts and Crafts aesthetic. The living room draperies are made from a fabric with the look and feel of raw silk. Elsewhere in the home, windows have either been left bare or covered with translucent shades, which expose the shadows and outline of the surrounding trees on their property while blocking the sun's glare. During the day, the shades can be pulled up all the way to reveal a view of the woods.

Despite the home's period sensibility, Karen Cohen maintains, "We aren't purists." Throughout the rooms, such non-Arts and Crafts furnishings as a Japanese shoji screen, a Portuguese needlepoint rug, and American folk-art duck decoys and prints attest to this couple's adventurous decorating attitude.

Wood-paneled surfaces, Stickley settles with woven fabric cushions, a Portuguese needlepoint carpet, and a shoji screen diffusing ambient light are the diverse elements that decorate the couple's warm and cozy living room. The embroidered scarf on the dining table was a serendipitous find at an antiques store.

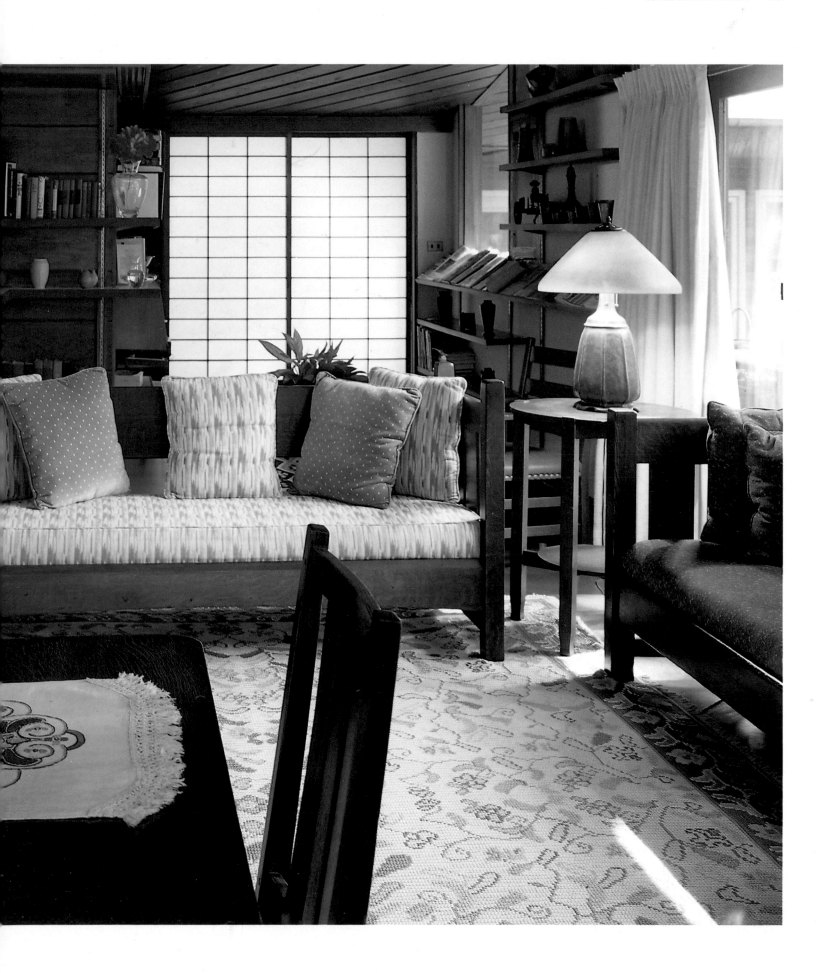

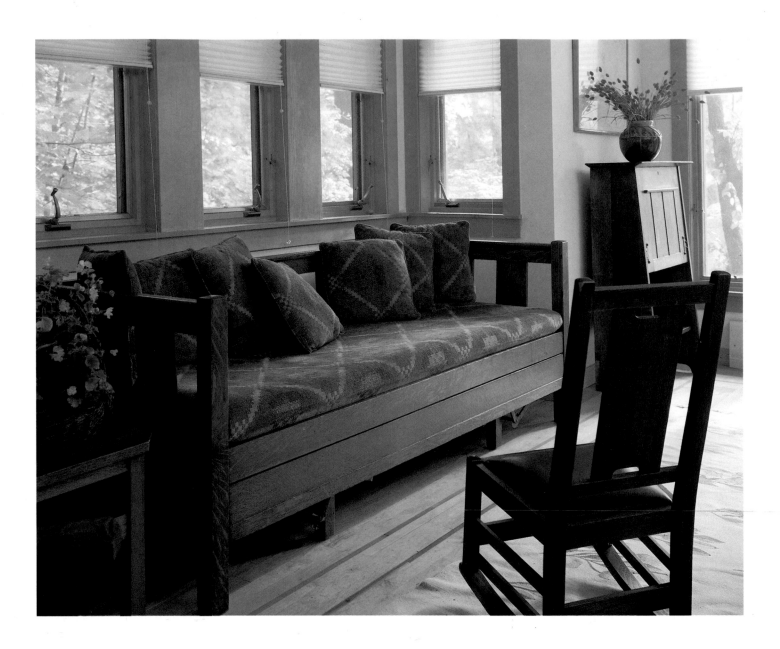

A Gustav Stickley settle and dropfront ladies' writing desk are important pieces in the study, above. In the foreground, a delicately scaled ladies' rocker does not overwhelm the small den, a later addition to the house.

The Stickley settle in the study, right, may well be one-of-a-kind: It doubles as a pull-out trundle bed, which provides a comfortable sleeping spot for overnight guests.

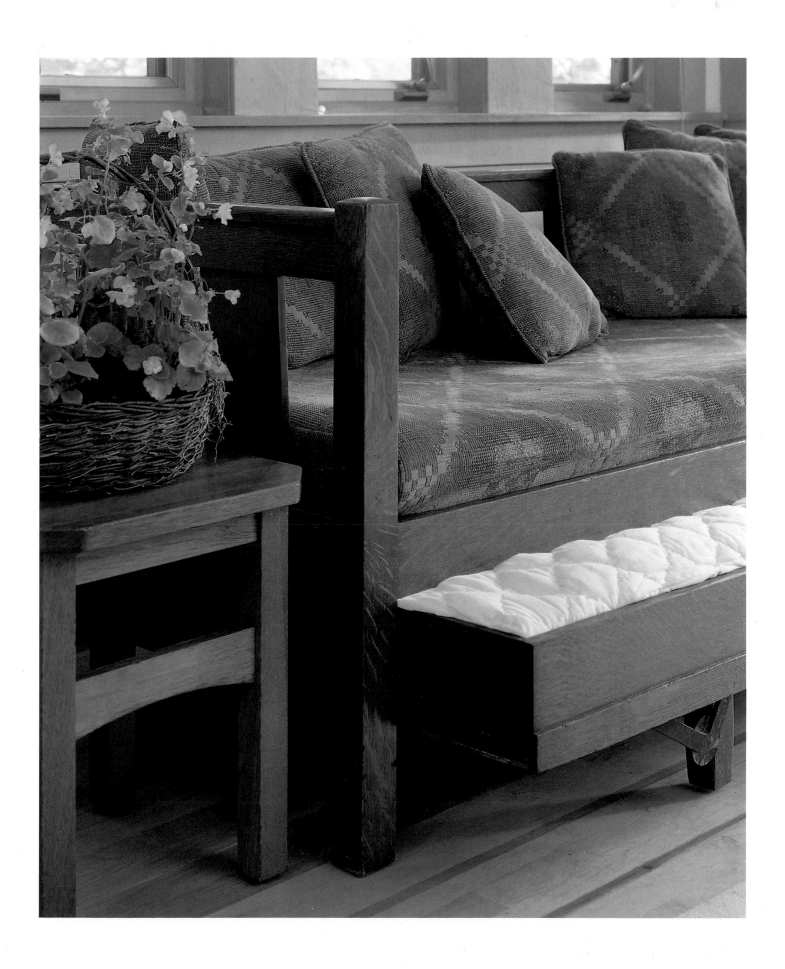

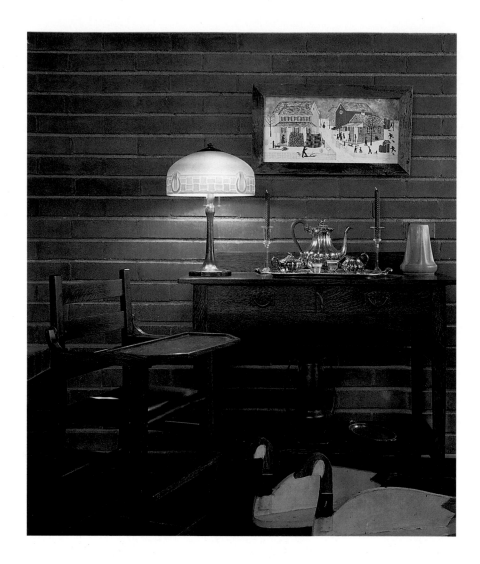

In the dining room, above, exposed brick makes a fine background for a smaller-scale Gustav Stickley server. Designed by Harvey Ellis, it bears his characteristic stamp in the curved form just below the two drawers. The sturdy Stickley high chair—now a conversation piece—was put to good use when the Cohen children were infants. Also of note is the truly elegant Handel lamp, which illuminates the silverware and a Fulper vase.

The open-plan home, right, flows easily from one room to the next. Beyond the living room—which features, among other prized possesions, a Handel lamp and an L. & J.G. Stickley settle—the dining room is graced by Harvey Ellis-designed chairs.

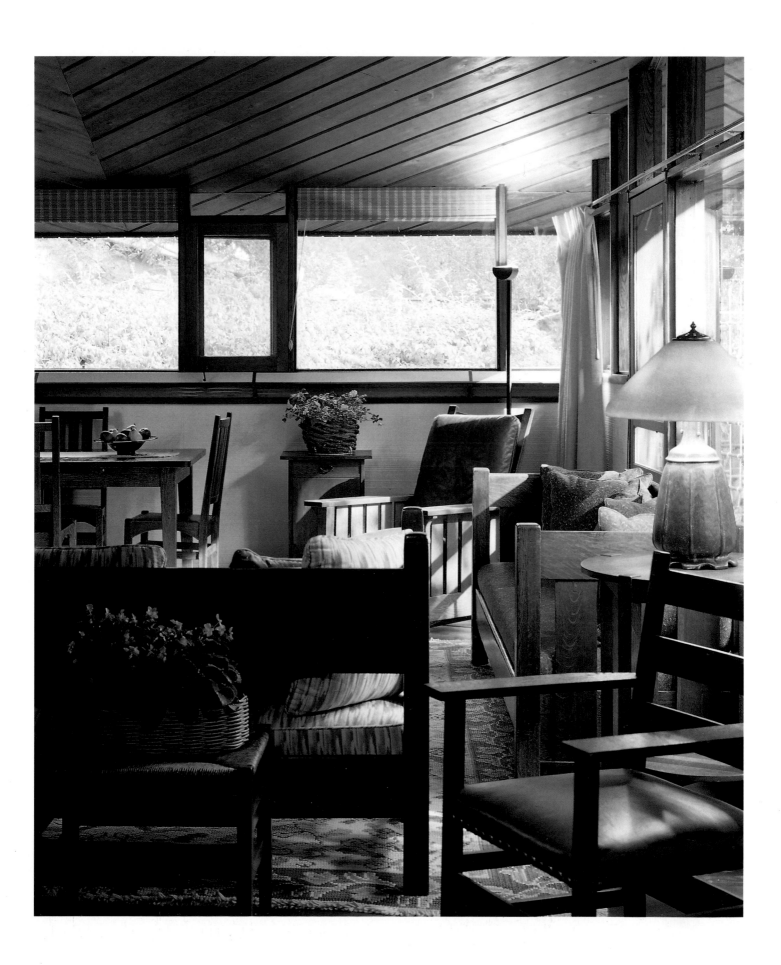

Stickley Sophisticates

❧ Outside the windows of a spacious, light-filled loft with white walls, the fast beat of New York City keeps up a steady clamor. But within, all is serenity. It's an adventurous and thoroughly modern idea to furnish a loft with a treasure trove of turn-of-the-century Arts and Crafts furniture, accessories, lighting, and California paintings—but it works.

The main space in the loft, located in Manhattan's Flatiron district, is given over to spacious, open living and dining areas. This floor area is large enough for several different seating arrangements, furnished with the characteristic Morris chairs and settle, as well as bookcases, a bridal chest, a hexagonal table, a dropfront desk, and an inlaid plant stand. Floor and table lamps illuminate and define separate areas.

Each piece was painstakingly chosen for its beauty and functionality. For example, a small settle by Gustav Stickley is the perfect "loveseat" for conversation removed from the main seating area; a Stickley dinner gong is a lovely conversation piece for the dining area.

Rookwood, Newcomb, and Grueby art pottery make for a distinctive trio atop a Harvey Ellis-designed oak secretary, circa 1903, from the Gustav Stickley workshop. The painting, right, is by Edgar Payne.

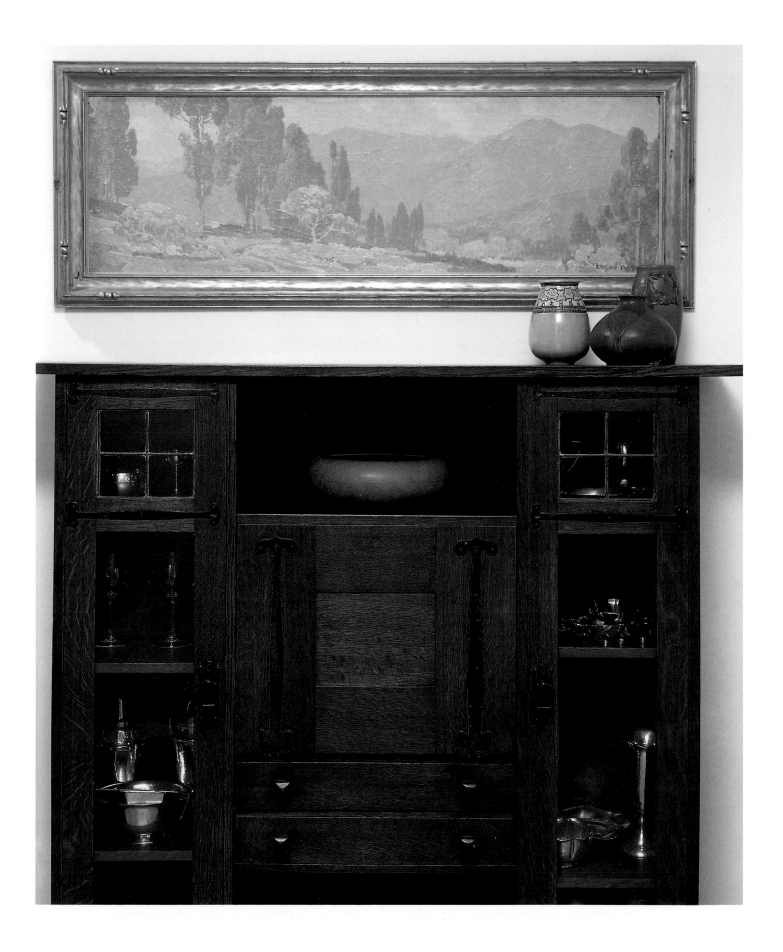

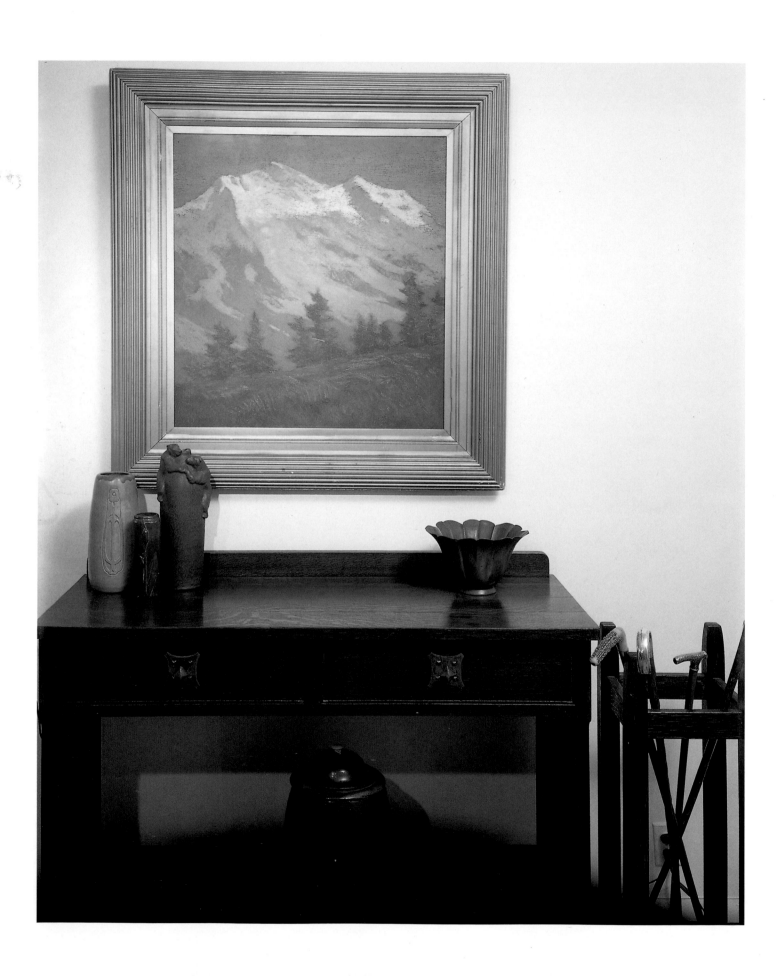

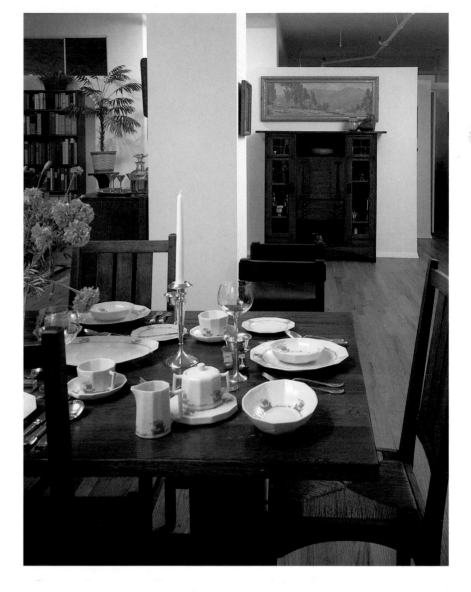

Left, a painting by the atonalist Charles Warren Eaton hangs above a very early Gustav Stickley server that has retained its original hardware. The 1920s bowl, on the right side, is by Chicago period artist Marie Zimmermann. Of special note is the brown art pottery by Van Briggle, on the left, created in 1901 and entitled "The Bears."

Charming and rare, Rookwood Blue Ship pattern china adorns the Stickley dining table, right. Other period tableware includes Shreve & Company hammered silver utensils, sherbet cups, and candlesticks.

The couple's collection of art pottery by such virtuoso makers as Newcomb and Grueby adds warmth throughout the loft. Serious about imbuing their home with an Arts and Crafts ambience, they have even collected period silverware and tableware to adorn their dining table.

The most distinctive and enlivening touch of all comes from the couple's collection of early twentieth-century landscapes by California artists. Displayed against unadorned, white walls, the paintings imbue the room with lush California nature colors—the perfect visual relief from the glass and steel of the city.

Outstanding furniture and objects with a harmonious sensibility define the living area. Beyond the hexagonal library table by Gustav Stickley, an L. & J.G. Stickley Morris chair and settle beckon with comfort. The plant stand in the right foreground is inlaid with Grueby tile; another prized possession is the Tiffany standing lamp.

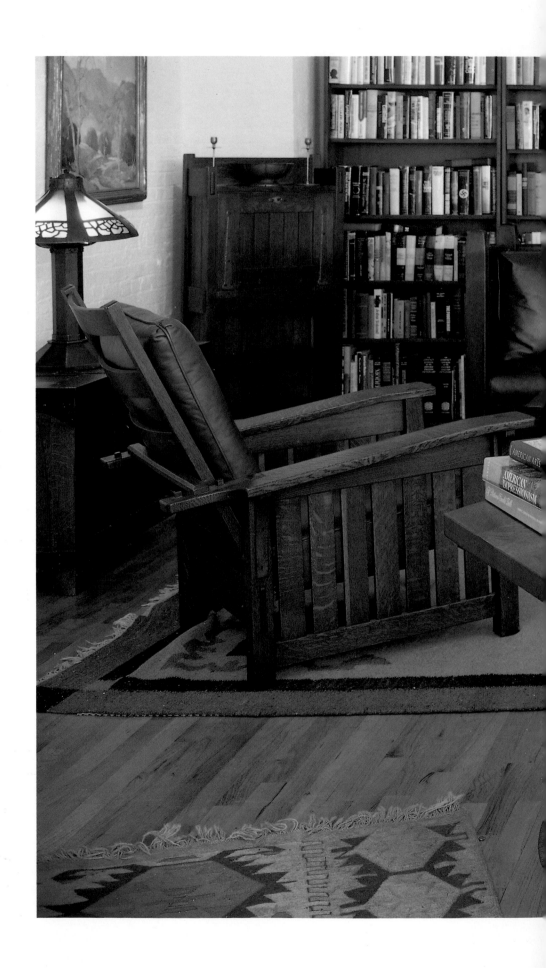

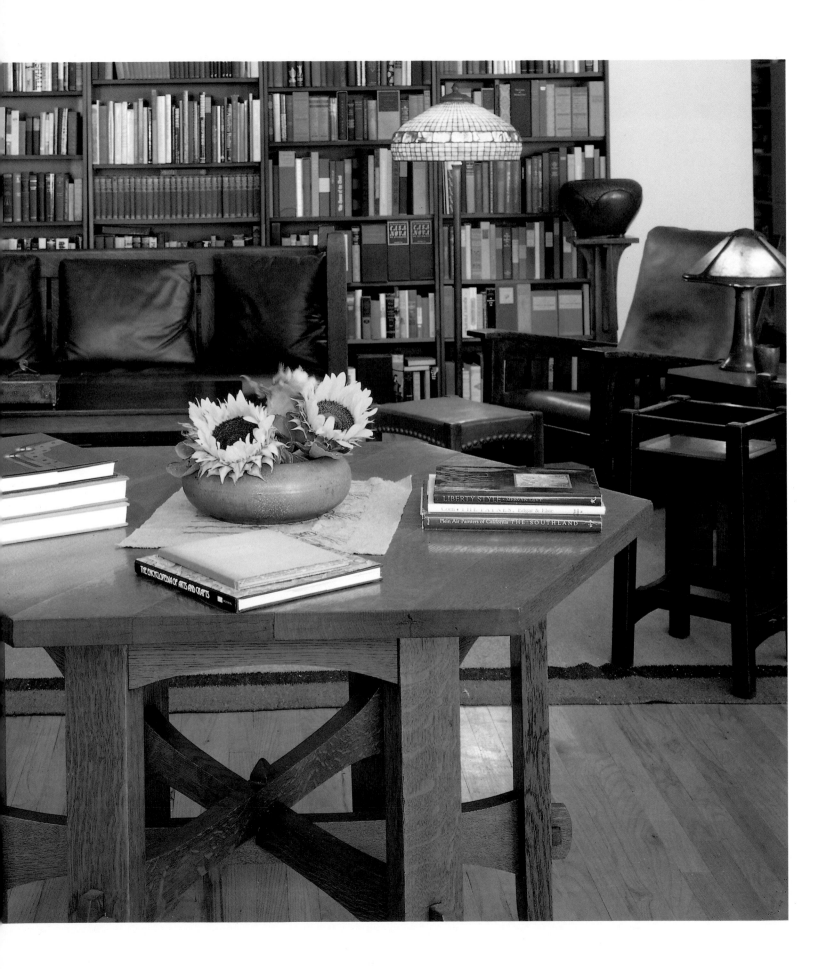

Farmhouse Craftsman

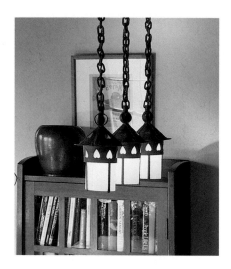

∂🖙 Some collectors say that Arts and Crafts is an acquired taste. But for Stephen Gray, it was love at first sight.

He first became interested in the movement after buying a Hudson River farmhouse in Columbia County, New York, in 1976. In his search for furniture that would complement the late eighteenth-century house—which has nineteenth-century additions in the Greek Revival and Italianate styles, as well as a new addition to the living room carried out by Gray—he was immediately drawn to Arts and Crafts pieces.

Soon he found himself decorating not only his farmhouse, pictured here, with Arts and Crafts, but also in his New York City apartment. "The style began to consume my life," explains Gray. "I became interested in the ceramics, the lamps, the metalwork. I wanted to recreate the atmosphere of the way those people lived in my two residences."

Visitors to Gray's country house gather around a Gustav Stickley table at mealtime, the soft glow of the Dirk Van Erp uplighter illuminating the room. When not in use, the table is surmounted by a Fulper bowl. Underfoot, the drugget rug is a classic accoutrement of Craftsman rooms (Gustav Stickley himself imported them from India). This one is particularly appropriate, as its Greek motif design complements the Greek Revival architecture in this part of the house.

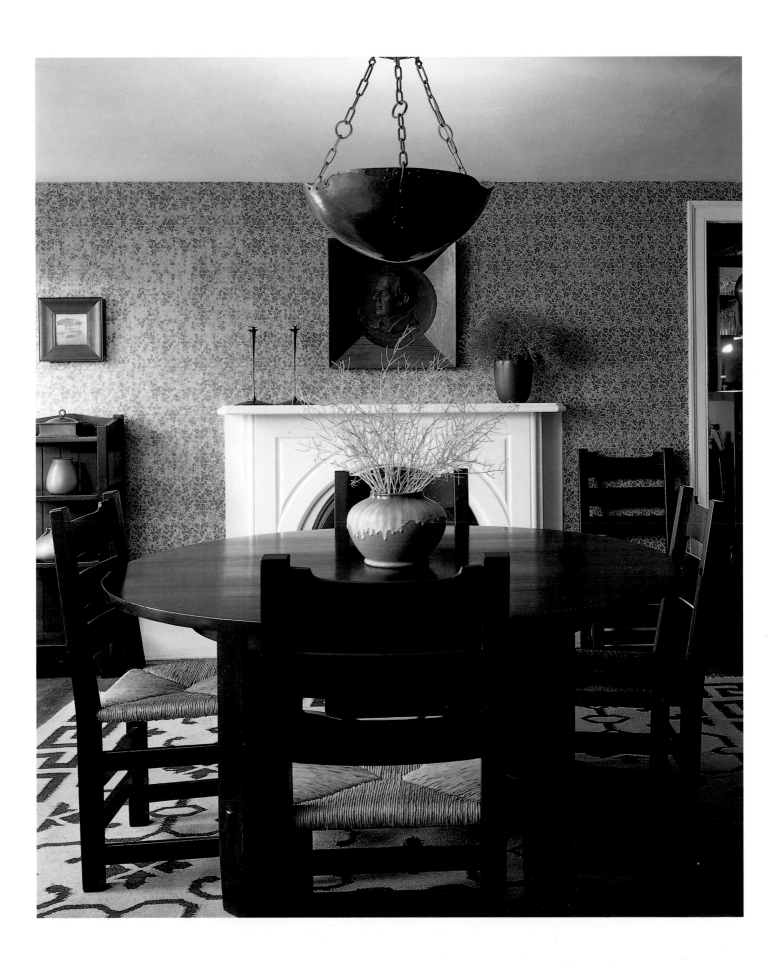

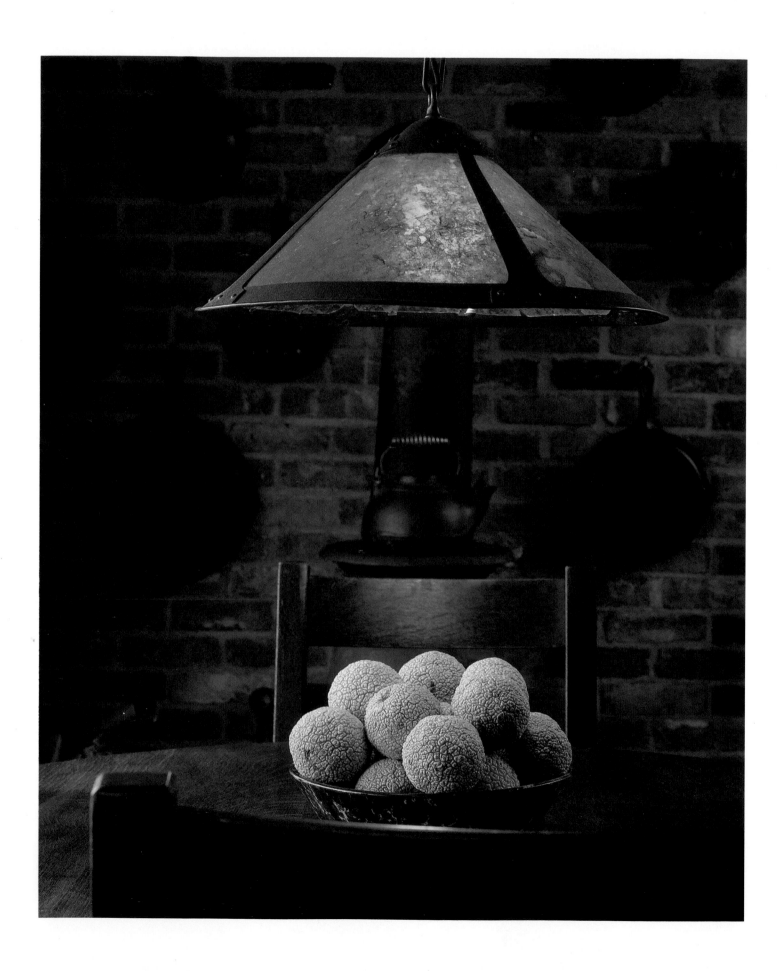

In the front hallway, William Morris wallpaper is actually a reproduction from Arthur Sanderson & Co. The honeycomb-pattern drugget hall runner is a genuine antique, however, and is one of Gray's most valued possessions. The early Gustav Stickley card table and three-section hall mirror were also special finds. The Roycroft hanging up-lighter was originally in the Grove Park Inn, in Asheville, North Carolina. Perhaps the most intriguing piece of all is the high-backed settle, bought from an Elk's Lodge in Skaneateles, New York.

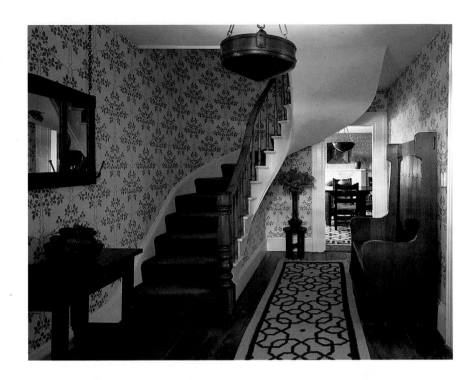

A copper-banded mica shade by Van Erp is suspended above the kitchen table, left. Cast-iron skillets, which Gray uses for cooking as well as display, hang on the brick wall. The Griswold tea kettle on the Franklin stove is thought to date from the early twentieth century.

Gray went so far as to learn how to color-treat and restore leather for furniture coverings and to annotate and reprint a series of catalogues of Stickley, Roycroft, and other period furnishings, which he publishes under the Turn of the Century Editions imprint.

In the course of decorating with Arts and Crafts, Gray has learned a great deal about what does and doesn't work. For example, he says, "You can't use naturalistic flowers either on wallpaper or fabric. You need to use conventionalized or abstract forms." Similarly, for carpeting, particularly Oriental rugs, he feels that the simpler, muted geometric patterns are superior to floral ones for Arts and Crafts interiors.

Although it is said that good pieces are getting harder to find now that more people have taken an interest in Arts and Crafts, Gray has never come up empty-handed in his search. Each year, he seems to find "the thing that I've been dreaming of. I have nothing in storage. I do, however, try to have backups for the rugs because they are so fragile."

Of course, Gray's decorating success comes with years of experimentation. "I would find my eye," he says. "I don't make mistakes anymore, and I know what I like." This, above all, may be the secret to great collections: finding one's own aesthetic within the vast selection of Arts and Crafts.

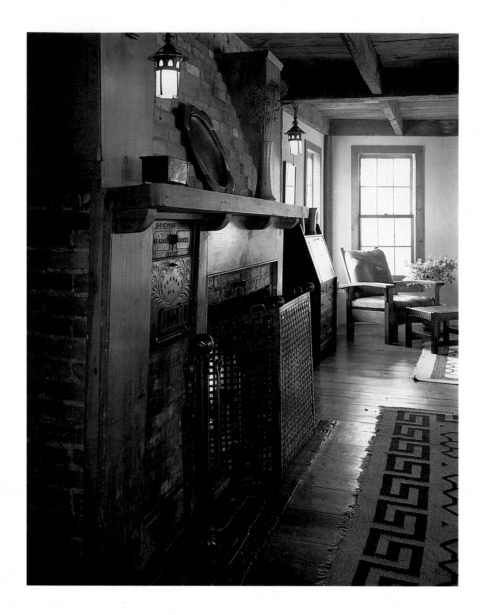

Handwrought copper fireplace accessories—including a screen, and iron, and tools—are all by Dirk Van Erp. The copper charger on the mantel is a Gustav Stickley piece. The centerpiece of the room, this fireplace retains its original pine woodwork, which has mellowed with age. Gray added the hemlock mantel. On the left side of the fireplace, a cast-iron plate covers a warming oven.

Right, most of the living room furniture is by Gustav Stickley, including the large settle, the hexagonal table, glass-door bookcase, split-bamboo Japanese shade, and beautifully preserved chair covered in the original leather. The Stickley three-light drop lantern with heart cutouts—attached to its original hanging beam with pristine hardware—visually divides the new section of the living room, built from old wood, from the original. On the table, a Teco garden planter is a graceful accent.

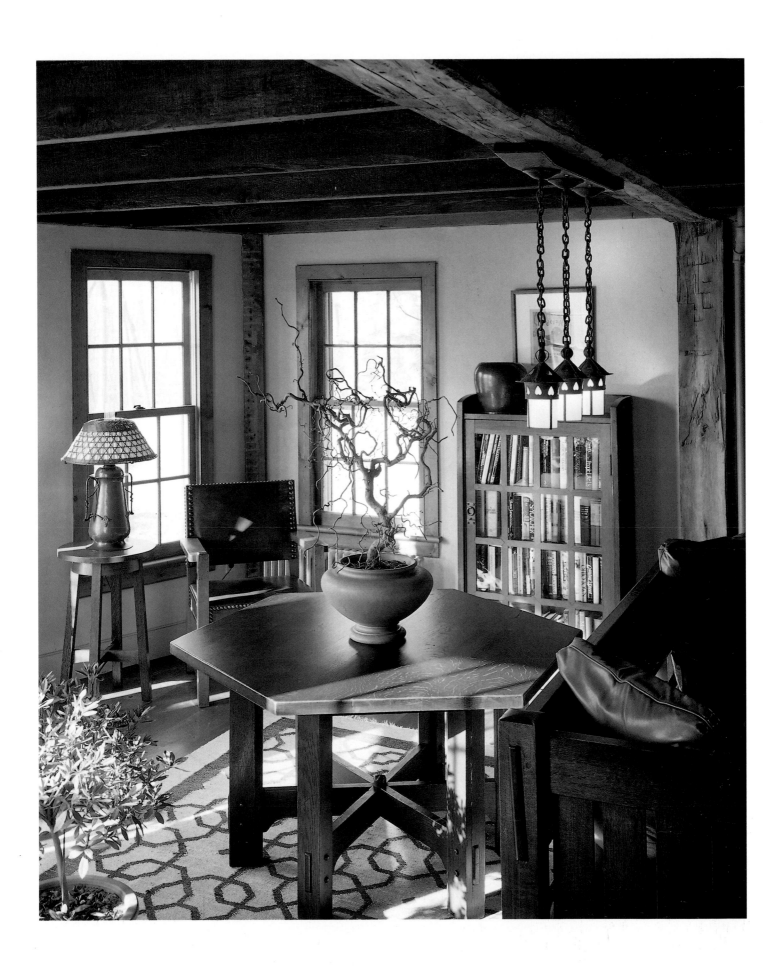

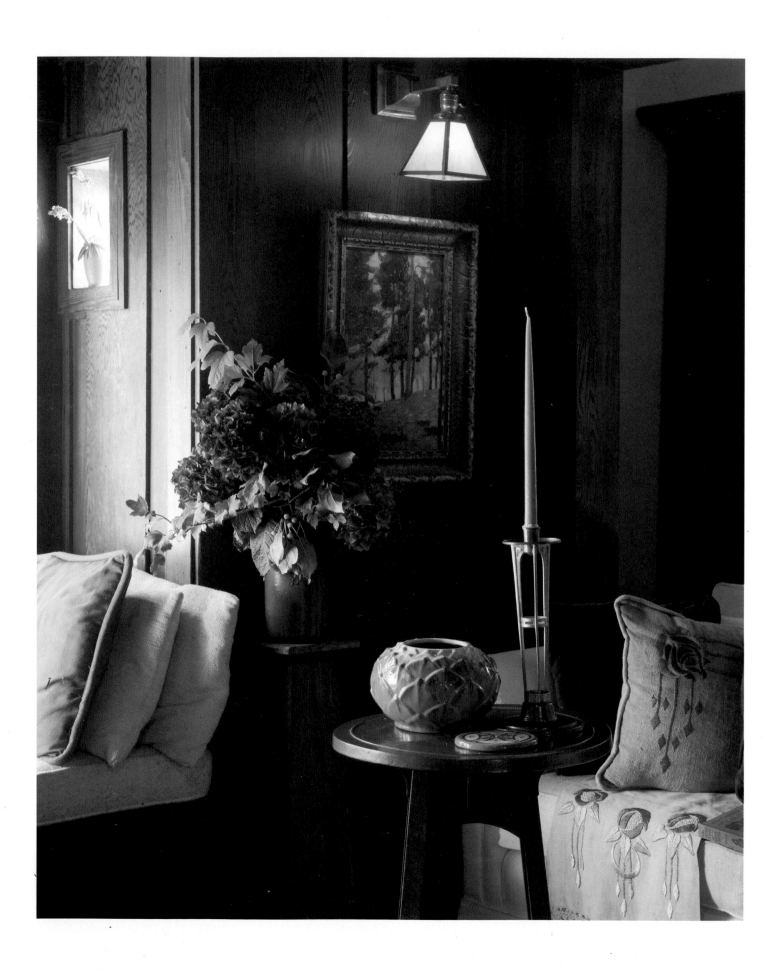

California Craftsman

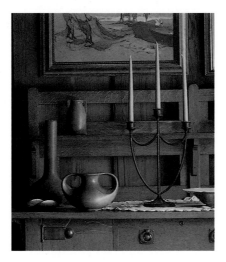

A little over twenty years ago, Caro Macpherson fell in love with the redwood craftsman cottage that she now calls home. Located in hilly North Berkeley, California, the house is dated from 1906 and is traditionally considered to be the work of Bernard Maybeck, the local but widely known Arts and Crafts architect.

Public records pertaining to the house are long gone, most likely destroyed in the Berkeley fire of 1923. Despite lack of documentation, however, those knowledgeable about Maybeck's work credit him with the home, as its architecture and construction details are in keeping with his distinctive style. The wood-paneled walls and dramatic ceiling beams have made the home the perfect backdrop for Macpherson's collection.

Macpherson's cushioned window seat is a charming place to relax in the living room. Displayed nearby, a period candle holder and Fulper artichoke bowl are impressive accessories on a copper-top Limbert table. Turn-of-the-century textiles by the Richardson Company enhance the homey atmosphere.

In the early 1970s, nobody seemed very interested in Mission or Arts and Crafts furniture, but since this style harmonized so beautifully with the house, Macpherson ignored prevailing design trends and sought to decorate her newly purchased home in the Arts and Crafts mode. She duly haunted flea markets and yard sales, buying what she could afford. Her first acquisition was a large green vase labeled "Mission Pottery."

"I put out want lists," says Macpherson, a resourceful collector who enjoys researching the Arts and Crafts field and has amassed a library of books and catalogues. "Dealers laughed at me when I said I wanted five matching lanterns for the bedroom, but eventually I got them."

She has furnished the cottage, which measures about 1400 square feet, with a mixture of American and English Arts and Crafts furnishings. Period accessories are her strongpoint: "I have almost four hundred pieces of American art pottery, as well as a collection of Heintz art metal vases," says this completely addicted collector.

Each room of Macpherson's home is beautifully appointed. Of special note in the living room is a Morris chair and Gustav Stickley sideboard filled with the work of such great Arts and Crafts names as Teco and Batchelder and with later studio pottery by Gertrude and Otto Natzler.

In the dining room, Rookwood and Fulper pieces are arranged on a Michigan Chair Company sideboard. The bedroom boasts a Liberty of London chest ornamented with Ruskin pottery.

Patiently acquired and sensitively arranged, this collection is perfectly in keeping with its environment and has inspired many of Macpherson's friends and acquaintances to begin their own Arts and Crafts quests.

Rich wood tones resonate throughout the home. The light brown grains of the Stickley sideboard and chair make an interesting counterpoint to the red-brown paneled walls. The design motifs of the foyer and living room are unified with pottery and matching Oriental carpets. A particularly intriguing arrangement is the Peters & Reed "Moss Aztec" plant stand crowned with a Van Erp bowl. An E.T. Hurley bronze candlestick and Teco bowl make a dramatic presence on the living room sideboard. Fine art—in the form of Fishermen, *by Frances Arthur Bischoff, and* Sunrise over Grand Canyon, *by A.W. Best—brings even more vivacity to the scene and invokes the simple, natural themes of the movement.*

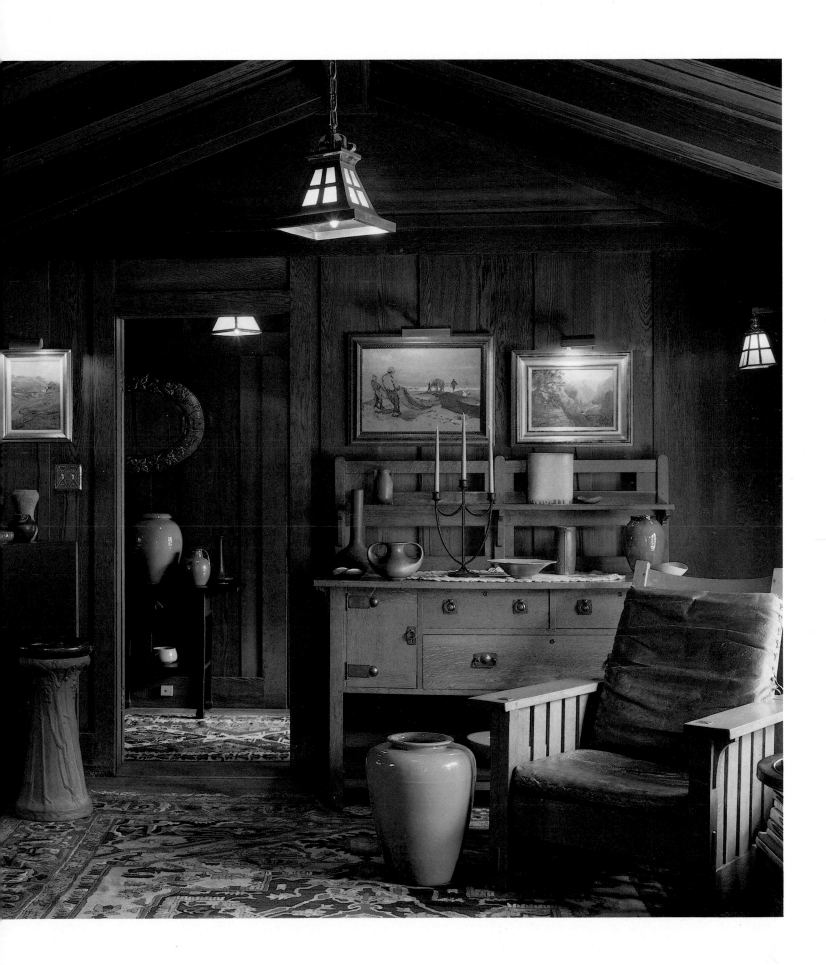

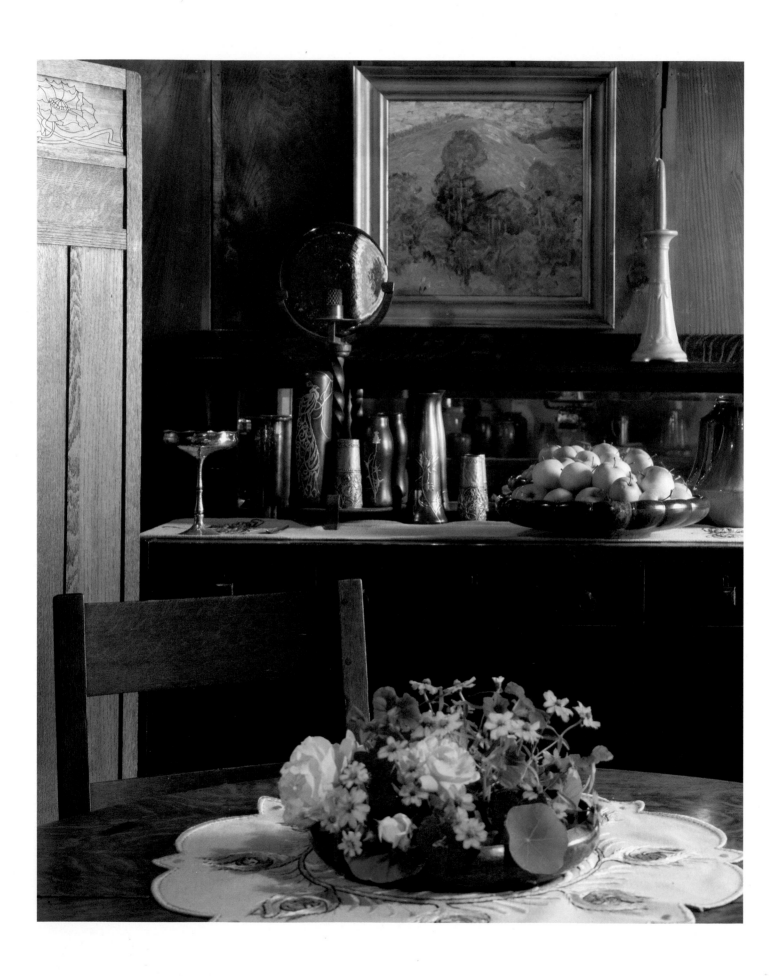

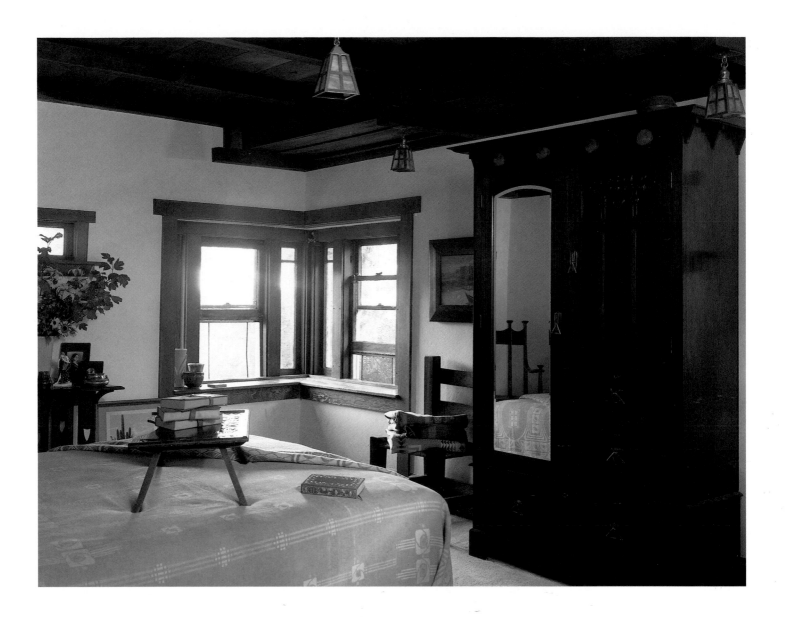

Above, the dropped treatment of the bedroom's ceiling beams mark the house almost unquestionably as a Maybeck design. Fittingly, a Maybeck chair piled with period Pendleton blankets sits adjacent to a Liberty of London armoire with Ruskin pottery decorative medallions.

"The dining room sideboard is one of the first things I bought," says Macpherson. A collection of copper and bronze vessels with sterling silver overlays, left, is by the Heintz Art Metal Shop of Buffalo, New York. These are now highly collectible.

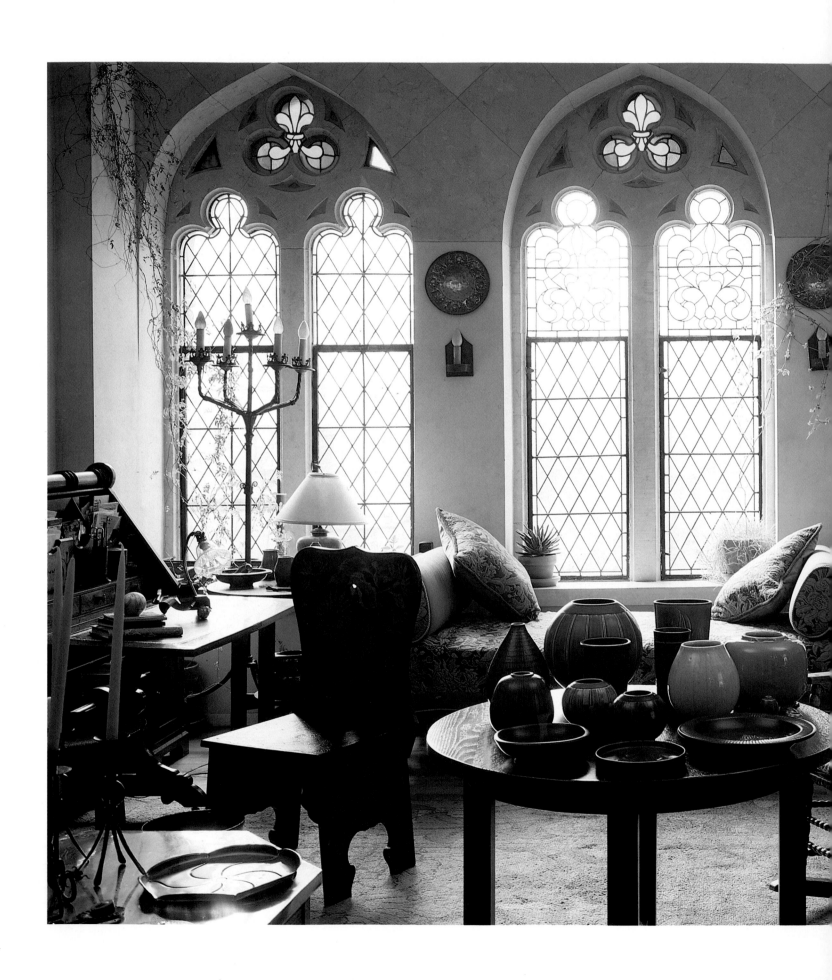

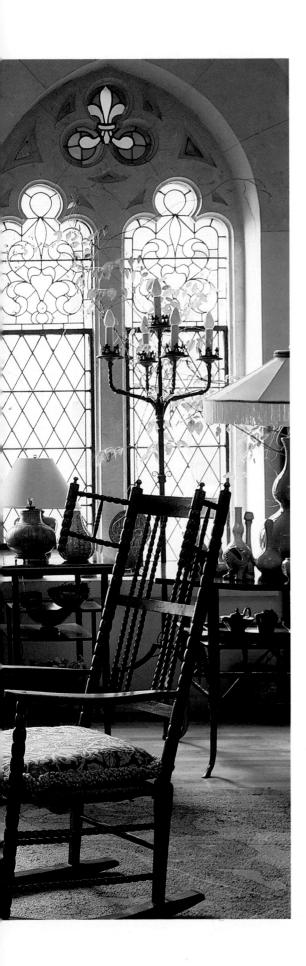

American Gothic

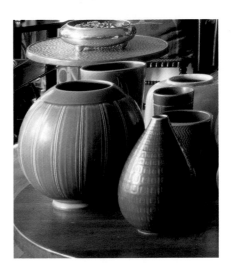

Sarah and Richard Kearns live in a quirky three-room apartment in a former New York City parish house dating from the 1880s. The Gramercy Park building's romanesque style is a splendid showplace for the couple's unusual collection of English Arts and Crafts.

Though the building has been divided into smaller rooms than those in the original plan, the renovated spaces still retain the grandeur of generous proportions and high ceilings. The Kearns' living room, for example, measures twenty by twenty-two feet and is distinguished by three tall stained-glass windows with gothic arches.

The Kearns have furnished their apartment primarily with English Arts and Crafts, which have an almost medieval presence, making them more decorative and frankly antique-looking than most American pieces from the same period. They have accentuated this quality by filling their rooms more generously than is typical in American Arts and Crafts interiors.

Graceful stained-glass windows are accented with faux stone wallpaper, which the couple painstakingly applied by hand. Most of the furniture and accessories are English, though there are exceptions: for example, the wrought-iron candlestands by Addison Mizner, a Florida period architect who worked in the Spanish colonial revival style, and the dropfront desk by Daniel Pabst, a German emigre who worked in Philadelphia.

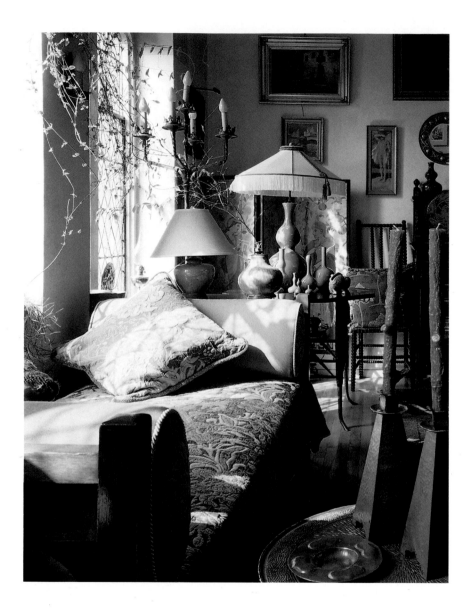

"To look its best, this furniture needs the richness of textiles, pottery, and metalwork," says Sarah Kearns, who is a historic preservation instructor at the Fashion Institute of Technology in New York. Textiles are especially important in imparting vitality, according to the Kearns, who are dealers, as well as collectors, of decorative objects dating from the 1880s to about 1960. In their living room, an area rug by C.F.A. Voysey and a daybed covered with circa 1900 fabric beautifully convey this idea.

A stellar example of how Arts and Crafts collectors take their cue from architecture, the Kearns' home is a remarkable conjuring of late nineteenth-century British manor, tempered by an American eclecticism.

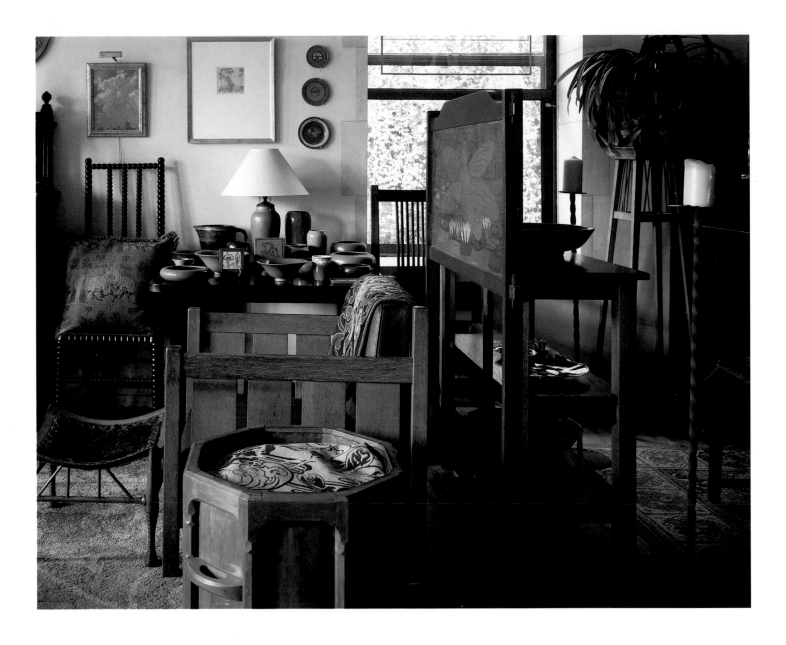

An L. & J.G. Stickley cube chair is paired with a charming screen—possibly by Harvey Ellis—ornamented with pyrography, a popular Arts and Crafts technique that involved using a heated stylus to burn decorative motifs into wood.

Left, the Kearns covered a Gustav Stickley daybed with an embroidered textile— successfully uniting the pattern-oriented English aesthetic with the spare American style. Adorning the Stickley lamp table, a period lampbase is topped by an offbeat fringed shade, which is a modern copy of a Tiffany original.

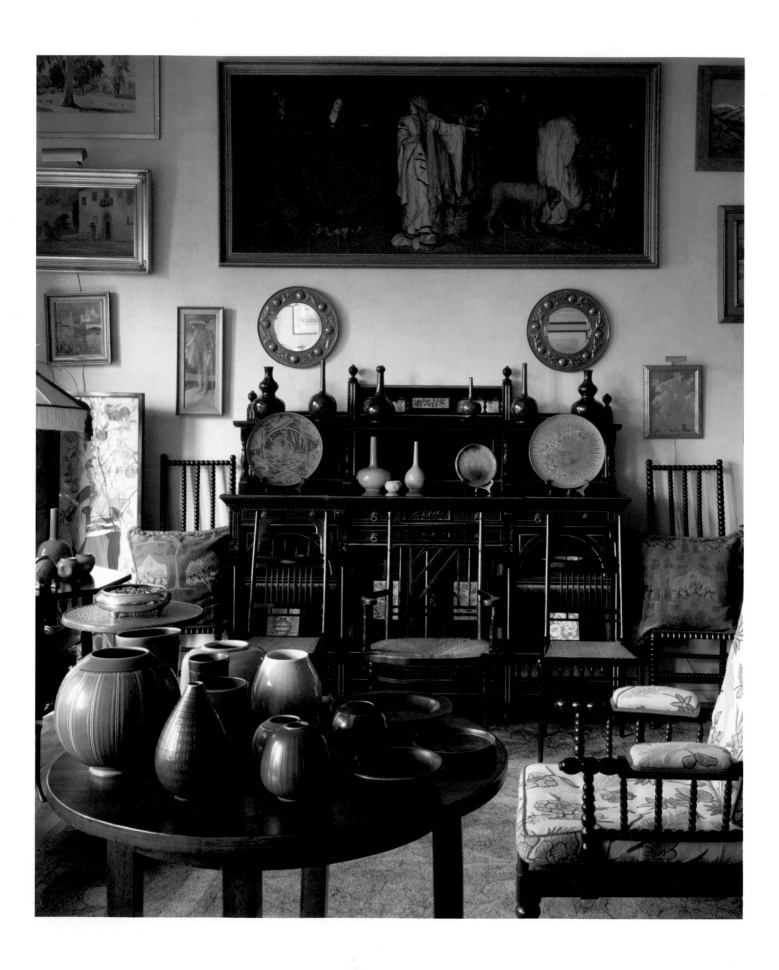

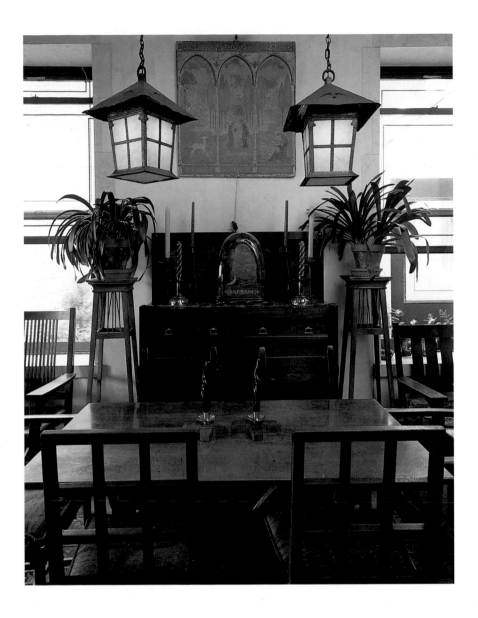

Freely mixing American and English pieces, the Kearns have created a cosmopolitan dining room, above. The table is by Gordon Russell, an English architect, the chairs were made by the British firm Heal & Co., and the copper lanterns are American. Egyptian revival plant stands add a note of intrigue.

Left, pottery in aqua blue, sang de boeuf *red, and mustard yellow shades are all creations of Burmantofts Faïence, an English pottery firm of the 1880s. The pieces decorate an ebonized English sideboard. In the foreground, the round table displays modern-style Danish studio pottery.*

Twentieth-Century Retrospective

Designer Jed Johnson and architect Alan Wanzenberg have worked in many design motifs for clients around the world. Yet for their own home—a seven-room duplex apartment in Manhattan—they chose the Arts and Crafts style.

The apartment is in a building put up at the turn of the century to house artist's studios. Its amenities include double-height windows, fine oak floors, and generous amounts of oak paneling and moldings in the Arts and Crafts style. The designers retained these desirable features, while modernizing plumbing and electrical wiring and redoing the kitchen.

The intrinsic interest of the architecture almost dictated the selection of the Arts and Crafts style. "Perhaps if the apartment hadn't been in such good condition when we bought it, we might have done something in a more modern vein," says Wanzenberg.

One of the first things visitors notice is a stylized thistle motif on the mosaic-tile surrounding the fireplace. Originally created as a collaborative effort between architect George Washington Maher and designer Louis Millet for a Chicago home, the tiles were reinstalled in this apartment. The table lamp and tall copper pot on the mantel are the work of Dirk Van Erp; Gustav Stickley contributed the sconce.

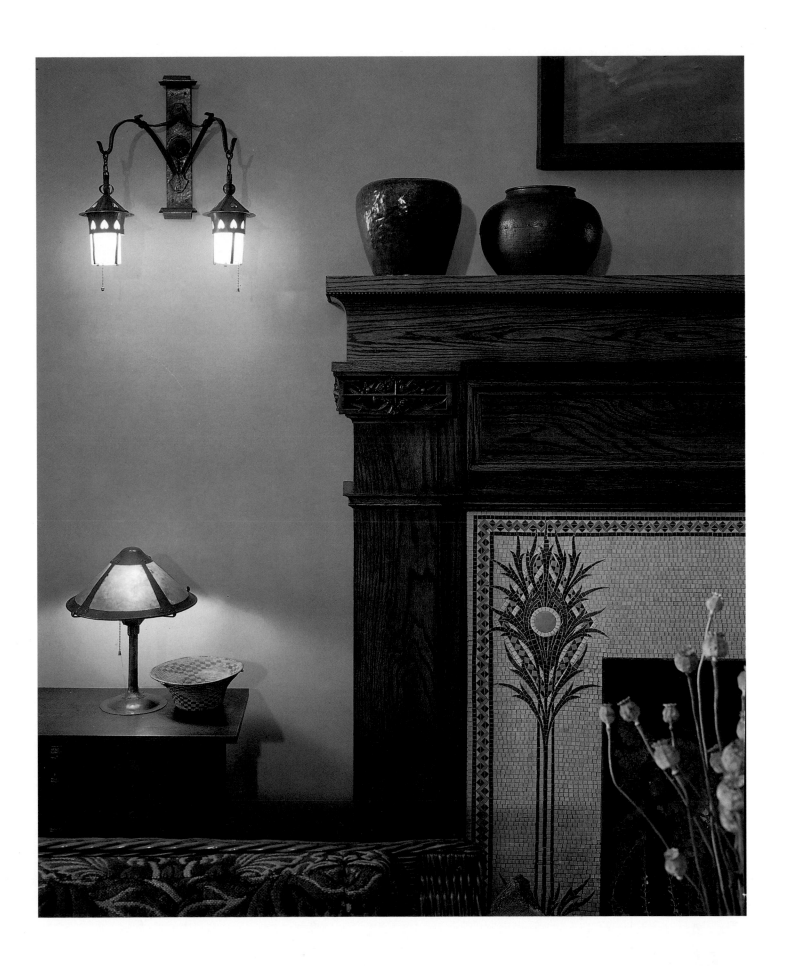

Despite the fact that they were primarily motivated by decorative considerations, and not the wish to assemble a museum-quality collection, they have managed to amass an impressive array of important American and English furniture, art pottery, metal accessories, lighting, and rugs.

The Arts and Crafts objects coexist with modern art, which includes graphics by Andy Warhol and paintings and sculpture by later American and Italian artists. "The art is the only thing that is contemporary," says Johnson, who worked on Andy Warhol's films after moving to New York from California. The apartment is also home to a small collection of American Indian artifacts.

Wanzenberg and Johnson often work in the Arts and Crafts style for clients. To counter its severity—especially the seating—they sometimes select contemporary upholstered pieces and modern fabrics, which can add color to the muted Arts and Crafts palette. "Any of the natural linens, woolens, and leathers can be adapted, and hand-loomed contemporary fabrics are also a fine choice," says Johnson.

Wanzenberg says those seeking inspiration for authentic interiors and adaptations should visit one or more of the Arts and Crafts architectural masterpieces, where each detail contributes to the entire effect. Certain houses by Greene and Greene and Frank Lloyd Wright are open to the public and can deepen an understanding of how to adapt the style to the present. "Even a simple bungalow furnished with Craftsman pieces has a special dignity because of details such as wooden wainscoting and oak trim," he says. If necessary, architectural ornamentation can be added to an interior to evoke a period feel. Wherever one calls home, the message is clear: Arts and Crafts furnishings adapt easily to a variety of surroundings, with surprisingly original results every time.

Arts and Crafts interiors needn't be completely authentic to succeed. In the library, the desk and hexagonal table are English gothic revival pieces. The chairs are by Alexander Roux, a midnineteenth-century American furniture maker. Johnson and Wanzenberg themselves designed the oak cabinetry along the wall and have displayed their collection of American art pottery.

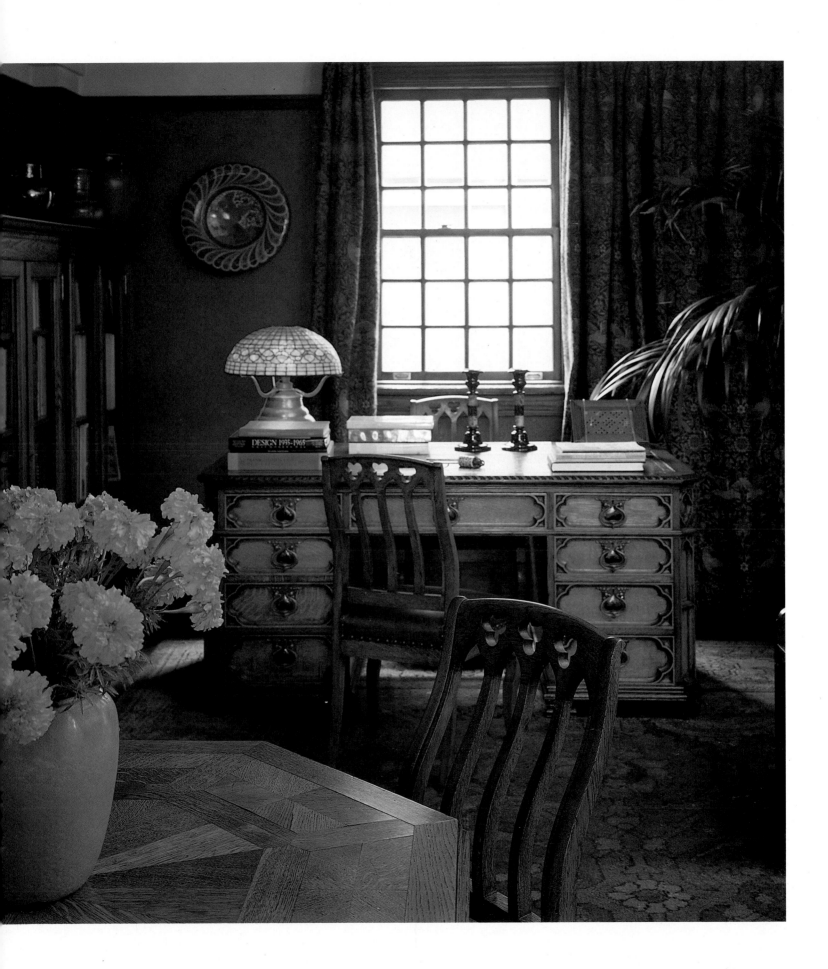

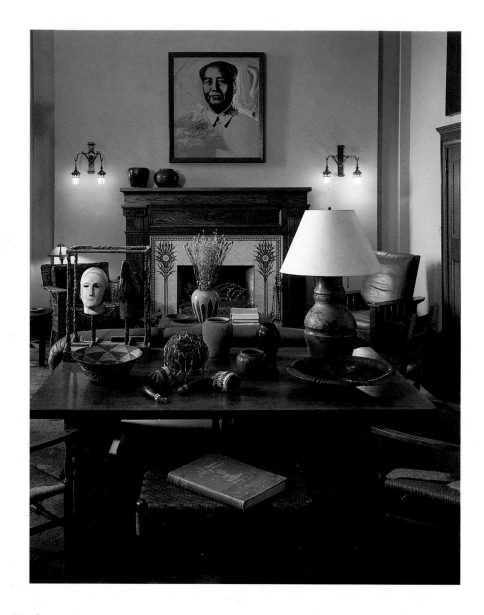

Above, Andy Warhol's silk-screen portrait of Chairman Mao hangs over the living room fireplace. The L. & J.G. Stickley console table holds a modern bronze head by Mimmo Paladino and American Indian artifacts. Enriching the mix is a lamp with a New England Hampshire pottery base.

Double-height north-facing windows in the living room, right, recall the building's origin as an artists' studio space. At night, the curtains are drawn, revealing a rich Arts and Crafts–inspired textile motif. Comfortably broken-in English turn-of-the-century club chairs flank the Stickley leather-top table. The straight-back, rush-seat chairs are also English. Repeating the verticality of the windows, silk-screen Warhol dollar bills are displayed atop a cabinet attributed to the English Arts and Crafts designer Ernest Gimson.

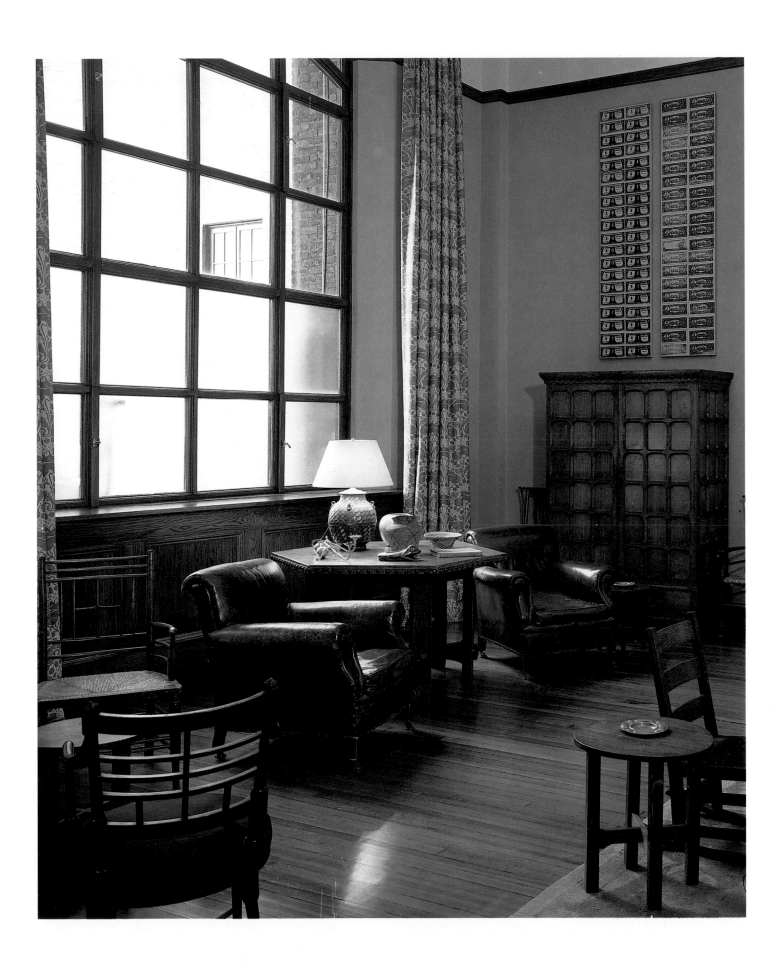

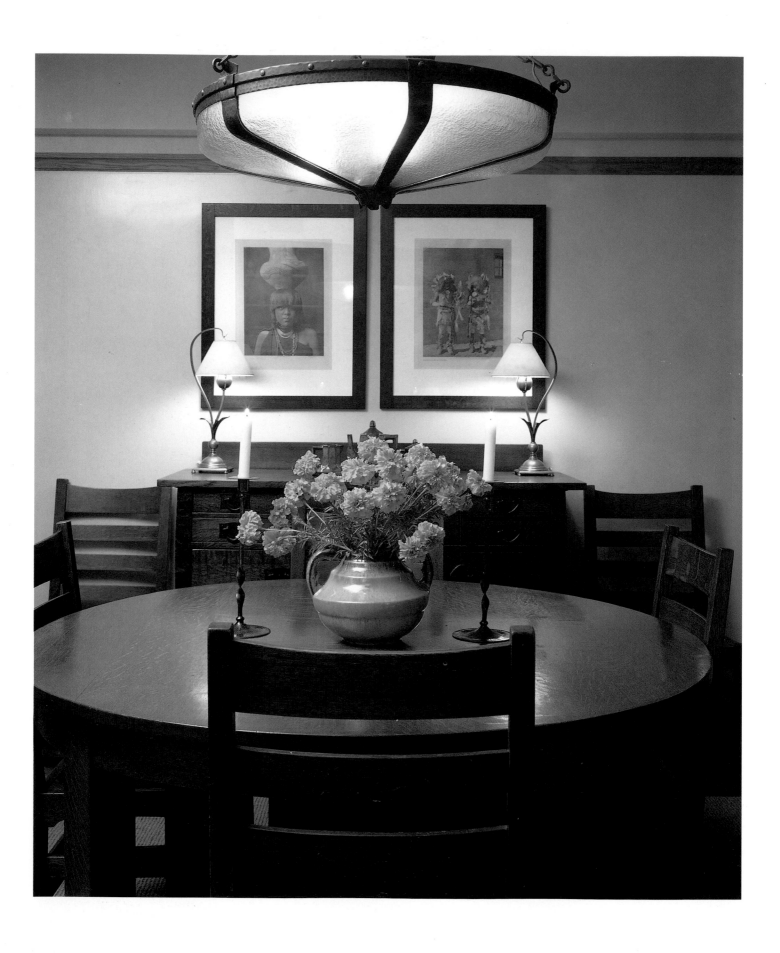

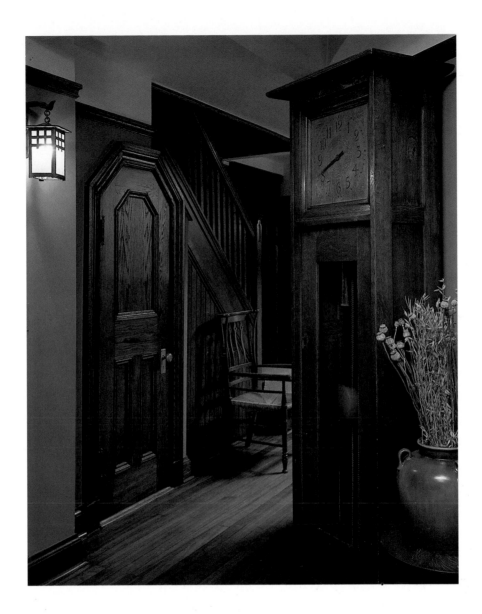

Original woodwork is one of the outstanding features of the apartment and is particularly beautiful on the chamfered doors and stairway, above. The urn is by Fulper, the tall case clock by Gustav Stickley, and the chair by the English designer-architect Edward Lutyens. Only the lantern is not authentic.

Left, dining room furniture by Gustav Stickley, including a Harvey Ellis–designed table, is in distinguished company: framed photogravures by Edward S. Curtis and lamps by W.A.S. Benson, a member of Morris's circle. The overhead lighting fixture is also a Stickley design.

Hollywood Hacienda

"A Hollywood hacienda" is the way screenwriter Nancy Dowd describes her stucco house built in 1927 as part of a development known as Hollywoodland. Dowd purchased the house on sight over a decade ago. She found the simple structure, whose features include exposed beam ceilings and a generous veranda, completely irresistible.

It was only after she had lived in the house for a few years that Dowd discovered it had inspired the setting for a Raymond Chandler short story entitled "Try the Girl." The story concerns a woman writer who lives in the very same house, recalls Dowd with evident amusement. The detective writer later expanded the story into his novel, *Farewell My Lovely*.

At the time she bought the house, Dowd owned only a few items of furniture, but they happened to be in the Mission style. "This kind of furniture reminded me of New England, which is where I am from," says the writer. Since these pieces fit the house like a glove, she began to acquire more, working with photographs mainly through the Jordan Volpe Gallery in New York City. "I don't think of myself as a collector. I use all this stuff. I bought what I needed when I found something I liked," Dowd says.

The dining room is serenely simple, boasting a Gustav Stickley dining set and a Stickley screen with leather inserts. An iridescent overhead lighting fixture complements the sunflower-yellow tones of the Fulper bowl on the table.

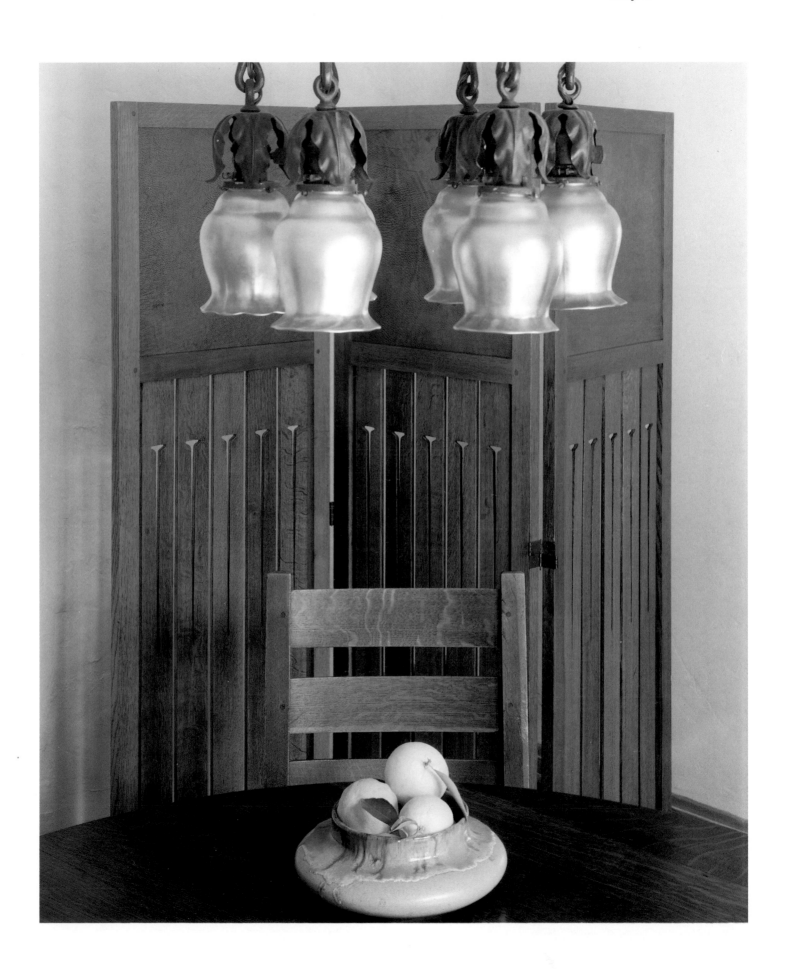

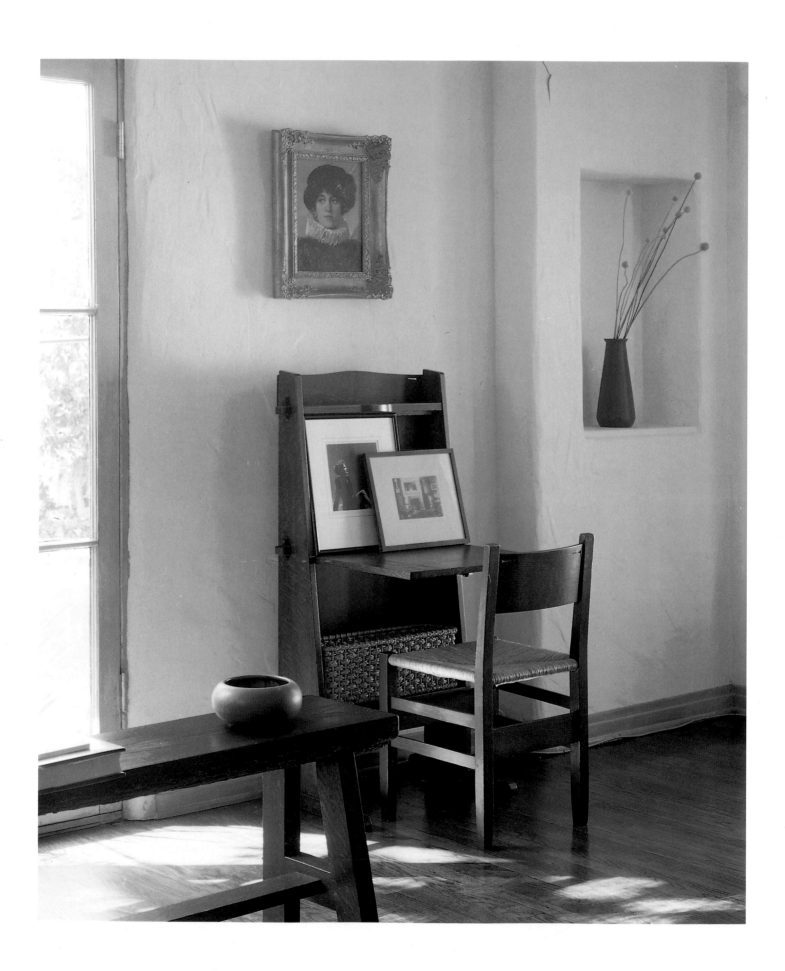

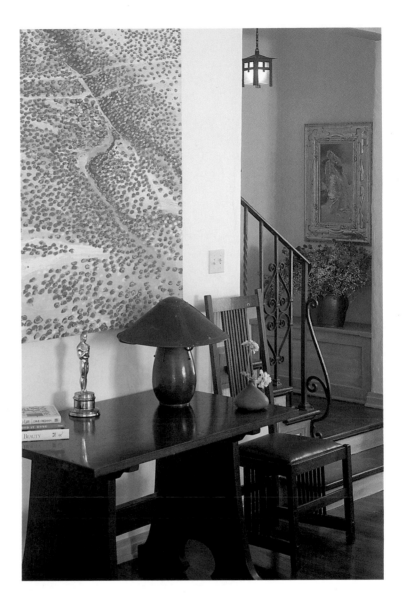

Though movie Oscars are not on any official list of Arts and Crafts accessories, Dowd's award looks beautiful illuminated by a Van Erp lamp, right. The modern painting of the California desert is by Michael Moore.

Left, a Gustav Stickley dropfront desk serves writers just as well today as it did decades ago, though here it is used for photograph display. Dowd's prized Roycroft Ali Baba bench is topped by a Teco vase.

She has accessorized the Gustav Stickley pieces she prefers with fine art, from both the Pre-Raphaelite era and the contemporary realist California school, art pottery, and Dirk Van Erp and Roycroft lamps. Throughout the home, wood floors are scattered with Oriental rugs.

"I think the cool sobriety of the wood makes a nice contrast to the exterior light of Los Angeles, which can be very hard," Dowd says.

For this Los Angeles resident, the Arts and Crafts style grows ever more beautiful in the eye of its beholder. Says Dowd, "This furniture has weathered a number of decorating storms and has come out on the other side looking nicer all the time."

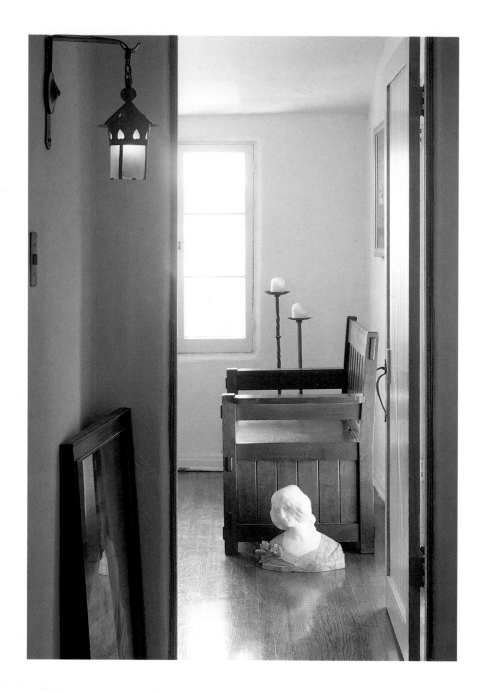

Above, an English marble bust stands next to a hall bench by Gustav Stickley. The lantern is a reproduction from the Mission Oak Co.

The Spanish "hacienda" effect is conveyed with a series of arched doorways, right. The rough-plastered walls and the ceiling beams suggest the interiors of the Franciscan missions.

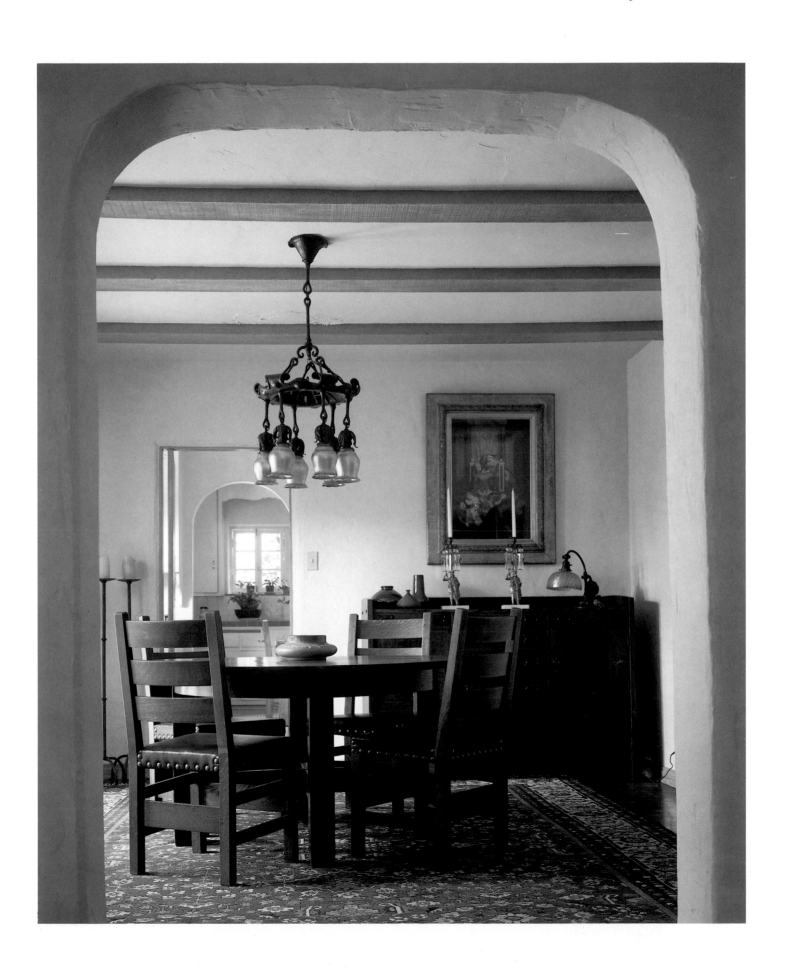

Collective Consciousness

There was absolutely no question that Robert Winter's historically significant California bungalow would be furnished in the Arts and Crafts style. The house, built in 1909 by Ernest Batchelder—an important Arts and Crafts ceramist and design theorist—was constructed by the artisan for himself and his family.

Batchelder came to Pasadena to teach at Throop Polytechnic Institute—known today as the California Institute of Technology. He stayed on to make tiles for a generation of southern Californians. Winter bought the house in 1972 when it came on the market.

"At the time, nobody knew who Ernest Batchelder was, or cared, for that matter," recalls Winter, a professor at Occidental College, whose field is American architectural history. Since then, Winter's own research has helped bring the achievements of Batchelder to light. He is writing a biography of Batchelder and his wife, Alice Coleman.

Built-in cabinetry is typical of Arts and Crafts interiors. The dining room chairs were created by Oscar Oncken, a Cincinnati cabinetmaker, but Winter found them in a California antiques store. There were only seven, and he hopes to find an eighth chair in his ongoing search.

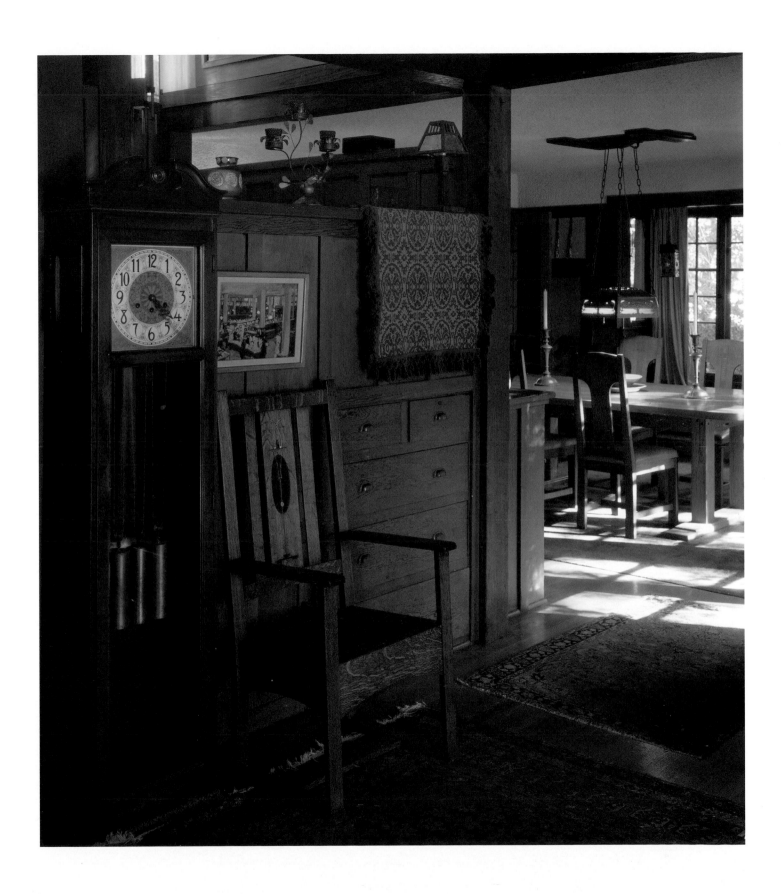

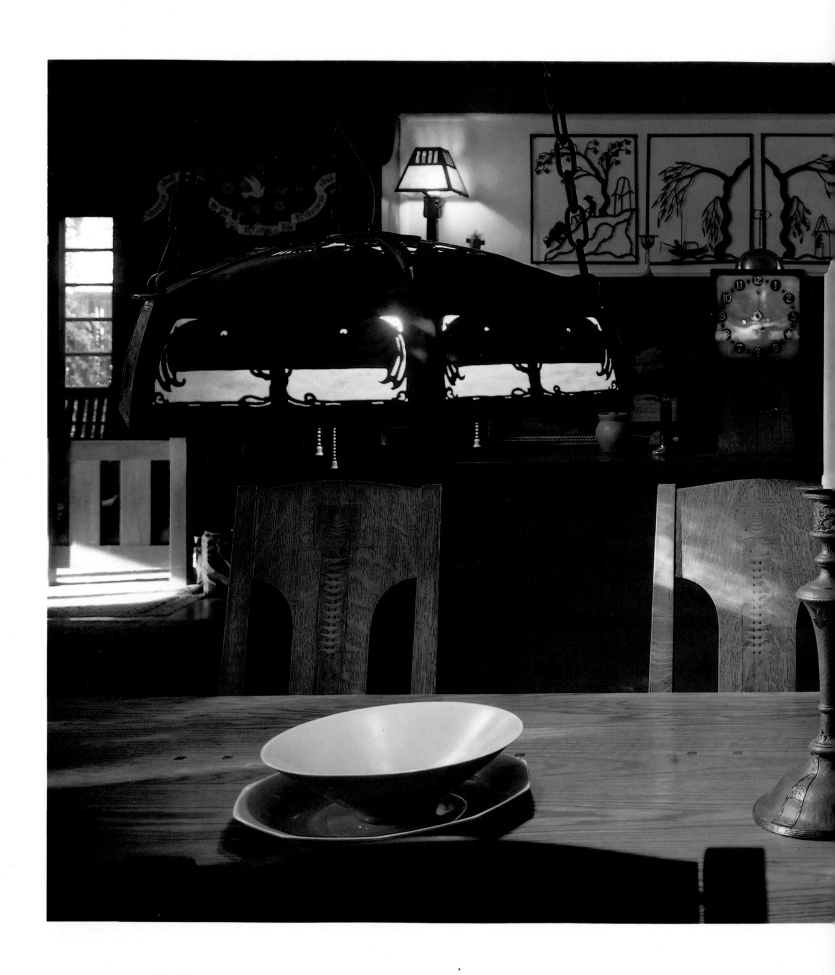

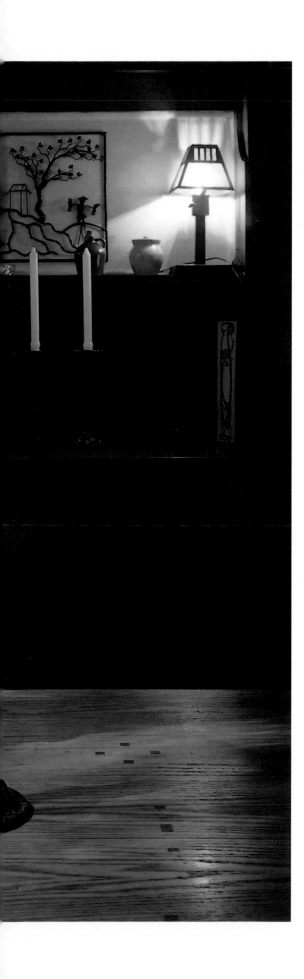

The house, which is a prime example of the California Arts and Crafts bungalow, is "literally a museum of tiles," says Winter. Its most spectacular feature is the ceiling-height fireplace of variegated brown-and-blue tiles with pictorial tile inserts. Batchelder added it to the house as a present to his new wife. Also marking the residence as an Arts and Crafts house are extensive wood paneling, built-in cabinetry, and stained-glass and metal lighting fixtures.

Winter was lucky enough to find the house basically intact and all the original lighting fixtures in place. He has furnished it with additional Arts and Crafts period furniture and high-quality reproductions, such as a wallpaper frieze by Walter Crane on which the words "The wilderness shall blossom as the rose" are interwoven with images of lions and doves and plants. (The frieze is a reproduction by Bradbury and Bradbury.)

It's not essential to stay totally within the period in order to produce an authentic period interior, as Winter has done. He has found that family pieces such as a Victorian chair go nicely with the Arts and Crafts furnishings, both originals and reproductions.

Some people might find the Arts and Crafts style rather dark. But Winter sees the subdued palette as part of the appeal and likes to consider the style as a series of juxtapositions. Says Winter, "The front of the house was consciously kept almost cave-like to encourage a feeling of enclosure and warmth, and the fireplace is meant to be a focal point of light." Such is the complexity and charm of Arts and Crafts architecture.

A superb example of an Arts and Crafts dining room, Winter's features a lighting fixture probably designed by Batchelder himself. The built-in sideboard and wood paneling exemplify design tenets of ideal Arts and Crafts interiors. Originally, a stained-glass panel covered the section of white wall above the sideboard; the metal plaques now adorning the wall are Chinese.

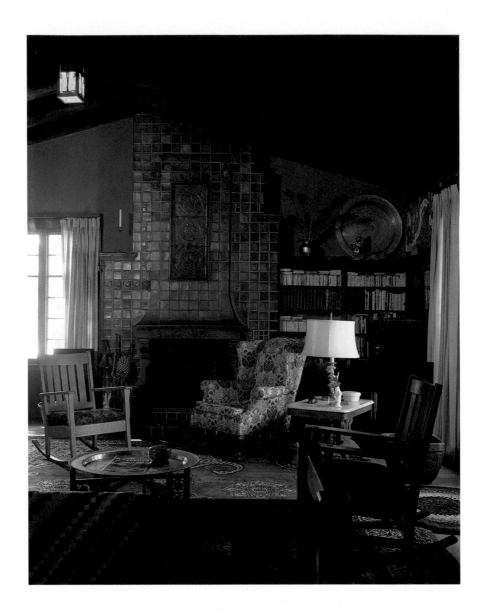

Batchelder fabricated both the plain and the pictorial tiles for the fireplace in the living room above. Winter considers it the most spectacular feature of the house.

Right, wood wainscoting, a window seat, and the decorative wallpaper frieze near the ceiling are typical Arts and Crafts features. The paneling is original, but Winter added the frieze, a Bradbury and Bradbury reproduction.

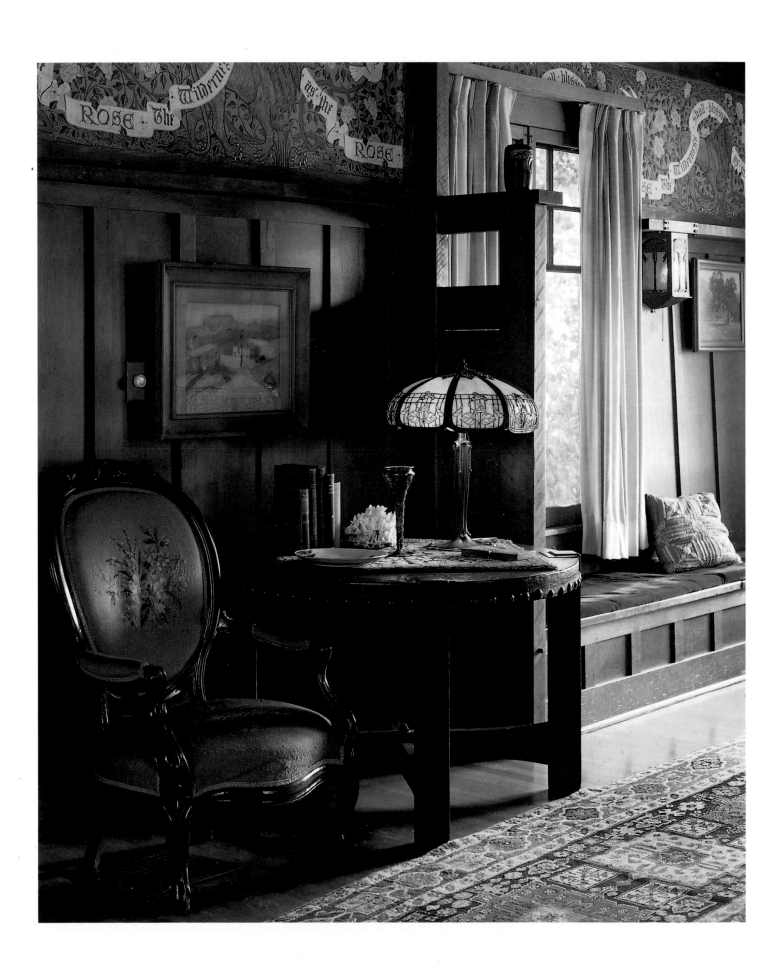

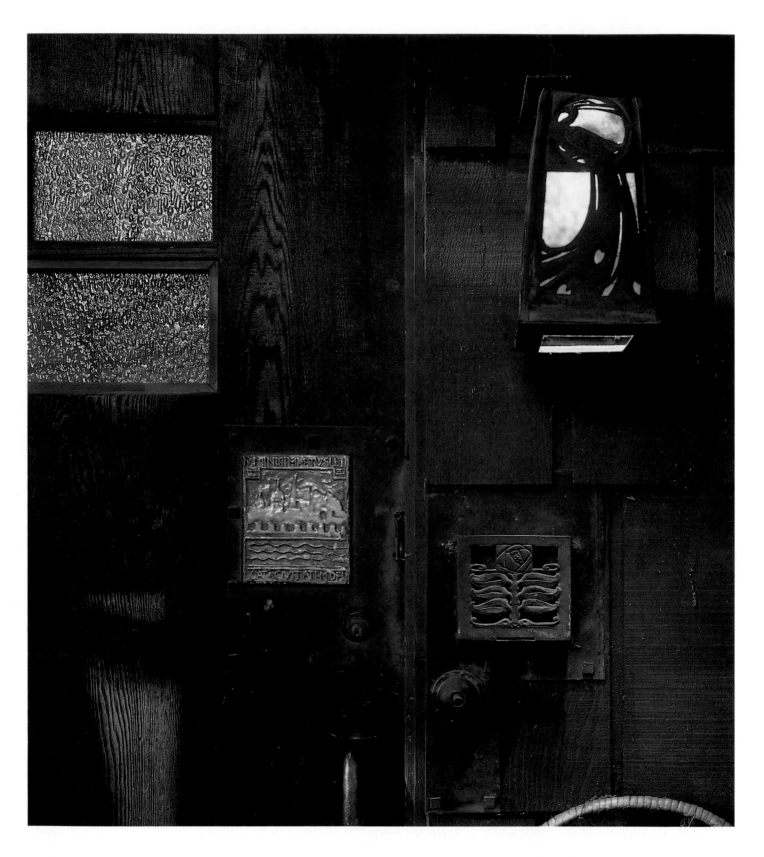

The front door, lantern, and mailbox are Batchelder designs, but the pictorial tile is from Henry Mercer's Moravian Tile Works in Pennsylvania.

Bibliography

Books

Anscombe, Isabelle. *Arts & Crafts Style.* New York: Rizzoli, 1991.

Anscombe, Isabelle, and Charlotte Gere. *Arts and Crafts in Britain and America.* New York: Rizzoli, 1978

Bishop, Robert, and Patricia Coblentz. *American Decorative Arts 360 Years of Creative Design.* New York: Harry N. Abrams, 1982.

Brooks, H. Allen. *Frank Lloyd Wright and the Prairie School.* New York: George Braziller, Inc., in association with Cooper-Hewitt Museum, 1984.

Cathers, David M. *Furniture of the American Arts and Crafts Movement: Stickley and Roycroft Mission Oak.* New York: New American Library, 1981.

Clark, Garth. *American Ceramics 1876 to the Present.* New York: Abbeville Press, 1987.

—, et al. *The Mad Potter of Biloxi: The Art and Life of George E. Ohr.* New York: Abbeville Press, 1989.

Darling, Sharon S. *Chicago Furniture Art, Craft, and Industry 1833–1983.* Chicago: Chicago Historical Society, 1984.

Hanks, David A. *The Decorative Designs of Frank Lloyd Wright.* New York: E. P. Dutton, 1979.

Hayward, Helena, ed. *World Furniture.* London: Hamlyn Publishing Group, 1970.

Hosley, William. *The Japan Idea Art and Life in Victorian America.* Hartford, Connecticut: Wadsworth Atheneum, 1990.

Lambourne, Lionel. *Utopian Craftsmen: The Arts and Crafts Movement from the Cotswolds to Chicago.* Salt Lake City: Peregrine Smith, Inc., 1980.

Larkin, Oliver W. *Art and Life in America.* New York: Rinehart & Co., 1949.

Levin, Elaine. *The History of American Ceramics 1607 to the Present.* New York: Harry N. Abrams, 1988.

Lynn, Catherine. *Wallpaper in America.* New York: W. W. Norton & Co., 1980.

Makinson, Randell L. *Greene and Greene Architecture as a Fine Art.* Salt Lake City and Santa Barbara: Peregrine Smith, Inc., 1977.

Naylor, Gillian. *The Arts and Crafts Movement: A Study of Its Sources, Ideals, and Influence on Design Theory.* Cambridge, Massachusetts: MIT Press, 1971.

Sanders, Barry, ed. *The Craftsman: An Anthology*. Salt Lake City and Santa Barbara: Peregrine Smith, Inc., 1978. A collection of articles, photos, and drawings from *The Craftsman*.

Volpe, Tod M., and Beth Cathers. *Treasures of the American Arts and Crafts Movement 1890–1920*. New York: Harry N. Abrams, 1988.

Wilhide, Elizabeth. *William Morris Decor and Design*. New York: Harry N. Abrams, 1991.

Wilson, H. Weber. *Great Glass in American Architecture: Decorative Windows and Doors Before 1920*. New York: E.P. Dutton, 1986.

Exhibition Catalogues

Anderson, T. J., E. M. Moore, and R. W. Winter, eds. *California Design 1910*. Salt Lake City and Santa Barbara: Peregrine Smith, Inc., 1980. Reprint of catalogue for an exhibition at Pasadena Art Museum, October through December 1, 1974.

Bowman, Leslie Greene. *American Arts & Crafts: Virtue in Design. A Catalogue of the Palevsky/Evans Colletion and Related Work at the Los Angeles County Museum of Art*. Los Angeles: Los Angeles County Museum of Art, 1990.

Clark, Robert Judson, ed. *The Arts and Crafts Movement in America 1876–1916*. Princeton, New Jersey: Princeton University Press, 1972.

Cooper-Hewitt Museum, ed. *American Art Pottery*. distributed by University of Washington Press, Seattle and London, 1987.

Dale, Sharon. *Frederick Hurten Rhead: An English Potter in America*. Erie, Pennsylvania: Erie Art Museum, 1986.

Darling, Sharon S. *Teco Art Pottery of the Prairie School*. Erie, Pennsylvania: Erie Art Museum, 1989.

Kaplan, Wendy. *"The Art that is Life": The Arts and Crafts Movement in America, 1875–1920*. Boston: Museum of Fine Arts, 1987.

Lamoureux, Dorothy, ed. *The Arts And Crafts Studio of Dirk Van Erp*. San Francisco: San Francisco Craft and Folk Art Museum, 1989.

Ludwig, Coy L. *The Arts and Crafts Movement in New York State 1890s–1920s*. Hamilton, New York: Gallery Association of New York State, 1983.

Marek, Don. *Arts and Crafts Furniture Design: The Grand Rapids Contribution 1895–1915*. Grand Rapids, Michigan: Grand Rapids Art Museum, 1987.

Sources

Dealers

The Arts & Crafts Emporium
1473 Pine Street
San Francisco, CA 94109
(415) 673-8309

The Arts & Crafts Shop
1417 Bridgeway
Sausalito, CA 94965
(415) 331-2554

A.S.G. Antiques
Route 2, Box 66
Berkeley Springs, WV 25411
(304) 258-4037

Bryce Bannatyne Gallery
604 Colorado Avenue
Santa Monica, CA 90401
(213) 396-9668

Robert Berman Antiques
441 South Jackson Street
Media, PA 19063
(215) 843-1516
By appointment only

Cadillac Jack
6911 Melrose Avenue
Los Angeles, CA 90038
(213) 931-8864

Capitol Arts and Antiques
134 East 9th Street
St. Paul, MN 55101
(612) 771-3724

Michael Carey Gallery
77 Mercer Street
New York, NY 10012
(212) 226-3710/4054

Cathers & Dembrovsky
1000 Madison Avenue
New York, NY 10021
(212) 737-4466

Craftsman Antiques
316 Occidental Avenue S.
Seattle, WA 98104
(206) 223-0717

Crybaby Ranch
1428 Larimer Square
Denver, CO 80202
(303) 623-3979

Dalton's
1931 James Street
Syracuse, NY 13206
(315) 463-1568

Geoffrey Diner Gallery
1730 21st Street, NW
Washington, DC 20009
(202) 483-5005

Duke Gallery
209 N. Woodward
Birmingham, MI 48009
(313) 258-6848

Michael FitzSimmons
311 W. Superior Street
Chicago, IL 60610
(312) 787-0496

Gallery 532
532 Amsterdam Avenue
New York, NY 10024
(212) 496-9794

Hirschl Adler
21 East 70th Street
New York, NY 10021
(212) 535-8810

JMW Co.
144 Lincoln Street
Boston, MA 02111
(617) 338-9097

Kelmscott Gallery
4611 North Lincoln Avenue
Chicago, IL 60605
(312) 784-2559

Kurland-Zabar
19 E. 71st Street
New York, NY 10021
(212) 517-8576

Isak Lindenauer
4143 Nineteenth Street
San Francisco, CA 94114
(415) 552-6436

D. Magner Antiques
275 Lafayette Street
New York, NY 10012

Dennis Miller
2166 Sunset Boulevard
Los Angeles, CA
(213) 413-5499

Mission Possible
801 Pennsylvania Avenue, S.E.
Washington, DC 20003
(202) 547-0440

Jack Moore—Craftsman Furniture
69 S. Colorado Avenue
Pasadena, CA 91107
(818) 577-7746

Barbara Nelson
Nelson Gallery of Antiquities
5011 Soquel Drive
Soquel, CA 95073
(408) 464-8393

The Pavilion Antiques
610 Sir Francis Drake Boulevard
San Anselmo, CA 94960
(415) 459-2902

Peter-Roberts Gallery
134 Spring Street
New York, NY 10012
(212) 226-4777

David Rago Arts & Crafts
17 S. Main Street
Lambertville, NJ 08530
(609) 397-9374

Richard Gallery
Parnassus Square
2 Lower Byrdcliffe
Woodstock, NY 12498
(914) 679-7561

Terry Seger
3730 Moonridge
Cincinnati, OH 45248
(513) 574-8649

Topaz Antiques
Main and Rector Streets
Manayunk, PA 11927
(215) 482-6500

Don Treadway
2128 Madison Road
Cincinnati, OH 45208
(513) 321-6742

Voorhees
1340 Fourth Street
Santa Rosa, CA 95401
(707) 584-5044

Auction Houses

Christie's
502 Park Avenue
New York, NY 10022
(212) 546-1000

Christie's East
219 East 67th Street
New York, NY 10021
(212) 606-0400

William Doyle Galleries
175 East 87th Street
New York, NY 10128
(212) 427-2730

Phillips
406 East 79th Street
New York, NY 10021
(212) 570-4830

David Rago
American Arts & Crafts Auction
17 S. Main Street
Lambertville, NJ 08530
(609) 397-9374
Auctions of Arts & Crafts objects
and furniture, five times a year

Savoia's Auction Inc.
Route 23
South Cairo, NY 12482
(518) 622-8000

Skinner Inc.
2 Newbury Street
Boston, MA 02116
(617) 236-1700

Sotheby's
1334 York Avenue
New York, NY 10021
(212) 606-7000

Tepper Galleries
110 E. 25th Street
New York, NY 10010
(212) 677-5300

Don Treadway
2128 Madison Road
Cincinnati, OH 45208
(513) 321-6742

Contemporary Craftsmen & Manufacturers

FURNITURE

The Arroyo Craftsman
2080-B Central Avenue
Duarte, CA 91010
(818) 359-3298

E. J. Audi
317 E. 34th Street
New York, NY 10016
(212) 679-7580

Berkeley Mill & Furniture Co.
1806 Fourth Street
Berkeley, CA 94710
(415) 549-2854

Coly Vulpiani
11 Field Court
Kingston, NY 12401
(914) 339-6146

Crate and Barrel
(800) 323-5461

Fletcher-Cameron
320 Dromara Road
Guilford, CT 06437
(203) 453-0149
Arts and Crafts and Mission-style furniture designed by great-granddaughter of Frank Lloyd Wright and her partner

Heinz and Co.
P.O. Box 663
Oak Park, IL 60603
(616) 245-9400

Tanya Hovnanian Decorative Arts, Inc.
5117 West Adams
Los Angeles, CA 90016
(213) 938 6523
Wrought-iron furniture and lamps

James Randell
768 N. Fair Oaks Avenue
Pasadena, CA 91104
(818) 792-5025
Custom furniture inspired by Greene & Greene

Scott Jordan Furniture
327 Atlantic Ave
Brooklyn, NY 11201
(718) 522-4459
New and vintage Arts and Crafts furniture and objects

Randolph Laub Furniture
310 Johnston Street
Santa Fe, NM 87501
(505) 984-0081
(800) 828-2313
Arts and Crafts-style furniture inspired by Stickley

The Mission Oak Shop
RR2, Box 331-B
Woodstock, CT 06281
(203) 928-6602

The Mission Oak Shop
4230 Park Boulevard
Oakland, CA 94602
(510) 482-1420

Perez Furniture
379 Summer Street
Plantsville, CT 06479
(203) 276-8200
Fine handmade wood furniture

Room and Board
4600 Olson Memorial Highway
Minneapolis, MN 55422
(800) 486-6554
Showrooms in Minnesota and Colorado

L. & J.G. Stickley, Inc.
Stickley Drive, P.O. Box 480
Manlius, NY 13104
(315) 682-5500/5441

Taos Furniture Co.
232 Galisteo Street
Santa Fe, NM 87501
(505) 988-1229

Taylor Woodcraft
Box 245
S. River Road
Malta, OH 43758
(314) 962-3741

Tiger Mountain Woodworks
P.O. Box 249
Scaly Mountain, NC 28775
(704) 526-5577

Vulpiani Workshop Inc.
11 Field Court
Kingston, NY 12401
(914) 339-6146

Charles Webb
51 McGrath Highway
Somerville, MA 02143
(617) 776-7100

Stephen W. Wescott
New Craftsman Furnishings
3820 Beecher Street N.W.
Washington, D.C. 20007
(202) 337-1978

LIGHTING

Michael Adams
Aurora Studios
R.R. 8, Box 554
Oswego, NY 13126
(315) 343-0339

Antique Lighting Co.
1000 Leonora Street
Suite 314
Seattle, WA 98072
(206) 622-8298

Architectural Rarities, Ltd.
10650 Country Road 81
Maple Grove, MN 55369
(612) 424-1158

Karl Barry Studio
396 Atlantic Avenue
Brooklyn, NY 11217
(718) 596-1419

Bruce Eigher
8755 Melrose Avenue
Los Angeles, CA 90069
(213) 657-4630

Umbrello
8607 Melrose Avenue
Los Angeles, CA 90069
(213) 659-4335

OBJECTS AND
DECORATIVE
ACCENTS

Architect Series from
Windows Pella
Pella/Rolscreen
102 Main Street
Pella, IA 50219
(515) 628-6467
Architectural details

Dianne Ayres
P.O. Box 9482
Berkeley, CA 94709
(510) 654-1645
Arts and Crafts-inspired textiles

Bradbury and Bradbury
Wallpapers
P.O. Box 155
Benicia, CA 94510
(707) 746-1900

Roycroft Associates
31 South Grove Street
East Aurora, NY 14052
(716) 655-0562
Tableware, furniture, and lighting

Arthur Sanderson & Co.
979 Third Avenue
New York, NY 10022
(212) 319-7220
William Morris wallpapers

Tony Smith
Buffalo Studios
1925 East Deere Avenue
Santa Ana, CA 92705
(714) 250-7333
Arts and Crafts-inspired
metalwork

Lars Stanley
Box 3095
Austin, TX 78764
(512) 445-0444
Arts and Crafts-inspired
metalwork

The Woods Company
2357 Boteler Road
Brownsville, MD 21715
(301) 432-8419
Architectural millwork

Zeze
398 E. 52nd Street
New York, NY 10022
(212) 753-7767
Arts and Crafts-style vases

Houses to Visit

Ennis Browne House
2655 Glendower Avenue
Los Angeles, CA 90027
(213) 660-0607
Frank Lloyd Wright textile-block
house; open a few times a month
for guided tours.

Craftsman Farms
2352 Rte. 10 West (Parsippany)
Box 5
Morris Plains, NJ 07950
(201) 540-1165
Once owned by Gustave Stickley;
now open to public, April–
October, Thurs. & Sun., 2–5 p.m.;
otherwise by appointment.

The Gamble House
4 Westmoreland Place
Pasadena, CA 91103
(818) 793-3334
Greene & Greene bungalow

Grove Park Inn
290 Macon Avenue
Asheville, N.C. 28804
(800) 438-5800
Furnished in Arts and Crafts style

Hollyhock House
Barnesdale Art Park
4809 Hollywood Boulevard
Los Angeles, CA
(213) 662-7272
Wright textile-block house; open
to public Tues.-Thurs., Sat., Sun.

Oak Park Visitors Center
Oak Park, Ill.
(708) 848-1500
Guided walking tours and tape
tours available of Frank Lloyd
Wright buildings in Oak Park.

Roycroft Inn and Restaurant
South Grove Street
East Aurora, NY 14052
Restoration of original; opens
summer 1992.

Frank Lloyd Wright Home & Studio
951 Chicago Avenue
Oak Park, Ill. 60302
(708) 848-1976
Wright's first residence; open to
public seven days a week, 9–5.
Guided tours three times daily on
weekdays and every 10–15
minutes on weekends.
Mail-order catalogue and gift-shop
offer Wright-designed items

Interior Design Consultants

Laurie King
Arroyo-Style
55 S. San Marino Avenue
Pasadena CA 91107
(818) 445-0987

Claus Radenmacher Architects
136 East 73rd Street
New York, NY 10021

Roycroft Associates
31 South Grove Street
East Aurora, NY 14052
(716) 632-3333

Appraisals

Marilee Boyd Meyer
P.O. Box 2140
Harvard Square
Cambridge, MA 02238
(617) 497-0044

Conferences

Grove Park Inn Arts & Crafts
Conference and Antiques Show
Asheville, NC
(800) 438-5800
Annual conference, third weekend
in February. Includes seminars,
tours, and antiques show with 600
dealers

Associations

American Art Pottery Association
Jean Okerkirsch, Secretary/
Treasurer
125 E. Rose
St. Louis, MO 63119

Roycroft Association and
Craftsman Homeowner's Club
31 South Grove Street
Roycroft Campus
East Aurora, NY 14052
(716) 652-3333

Publications

American Bungalow
123 South Baldwin Avenue
P.O. Box 756
Sierra Madre, CA 91025-756
(800) 350-3363

Antiques and Fine Arts
255 North Market Street
Suite 120
San Jose, CA 95110

Arts & Crafts Quarterly Magazine
12 South Main Street
Lambertville, NJ 08530

*The Craftsman Homeowner Club
News*
31 South Grove Street
East Aurora, NY 14052
(716) 655-0562, 632-3333

*Journal of the American Art Pottery
Association*
P.O. Box 210342
San Francisco, CA 94121

Old House Journal
435 Ninth Street
Brooklyn, NY 11215

Turn of the Century Editions
250 West Broadway
New York, NY 10013

Salvage Dealers

Architectural Antiques Exchange
709-215 North Second Street
Philadelphia, Pa 19123
(215) 922-3669

Architectural Emphasis Inc.
5701 Hollis Street
Emeryville, CA 94608
(415) 654-9520

The Architectural Salvage Co.
727 Anacapa Street
Santa Barbara, CA 93101
(805) 965-2446

Baltimore City Salvage Depot
213 West Pratte Street
Baltimore, MD 21201
(301) 369-4599

The Bank Antiques
1824 Felicity Street
New Orleans, LA 70015
(504) 523-6055

Gargoyles Limited
512 Third Street
Philadelphia, PA 19147
(215) 629-1700

The Great American Salvage Co.
3 Main Street
Montpelier, VT 05602
(802) 233-7711
and
34 Cooper Square
New York, NY 10003
(212) 505-0070
and
97 Crown Street
New Haven, CT 06508
(203) 624-1009
and
Route 50
Aldie, VA 22001
(703) 327-6159
and
1722 Hendrick Avenue
Jacksonville, FL 32207
(904) 396-8081

Irreplaceable Artifacts
14 Second Avenue
New York, NY 10003
(212) 777-2900

Lost City Arts
275 Lafayette Street
New York, NY 10012
(212) 941-8025

Nostalgia Architectural Antiques
307 Stiles Avenue
Savannah, GA 31401
(912) 232-2324

Old Mansions Co.
1305 Blue Hill Avenue
Mattapan, MA 02126
(617) 296-0445

Omega Salvage
2407 San Pablo Avenue
Berkeley, CA 94705
(415) 843-7368

Pasternak's Emporium
2515 Morse Street
Houston, TX 77019
(713) 528-3808

Red Victorian Salvage
1665 Haight Street
San Francisco, CA 94117
(415) 864-1978

Salvage One
1524 South Sangamon Street
Chicago, IL 60608
(312) 725-8243

Structural Antiques
3006 North Classen Boulevard
Oklahoma City, OK 73106
(405) 528-7734

Sunrise Salvage
2210 San Pablo Avenue
Berkeley, CA 94702
(415) 845-4751

United House Wrecking Corp.
535 Hope Street
Stamford, CT 06906
(203) 343-5371

Urban Archaeology
285 Lafayette Street
New York, NY 10012
(212) 431-6969
and
Montauk Highway and
Halsey Lane
Bridgehampton, NY 11932
(516) 537-0124

Webster's Landing
475-81 Oswego Boulevard
Syracuse, NY 13202
(315) 425-0142

The Wrecking Bar of Atlanta
292 Moreland Avenue, NE
Atlanta, GA 30307
(404) 525-0468

Flea and Antique Markets

WEST
"America's Largest" Antique and
Collectibles Sale
California State Fairgrounds
Sacramento, CA

and
Reno Convention Center
Virginia Avenue
Reno, NV
(503) 246-9996
Once each year—call for dates

Antique Peddler's Fair
Antique Show
Trail Creek Village
Ketchum-Sun Valley, ID
(208) 345-0755
July 4th and Labor Day weekends

Bakersfield Swap-O-Rama
4501 Wible Road
Bakersfield, CA
(805) 831-9342
Every Saturday and Sunday

Kam Super Swap Meet
98850 Moanalua Road
Honolulu, HI
(808) 487-1477
Daily

Outdoor Antique and
Collectible Market
Veterans Stadium
Lakewood Boulevard and
Conant Street
Long Beach, CA
(213) 655-5703
Third Sunday of every month

SOUTHWEST

Fairgrounds Antique Market
1826 West McDowell Street
Phoenix, AZ
(602) 247-1004
Third weekend of every month

First Monday Trade Days
Highway 19 and Kaufman Street
Canton, TX
(214) 567-6556
Begins the Friday before the first
Monday of every month

Trader Jack's Flea Market
2850 Cerrillos Road
Santa Fe, NM
(505) 455-7874
Every Friday, Saturday, and
Sunday

MIDWEST

Ann Arbor Antiques Market
Washtenaw Farm Council Grounds
Ann Arbor, MI
(313) 662-9453
Third Sunday of the month, April
through October, and the second
Sunday in November

Aurora Farms Flea Market
549 South Chillicothe Road
Aurora, OH
(216) 562-2000
Every Wednesday and Sunday

Barn and Field Flea Market
150th Street and Parrish Avenue
Cedar Lake, IN
(219) 696-7368
Every weekend

Caravan Antiques Market
Saint Joseph's County Fairgrounds
Centerville, MI
(312) 227-4464
Several times each year;
call for dates

Country Peddler Show
Drawbridge Inn and Convention
Center
Fort Mitchell, KY
(616) 423-8367
Once each year, usually in July;
call for dates

Franklin Antique Show and
Flea Market
Franklin County Fairgrounds
Franklin, IN
(317) 535-5084
Third weekend of each month,
September through May

Friendship Flea Market
State Highway 62
Friendship, IN
(606) 356-7114
Twice each year; call for dates

Giant Flea Market
Expo Gardens
Peoria, IL
(217) 529-6939
Fourth Sunday of every month
except July

Hump-T-Dump
9510 Old US 31 (Oceana Drive)
Montague, MI
(616) 894-8753
Every day except Tuesday and
Sunday, May through September

Hutchinson Flea Market
Kansas State Fairgrounds
Hutchinson, KS
(316) 663-5626
First Sunday of each month,
October through June

Kane County Flea Market
Kane County Fairgrounds
St. Charles, IL
(708) 377-2252
First Sunday of every month

Larry Nicholson's Collectors
Paradise Flea Market
Keokuk County Fairgrounds
What Cheer, IA
(515) 634-2109
First Sunday in May, August, and
October

Mt. Sterling October Court Days
Mt. Sterling, KY
(606) 498-3785
Begins at 6:00 a.m. the Saturday
before the third Monday in
October and runs non-stop until
midnight on Monday

Scott Antique Market
Ohio State Fairgrounds
Columbus, OH
(614) 569-4912
Eight times each year;
call for dates

Snow Springs Flea Market
and Park
Route 5 and Route 7N
Snow Springs, AR
Daily, February through
November

Springfield Antiques Show and
Flea Market
Clark County Fairgrounds
Springfield, OH
(513) 325-0053
Third weekend (Friday through
Sunday) of every month except July

Tri-State Antique Market
Route 50
Lawrenceburg, IN
(513) 353-2688
First Sunday of each month, May
through November

Wichita Flea Market
Kansas Coliseum
85th Street and Interstate 135
Wichita, KS
(316) 663-5626
Open various weekends October
through June—call for dates

NORTHEAST
Amherst Outdoor Antique Market
Route 122 South
Amherst, NH
(617) 461-0600
Every Sunday, mid-April through
October

The Annex Antiques Fair and Flea
Market
Sixth Avenue and 26th Street
New York, NY
(718) 965-1076
Every Sunday

Antique World and Flea Market
Main Street (Route 5)
Clarence, NY
(716) 759-8483
Every Sunday

Bouckville Antique Pavillion
Route 20
Bouckville, NY
(315) 893-7912
Sundays, May through October

Burlwood Antique Center
Route 3
Meredith, NH
(603) 279-6387
Daily, May through October

Crystal Brook Antique Show
Route 20
Brimfield, MA
(413) 245-3436
Three times each year;
call for dates

Dutch Mill Outdoor Antiques,
Crafts, and Flea Market
3633 Carman Road
Schenectady, NY
(518) 355-3420
Third Sunday of each month,
April through October

Farmington Antiques Weekend
Farmington Polo Grounds
TownFarm Road
Farmington, CT
(508) 839-9735
Twice each year; call for dates

Lambertville Antique Flea Market
Route 29
Lambertville, NJ
(215) 752-4485 weekdays; (609)
397-0456 weekends
Every Wednesday, Saturday, and
Sunday

Red Wheel Flea Market
Route 1
Freeport, ME
(207) 865-6492
Saturdays, Sundays, and holidays,
May through October

Renninger's #2 Antique Market
Noble Street
Kutztown, PA
(717) 385-0104
Every Saturday plus three
"Extravaganza" weekends each
year; call for dates

William Spencer's Antique Show
Creek Road
Rancocas Woods, NJ
(609) 235-1830
Second Sunday of each month,
March through December

SOUTHEAST

Atlanta Flea Market and Antique
Center
5360 Peachtree Industrial
Boulevard
Chamblee, GA
(404) 458-0456
Every Friday, Saturday, and
Sunday

Georgia Antique Fair
Interstate 75 and Aviation
Boulevard
Atlanta, GA
(404) 872-1913
Begins the Friday before the
second Saturday of every month

Jeff William's Everything Show
and Flea Market
Governor's Building at Kemper
Arena
1800 Genessee
Kansas City, MO
(816) 228-5811
One Sunday each month;
call for dates

Joplin Flea Market
Virginia Avenue
Joplin, MO
(417) 623-3743
Every weekend

Malfunction Junction
7721 Highway 90
Mobile, AL
(205) 653-5549
Daily

Metrolina Fairgrounds
Flea Market
7100 Statesville Road
Charlotte, NC
(704) 596-4645
First and third Saturday of
every month

Scott Antique Market
Atlanta Exposition Center
3650 Jonesboro Road SE
Atlanta, GA
(614) 569-4912
Second weekend of every month

Index

Adams, Michael, *89, 133*
Ali Baba benches, 103, *198*
American Terra Cotta and Ceramic Company, 126
architecture, 36, 39
 case studies. *See* case studies
 details, attention to, 48–55
 Gamble house, *30, 32–33,* 46,
 55, 56
 homes, character of, 56, 58
 bedrooms, 72–73, 76
 dining rooms, 64–66
 kitchens, 66–69
 living rooms, 60–63
 walls and floors, 75, 77
Arequipa Pottery, 128
Art Institute of Chicago, 34
"Art and Craft of the Machine,
 The" (Wright), 42
Arthur Sanderson & Co., *173*
"Arts and Crafts Movement in
 America, The: 1876–1916"
 (exhibit), 22
 catalogue, 103, 144
Arts and Crafts style
 accessories, importance of,
 111–12. *See also* specific types
 American flowering of, 34–42
 architecture. *See* architecture
 background of, 13–14, 17
 books and illustrations, 141–142,
 144
 case studies in. *See* case studies
 details, attention to, 48–55
 English roots of, 27–33
 fall and rise of, 21–23
 furnishings for the people, 40–42
 furniture. *See also* specific pieces
 of furniture
 classic pieces, 86–91
 collector's choice, 93–109
 popularity of, 83, 85
 harmonious principles of, 18
 height of, 13
 homes, character of. *See*
 architecture
 international movement, 25
 mass-marketing of, 40, 42
 simplicity of, 17
 vulgarization of, 108
Ashbee, C.R., 136

Ayres, Dianne, *76*

Baggs, Alfred, 128
Banham, Reyner, 46, 111
Batchelder, Ernest, 128, 202, 205
 house designed by, *202–8*
beds, 72–73, *76, 78, 79, 80–81, 184*
benches, *200*
Benson, W.A.S., *194*
Berkeley Mill and Furniture Company, *92*
Bernstein home, *53, 59, 64,*
 66–67, 72, 78, 134, 139
Best, A.W., *179*
Bischoff, Frances Arthur, *179*
bookcases, *11, 20, 47, 59, 102, 107,*
 175
books and illustrations, 141–142, 144
bookstand, *96*
Boston Society of Arts and Crafts,
 34
Bradbury and Bradbury, *28, 52,*
 118, 205, *207*
bridal chest, *22*
Brooks, Digby, *133*
Brown, Ford Madox, 31
Brown, Philip King, 128
Buchta, Anthony, *89*
buffets, *8, 16, 65,* 91
 Stickley servers, *12,* 91, *154, 162,*
 166
Burmantofts Faïence pottery, *186*
Burne-Jones, Edward, 31

cabinets, *82, 101, 203*
"California Design 1910" (exhibit),
 22
candlesticks and -stands, *16, 29,*
 41, 76, 120, 132, 150, 153, 154,
 167, 179, 182–83
Carpenter, James W., 130, 135
carpets. *See* rugs
Carrino, David, *19*
case studies. *See also* Bernstein
 home; Gamble House
 Cathers and Dembrosky's Dutch
 colonial, 150–55
 Cohen's Usonian-style home,
 156–63
 Dowd's Hollywood hacienda,
 196–201

Gray's farmhouse, 170–75
Johnson and Wanzenberg's
 Manhattan duplex, 188–95
Kearns' New York apartment,
 182–87
Macpherson's California cottage,
 176–81
Manhattan loft, 164–69
Cathers, David M., 104
Cathers and Dembrosky home,
 150–55
ceramics, 17, *35, 47, 57, 62, 110,*
 119, 120–35, *154–55, 166,*
 178–79, 186, 190–91, 192
 Arequipa Pottery, 128
 Burmantofts Faience pottery,
 186
 Chelsea Pottery, 121–22
 Dedham Pottery, 34, 122
 Fiesta ware, 74
 Fulper Pottery, *12,* 126, *134, 162,*
 171, 176, 178, *195, 197*
 Grueby ceramics, *36, 38, 53,*
 101, 115, 124, 126, *154, 165, 169*
 Marblehead Pottery, 128
 Newcomb Pottery, 128, *165*
 Ohr pottery, *35,* 130, 135
 Pewabic Pottery, 130
 Revere Pottery, 128
 Robertson family, 120–22
 Rookwood Pottery, 22, 25, *53,*
 88, 122, 124, 130, *134, 135,*
 165, 167, 178
 Ruskin pottery, *181*
 Stickley Brothers china, *134*
 Teco pottery, *16,* 126, *175,*
 178–79, 198
 tiles, *16, 24,* 46, *55,* 77, 121, 126,
 128, *133, 134, 147, 169, 189,*
 205, *206, 208*
 Van Briggle pottery, *133, 166*
 Wright urn, *36*
chairs, *19,* 60, *84, 92, 94, 187,*
 190–91, 195, 203
 Adirondack chairs, *26*
 classic designs, 86, 89
 Limbert chairs, *67, 72*
 Maybeck chair, *181*
 Mission style, *61,* 89
 Morris chairs, *73,* 86, 89, *90,*
 102, 157, 158, *168–69*

Stickley chairs, *14, 22, 53, 64, 66, 73, 150–51, 153, 162, 163, 168–69, 175, 179, 185, 194, 197*
Wright design, *36*
Chandler, Raymond, 196
Chelsea Keramic Art Works, 120–21
Chelsea Pottery, 121–22, *122*
chest of drawers, *35*
Chicago Architectural Club, 34, 126
Chicago Arts and Crafts Society, 34, 42, 126
Christie's, 23
Cincinnati Art Museum, 22
Clark, Robert Judson, 103
clocks, *125, 127, 195*
Cohen home, 156–63
Coleman, Alice, 202, 205
Contrasts (Pugin), 27
Coonley, Avery, 48
Copeland and Day, 142
Copper Shop, 120
Copper Work (Rose), 135
Costello, Patrick, *20*
Coxhead, Ernest, 39
Craftsman, The, 58, 75, 104, 141
Crane, Walter, *118*
Curtis, Edward S., *11, 194*

Darling, Sharon, 106
Deakin, Edwin, *107*
Decorative Designs of Frank Lloyd Wright, The (Hanks), 46, 120
Dedham Pottery, 34, 122
Deerfield Society, 34
Dembrosky and Cathers home, 150–55
desks, *98, 109, 182*
classic designs, 91
Limbert desk, *97*
Rohlfs desk, *37, 91*
Stickley desk, *198*
wicker desk, *74–75*
Diamond Dust Shoe (Warhol), *20*
Donghia seating, *98–99*
Dowd, Nancy, 196–201
Duffner & Kimberly chandelier, *53*

Eastlake, Charles Lock, 31, 33
Eaton, Charles Warren, *166*
Edison, Thomas, 115
Ellis, Harvey, 25, *35, 82,* 104, *153, 162, 163, 165, 185*
Elmslie, George Grant, 55, 126
entries, *30,* 50, *143*

fabrics and coverings, 17, *19,* 31, *42–43,* 50–51, *71, 72, 76, 78–81, 85, 102, 137, 138, 139, 140,* 141, *176. See also* rugs; wallpapers
Farewell My Lovely (Chandler), 196
Feick, George, Jr., 55
Fiesta ware, *74*
fireplaces, *40, 52, 57, 73, 107,* 152, *174, 192,* 205, *206*
"Fishermen" (Bischoff), *179*
floors, *70,* 80
Friedell, Clemens, 139
Fulper Pottery, *12,* 126, *134, 162, 171, 176,* 178, *195, 197*
Furniture of the American Arts and Crafts Movement (Cathers), 104
Furniture Shop, 93

Gamble, David B., 139
Gamble House, *8, 30, 32,* 46, *55, 56,* 111, 139
Gates, William D., 126
Gimson, Ernest, *193*
Gorham Manufacturing Company, 136
Gothic style, *29, 42–43,* 98, *190–91*
Grand Rapids manufacturers, 106, 115
Granger, Alfred H., 46
Gray, Stephen, 170–75
Greene & Greene: Architecture as a Fine Art (Makinson), 46, 56
Greene, Charles Sumner and Henry, *8,* 25, *30, 32, 33,* 39, 46, 48, 50, 52, 55, 56, 103, 190
built-in buffet, *8*
Gamble House, *8, 30, 32,* 46, *55, 56,* 111, 139
lamps and lighting design, 119
table design by, *65, 113*
tiles, use of, 128
"ultimate bungalow" idea, *33,* 56
wood carving by C.S.G., *116–17*
Griswold tea kettle, *173*
Grove Park Inn, *79, 173*
Grueby ceramics, 124, 126, *36, 38, 53, 101,* 115, 124, 126, *154*
Guild of Arts and Crafts (New York), 34

Hall, Herbert J., 128
Handel lighting fixtures, *64, 72, 88, 162, 163*

Hanks, David, 46, 120
Heal & Co., *187*
Heintz Art Metal Shop, 178, *180*
Heinz and Company, *41, 54, 58*
Henken, David, 156
Hints on Household Taste (Eastlake), 31
History of American Ceramics, The (Levin), 121
home case studies. *See* case studies
House Beautiful magazine, 34, 46, 91
Hubbard, Elbert, 34, 36, 93, 103, 141–42
Hunter, Dard, *11,* 25, 103
Hurley, E.T., *179*

Illinois Art League, 34
inglenooks, 63

Japanese design, 39, 50, 152, *153, 155, 154–55*
Jarvie, Robert R., 120, *154*
Jensen, Georg, 136
Johnson, Jed, 188–95
Jordan Volpe Gallery, 196

Kalo Shop, 136
Kato, Shioh, *92*
Kearns, Sarah and Richard, 182–87
Kelmscott Press, 141
Kipp, Karl, 136
kitchens, 66, *67, 68, 69*

Lakeside Crafts smoke stand, *67*
lamps and lighting, *20, 62, 65, 74–75, 89, 92, 94,* 115–20, *129, 133, 147, 187, 192, 194, 197, 200*
Batchelder designs, *204, 208*
candlesticks. *See* candlesticks and -stands
Duffner & Kimberly chandelier, *53*
by Fulper Pottery, 126
by Greene and Greene, 119
Grueby bases, 115
Handel fixtures, *64, 72, 88, 162, 163*
Mission style, *28*
Roycroft fixtures, 115, *173*
Stickley lamps and fixtures, *16, 22, 101,* 115, *175, 184, 194*
Tiffany lamps and fixtures, 22, *67,* 115, *143, 169, 184*

Van Erp lamps and fixtures, *22, 37, 116–17,* 120, *151,* 152, *154, 171, 172, 189, 199*
 Vase-Kraft lamps, 126
 Wright designs, *41, 54,* 119–20
Lang, Jeremy P., *37, 138, 143*
Langdon, Hilda, *97, 98–99*
Laub, Randolph, *87, 94*
Levin, Elaine, 121, 128
Liberty of London armoire, 178, *181*
Lifetime umbrella stand, *67*
Limbert Company, 106, 108
 bookcase, *59*
 bookstand, *96*
 chairs, *67, 72*
 desk, *97*
 tables, *53, 67, 176*
Lindstrom, Kristina, *97, 98–99*
Lutyens, Edward, *195*
Lynn, Catharine, 77

McHugh, Joseph, 40, 89
Mackintosh, Charles Rennie, 25, *65,* 104
Mackmurdo, Arthur Heygate, 104
McLaughlin, Mary, 122, 130
Macpherson, Caro, 176–81
magazine racks, *147*
Maher, George Washington, 55, *189*
Maier, R.E., 139
Makinson, Randell, *41,* 46, 56, *58*
Marblehead Pottery, 128
Marshall Field & Co., 34
Martele silver, 136
masks, *57*
Massachusetts Institute of Technology, 50
Mathews, Arthur and Lucia, 22, 93, 103
Maybeck, Bernard, 39, 177, *181*
Mercer, Henry C., 128, *207*
Merrymount Press, 142
metalwork, *29,* 50–51, *53, 69, 72, 80–81, 87, 92, 98, 105, 107,* 120, *129, 131, 132, 133,* 135–36, *138,* 139, 178, *180.*
 candlesticks and -stands. *See* candlesticks and -stands
 lamps. *See* lamps and lighting
 tableware. *See* tableware
 Van Erp pieces, *22, 37, 89, 107, 116–17,* 120, *124, 174, 178–79, 189*
Metropolitan Museum of Art, 22
Michigan Chair Company, *66,* 178

Millet, Louis, *189*
Mirman, Ben, *113*
mirror, *18*
Mission Oak Co., *200*
Mission style, *28,* 40, 50, *61, 70,* 85, 89, 106, *131,* 196, *197–98, 200–201*
Mizner, Addison, *182–83*
Moore, Michael, *199*
Moravian Tile Works, 128, *208*
Morgan, Julia, 39
Morris, William, 27, *28,* 31, 34, 42, 77, 80, 86, *137,* 141, *173*
 chair designs, *73,* 86, 89, *90, 102, 157,* 158, *168–69,* 178
Mount Tamalpais, *133*

Nakashima, George, *154–55*
Native American art and artifacts, *11, 42–43, 125,* 158, 190, *192*
 Navaho art, *38,* 152, *153*
Natzler, Gertrude and Otto, 178
Newcomb Pottery, 128, *165*
Nichols, Maria Longworth, 122, 130
Noguchi, Isamu, *153*

Oakland Museum, 21, 22
Ohr, George, *35,* 130, 135
Oncken, Oscar, *202*
Onondaga Shops, 106
oriental campaign chest, *76*
ottomans, *92, 153*

Pabst, Daniel, *182*
Paladino, Mimmo, *192*
Pasadena Art Center, 22
Payne, Edgar, *165*
Perry, Mary Chase, 130
Peters & Reed, *178–79*
Pewabic Pottery, 130
Philadelphia 1876 International Centennial Celebration, 122
photographic art, *11, 113, 125, 194*
plant stands, *44, 150–51, 169, 178–79, 187*
Popular Shop, 40, 89
pottery and china. *See* ceramics
Prairie School, 39, 55, *72,* 83
Price, Will, 147
Princeton University, 22
printing, 141–42, 144
Pugin, Augustus, 27
Purcell, William Gray, 55
pyrography, *185*

Quisel shades, *64*

Rademacher, Claus, *87, 94, 98–99*
Randell, James, *65*
Read, Peter, *60*
Red House, 31
Reeve, Jennie A., 50
Revere Pottery, 128
Rhead, Frederick, 128
Richardson Company, *176*
Riverside Press, 142
Robertson, Alexander, 121
Robertson, Hugh, 121–22
Robertson, James, 120–21
Robie House, 120
Robineau, Adelaide Alsop, 130
Rohlfs, Charles, 25, 34, 93, 103, 152
 desks, *37,* 91
 plant stands, *44, 150–51*
 tables, *67*
 taboret, *101*
Rookwood Pottery, 22, 25, *53,* 88, 122, 124, 130, *134, 135, 165, 167,* 178
Rose, Augustus Foster, 135
Rose Valley community, 147
Rossetti, Dante Gabriel, 31
Roux, Alexander, *190–91*
Roycroft Community, *11,* 36, 93, 95, 103, 152
 Ali Baba benches, 103, *198*
 bookends, *115*
 books, 34
 lamps and fixtures, 115, *173*
 magazine rack, *147*
 metalwork, 136
 picture frames, *154*
 plates, *16*
Roycroft Press, 141–42
rugs, *22, 53, 66–67, 70,* 71, 80, *84, 138, 178–79*
 drugget rugs, *171, 173*
 Navaho rugs, 152, *153*
 Stickley designs, *59, 64, 72*
Ruskin, John, 28, 31
Ruskin pottery, *181*
Russell, Gordon, *187*

Saturday Evening Girls, The, 128
Scott, M.H. Baillie, 104
screens, 73, *145, 150–51,* 159, *197*
Sedding, J.D., 27
servers. *See* buffets
settles, *22, 28, 71, 84, 85, 87*

classic styles of, 86
Stickley settles, *67, 88,* 156,
158–61, 163, 164
Wright design, *58*
Seven Lamps of Architecture, The
(Ruskin), 28
Shakers, 104
Shreve & Company, *135,* 136, 139,
167
sideboards, 66, *105, 154–55,* 178,
186. See also buffets
Stickley sideboard, 178, *179*
silverware. *See* tableware
Smith, Tony, *129*
Society of Decorative Arts, 34
sofas. *See* settles
Sophie Newcomb College, 128
Spanish colonial revival style, *29,
182–83*
Stickley, Albert, 106
Stickley, Gustav, *11, 23,* 34, 60, 66,
86, *103–4,* 106, 126, 152, 156,
164, *174, 189*
bed, *184*
bench, *200*
bookcases, 47, *107, 175*
bridal chest, *22*
cabinets, *82, 101*
chairs, *64, 73, 150–51, 153, 162,
163, 175, 175, 179, 194, 197*
chest of drawers, *35*
clocks, *195*
desk, *198*
Ellis designs. *See* Ellis, Harvey
hearth, *40*
house, *26*
influences on, 103–4
lamps and fixtures, *16, 22, 101,*
115, *175, 184, 194*
rug designs, *59, 64, 72*
screens, *150–51, 197*
secretary, *165*
servers, *12,* 91, *154, 162, 166*
settles, *88,* 156, *158–61,* 164, *175*
shades, *175*
sideboards, 23, 178, *179*
tables, *64, 150–51, 168–69, 171,
173, 175, 193, 194, 197*
taboret, *67*
Stickley, Leopold and John
George, 34, *53,* 106
bookcase, *20*
chairs, *14, 22, 28, 66, 168–69,
185*
china, *134*

metalwork, 136
settles, *22, 28, 67, 163*
tables, *14–15, 52, 88, 192*
slantfront desk, *66*
Stickley Brothers Company, 106
Stocksdale, Robert, *92*
Stones of Venice, The (Ruskin), 28,
31
Story of the Glittering Plain, The
(Kelmscott Press), 141
Studio, The, 104
Sullivan, Louis, 25
"Sunrise over Grand Canyon"
(Best), *179*

tables, *19,* 89, 91, *92, 94, 187*
buffets or servers. *See* buffets
Greene and Greene, *113*
Limbert tables, *53, 67, 176*
Read table, *60*
Rohlfs table, *67*
Stickley tables, *14–15, 38, 52,
64, 88, 150–51, 168–69, 171,
173, 175, 192, 193, 194, 197*
Vulpiani table, *58*
White Brothers table, *78*
Wright design, *41*
tableware, *135,* 136, 139, *167*
taborets, *67, 101*
Taylor, Warrington, 86
Taylor, William Watts, 122, 124
Teco pottery, *16,* 126, *175, 178–79,
198*
textiles. *See* fabrics and coverings
Thompson, Susan Otis, 142, 144
Throop Polytechnic Institute, 202
Tiffany, Louis Comfort, 65
candlestick, *41*
lamps and fixtures, *22, 67,* 115,
143, 169, 184
windows, 80
tiles, *16, 24, 46, 55,* 77, 121, 126,
128, *133, 134, 147, 169, 189,
205, 206, 208*
Tobey Co., 106
Trapp, Kenneth, 21
*Treasures of the American Arts and
Crafts Movement* (Cather, co-
author), 150
"Try the Girl" (Chandler), 196

University Press, 144

Van Briggle pottery, 124, *133, 166*
Van Erp, Dirk, *107, 174*

bowls, *124, 178–79*
copper pots, *89, 189*
lamps and fixtures, *22, 37,
116–17,* 120, *151,* 152, *154,
171, 172, 189, 199*
Vase-Kraft lamps, 126
Voysey, C.F.A., *138,* 184
Vulpiani, Coly, *58*

Wallpaper in America (Lynn), 77
wallpapers, *28,* 31, *48,* 77, *79, 173,
182–83,* 205, *207*
walls, 75, 77, *78, 79–80, 118*
Wanzenberg, Alan, 188–95
Warhol, Andy, *19, 20,* 190, *192,
193*
Webb, Philip, 31, 86
Welles, Clara Barck, 136
White Brothers, *78*
wicker, *23, 59, 73, 74–75, 107*
Wilhelm, Paul, 34
William Morris Society, 34
windows, *48–49, 56,* 50, 52, *56,
61,* 80, *119, 182–83*
window seats, *14–15, 52, 63*
Winter, Robert, 202–8
World's Columbian Exposition,
124
Wright, Christopher, *92*
Wright, Frank Lloyd, 34, 39, 42,
45–46, 48, 75, 103, 111, 126,
156, 190
furnishings, *36*
lighting fixture designs, *41, 54,*
119–20
settle design, *58*
table design, *41*

Yens, Karl, *88*

Zimmermann, Marie, *166*
"Zuni Governor, A," (Curtis), *11*